Gauguin's Skirt

With 110 illustrations, 7 in color Thames and Hudson

Gauguin's Skirt

Stephen F. Eisenman

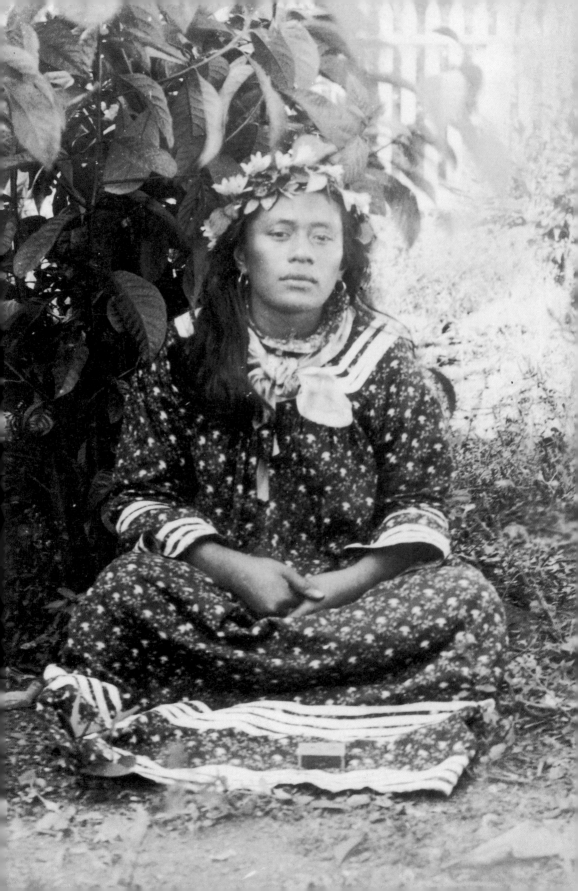

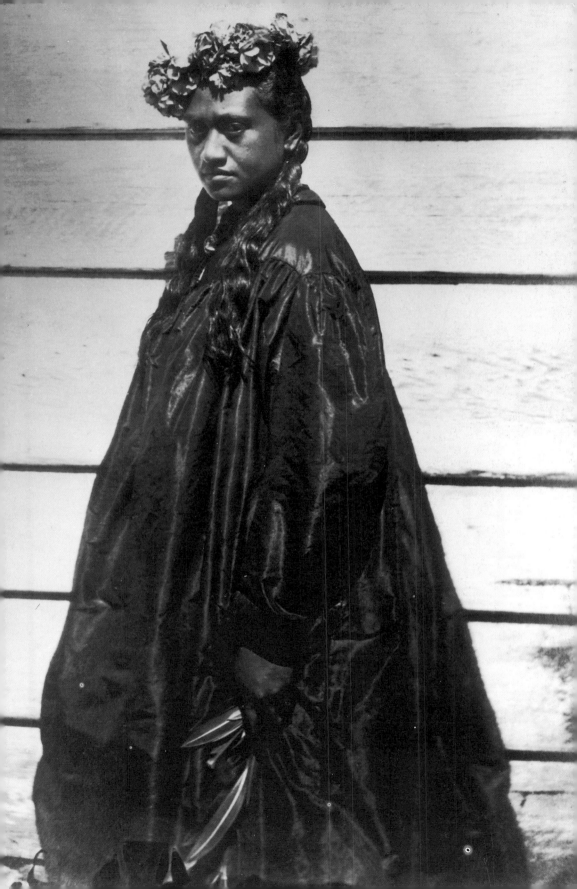

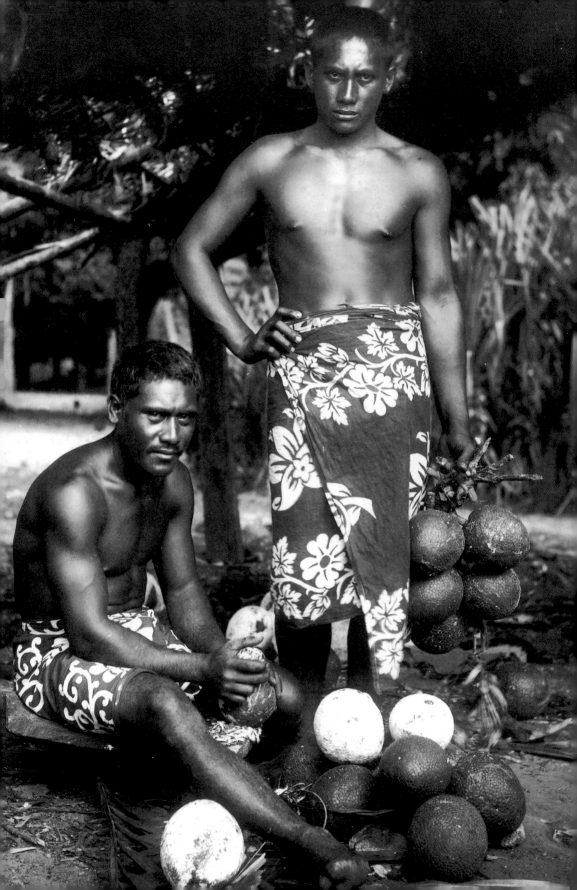

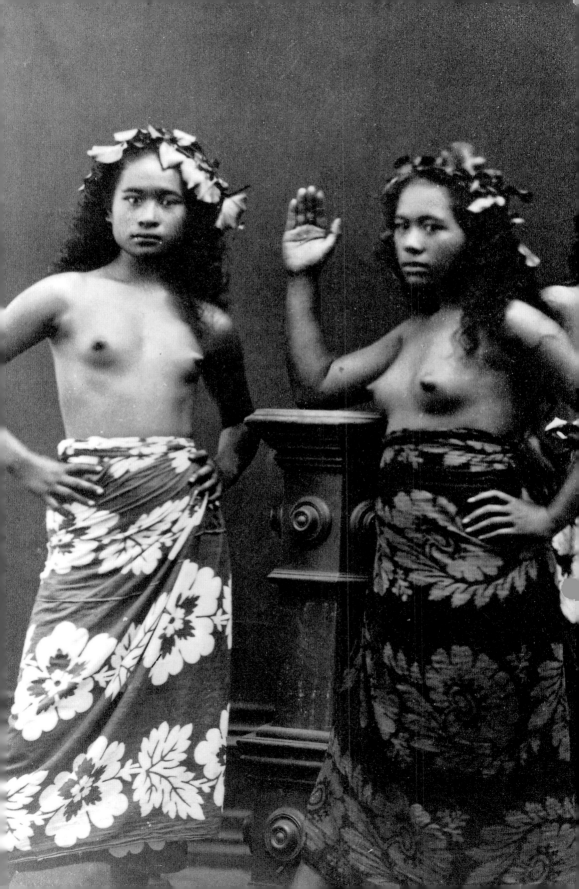

pp. 4–7
Gauguin's female models recline, sit, stand, walk,
gossip, sing, dance, sleep and dream; they may be
at once human and divine, animal and totem, alive
and dead, child and adult. His rarer depictions of
men frequently display a gender ambiguity too.

© 1997 Thames and Hudson Ltd, London

First published in the United States of America in 1997 by
Thames and Hudson Inc., 500 Fifth Avenue, New York,
New York 10110

Library of Congress Catalog Card Number 96-61176
ISBN 0-500-01766-2

Printed and bound in Slovenia

Contents

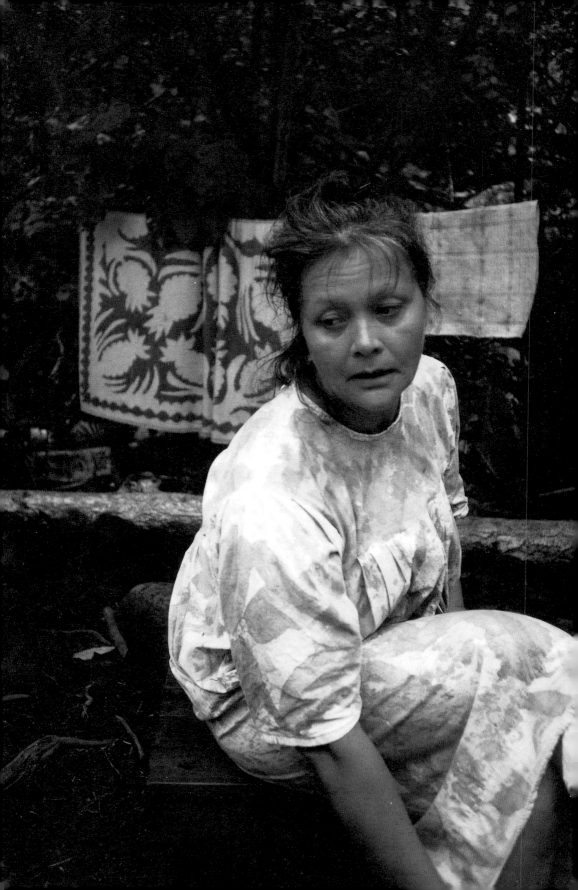

The past and present of colonialism daily rub elbows in Tahiti. A French naval officer in starched khakis, and a vacationing sybarite in shorts and sandals jostle on the wharf of Papeete, Tahiti's ramshackle capital. One has disembarked from a gray French Zodiac cruiser, the other from the gleaming white *Club Med II*. Their perspective down the long, straight rue Paul Gauguin is obscured by the glare of South Pacific sunlight and the brown exhaust of diesel engines. Each in turn crosses the traffic-jammed Boulevard Pomare (named after a line of nineteenth-century kings and queens), lured by native women selling rainbow-hued *pareus* from metal racks on the sidewalk opposite. The two visitors continue their perambulation down the boulevard, looking in the windows of the Banque Socredo, Tahiti Perles, American Express, the gendarmerie, and an art gallery called, after a famous Gauguin painting, *Matamua* (*Olden Times*).

The modern traveler to Tahiti is constantly asked to recall an exotic and fabled past—Cook, Bougainville, Loti and Gauguin—while indulging the pleasures and obligations of modern-day tourist consumption. *Gauguin's Skirt* is similarly about the present as well as the past. Its subjects are living Tahitians and a long-dead French painter, sex today and sex in the late nineteenth century, and colonialism new and old. My matter is thus the practice of daily life as much as the practice of painting, and my disciplinary allegiance is as much to anthropology as to art history. Questions of style and iconography are intermixed with inquiries about kinship, sexual practices and religious belief; the history of nineteenth-century France is conjoined with the history of the South Pacific. Having gained a modest conversancy with the anthropology of Oceania, I cannot even imagine writing a book on Gauguin that is other than hybrid.

Gauguin's Skirt was initially stimulated by a series of conversations (sometimes heated arguments) with American and British art historians and anthropologists on the subjects of Gauguin, colonialism, primitivism and ethnography. These debates occurred in classrooms, lecture halls, around dinner tables, in cars, on the telephone, via e-mail,

In her roles as artist, healer and political activist, Roti Make personifies the synthesis of traditional and contemporary cultures in present-day Tahiti

and in one instance (with Abigail Solomon-Godeau) on the beach at Sainte-Anne-la-Palud in Brittany, near Gauguin's retreat at Le Pouldu. I am immensely grateful to my many interlocutors (and antagonists) for their forbearance and their ideas. In addition to Solomon-Godeau, they include Rick Brettell, Linda Nochlin, Dan Segal, Thomas Crow, John House, Kathy Adler, Jeff Tobin, Eric Frank, David Craven, Tamar Garb, Nancy Troy, Pat Morton, Brian Lukacher, Anthony Vidler, Mark Haxthausen, Emily Apter, Cécile Whiting, James Herbert, Michelle Wallace, Rosemary Joyce, Benjamin Orlove, Donald Brenneis, Margaret Jolly, Sidney Mintz, Vincent Crapanzano, Peter Kort Zegers, Douglas Druick and Niko Besnier. Nicholas Thomas has been especially helpful at all stages of the composition of this book, and his comments on my penultimate draft were dauntingly incisive. Fran Terpak searched for photographs of nineteenth-century Tahiti in the archives of the Getty Center for the History of Art and the Humanities, and throughout the European art market. The staffs of the Archives d'Outre-Mer in Aix-en-Provence, the Mitchell Library at the State Library of New South Wales and the Musée de l'Homme in Paris were also extremely accommodating about photography. Elizabeth Childs helped me to identify the origins of a photograph showing Gauguin surrounded by three naked Tahitian women. The picture was indeed too good to be true, and Elizabeth saved the artist and myself from great embarrassment. Her own book on painting and photography in Tahiti will greatly enhance our understanding of the relation between the media during the *fin de siècle.*

In 1995, I finally traveled to Tahiti. There I had the good fortune to meet Deborah Elliston, a brilliant young anthropologist who was studying gender identity on Huahine. Her opinions on the matter of *raeraes* and *mahus* stimulated many of the ideas contained in Chapter Two. In Tahiti I also had the pleasure of meeting the anthropologists, historians and anti-nuclear activists Bengt and Marie-Thérèse Danielsson. They graciously welcomed me into their home and permitted me to consult their library. M. Gilles Artur, director of the Gauguin Museum, was similarly generous with his time and with library resources. Dave Enever, captain of the Greenpeace ship *Rainbow Warrior*, kindly instructed me in the consequences of anti-colonialism and environmental activism by displaying the results of the French seizure of his vessel. But above all, I benefitted in Tahiti from discussions about culture and politics with Roti Make, Joinville Pomare, Gabriel Tetiarahi, Pito Clement, Marius Raapoto, Tehaeura Teihoarii, Oscar Temaru and Manouche Lehartel. My Sunday afternoon lunch chez Roti was the highlight of my three years of work on *Gauguin's Skirt.*

Mary Weismantel has been indispensable to me throughout the writing of this book. She guided me through the history of anthropological thought, introducing me to classic texts by Durkheim, Mauss, Malinowski, Mead and Firth and to more recent works on Oceania by Douglas Oliver, Marshall Sahlins, Marilyn Strathern and Nicholas Thomas, among others. She also read and criticized successive drafts of *Gauguin's Skirt*, and took sole care of our beloved daughter Diane while I traveled to London, Tahiti, Hawaii and Sydney. I cannot adequately thank Mary for her gifts of time, thought and love; this book is dedicated to her.

Author's Note
I have adopted the Tahitian orthography Teha'amana throughout, except when referring to artworks, where I have adhered to the form Tehamana used by Gauguin.
Full details of the photographs preceding each section of this book are given in the List of Illustrations on pp. 228–29.

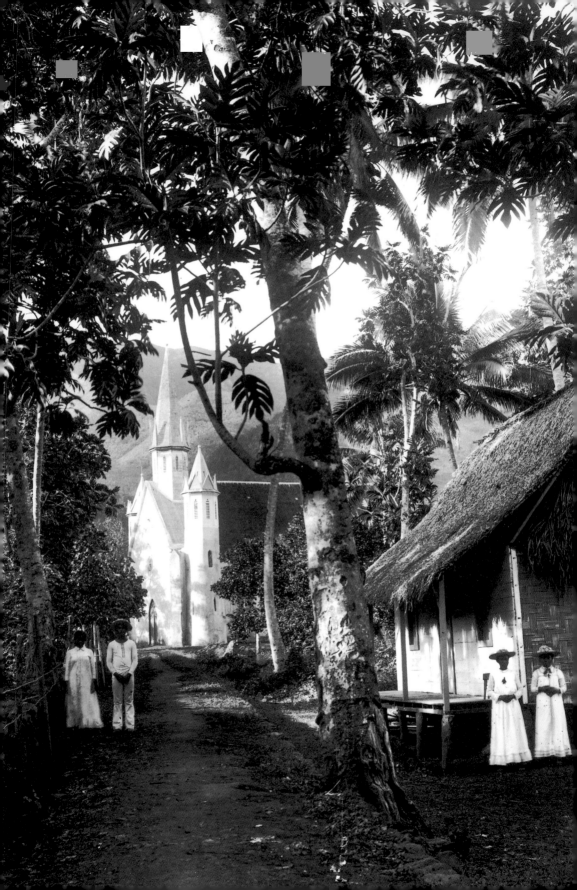

I

After a period of sustained research and thought about Gauguin in Tahiti, I arrived at three basic ideas: 1) *Fin de siècle* Tahiti–despite its small population–had a rich, complex and resilient culture; 2) nineteenth-century Polynesians, like their contemporary descendants, were more often active antagonists of than passive witnesses to French imperialism; and 3) Paul Gauguin was well aware of the Polynesians' cultural and political perspicacity and represented it in his art. These ideas are not found together in the existing literature but they are the guiding theses of this book.

Until recently, the following tale was told: In 1891, after several years of financial struggle and critical neglect, Paul Gauguin–the stockbroker-turned-Impressionist-painter–fled family and friends in France to seek financial, emotional, aesthetic and sexual solace in an indigenous community in the South Seas. There he embraced the habits of a savage–living in a grass hut, fishing, hunting, having sex with young native women–and learned to paint in a crude and primitive style. At first, so the story goes, life ebbed and flowed as gently as the waves that washed the shore facing Gauguin's simple house. Later, however, especially after his return to Tahiti in 1895 from an unhappy sojourn in Paris, life became bitter and barren. Forgotten and forsaken by his former friends in Paris, disliked and mistrusted by the colonial authorities in Tahiti, yet unable to assimilate fully into native society, Gauguin became impoverished and despondent. Before a failed suicide attempt in 1897, he painted his modern masterpiece and last testament, *Where Do We Come From? What Are We? Where Are We Going?*, a work which recast Genesis in Tahitian terms. Gauguin lived on for five more years–painting in fits and starts and scrambling for money any way that he could–before finally succumbing in 1903 to the ravages of hunger, disease and despair.

Embellished by dozens of biographers and art historians beginning with the artist's friend Charles Morice in 1903 and ending more recently with David Sweetman's biography,[1] the fable above generally

The village of Atuona, Hiva-Oa, Marquesas Islands photographed by HENRY LEMASSON in 1898–a pastoral image of colonialism

has an important coda: by virtue of the rigor and heroism of his life, and the originality and salience of his art, Gauguin exposed the hypocrisy of middle-class morality, the physical laxity of European men, and the timorousness of Western painting.[2] "Gauguin's nature," wrote Robert Rey in 1924, "compounded in part of wild but grandiose atavistic tendencies, urged him on in a vague, impossible dream of space, brute strength and mastery." Rey continued, somewhat crudely: "There surged up in him a formidable capacity for hope. Never has a man so thoroughly impressed others with being a moving force, a force that let itself go."[3] Half a century later, Wayne Andersen was equally clear in his perception of a vigorous, masculine persona: "Gauguin 'created' a style of painting in the sense that he gave it its life force; and the vitality of his art was matched by the potency of his personality, by the loudness of his actions."[4] By so forcefully asserting his personal and artistic autonomy, Gauguin cleared a path by which future generations discovered and colonized pure painting. Twentieth-century modernism was thus the vital response to Gauguin's critical challenge, the story concludes, and Western culture was infused with renewed energy and spiritual vigor. "The most curious aspect of Gauguin's œuvre," wrote Françoise Cachin in 1988, "is that, after living a romantic adventure . . . he made painting itself into such a sacred act that the liberties he took with it ultimately led to modern art. For it was the painting that became the absolute, not life."[5]

Like all myths, the one concerning Gauguin has a basis in fact, but is markedly selective in point of view; it overlooks the artist's initial support from the French state, his relative wealth in Polynesia, his modest celebrity in Paris and his ignoble treatment of wives and children, artist friends and Tahitian natives (especially young women). Gauguin's "primitivism" was mostly forged in Brittany, not Tahiti, and the modernism of which he was the champion now appears decidedly less radical than it once did. Artworks by its greatest (invariably male) exemplars grace the walls of Beverly Hills mansions, command princely sums at auction houses, and receive the genuflective attentions of conservative critics and scholars whose conception of reform begins and ends with reducing tax on capital gains. It is no wonder that Paul Gauguin has recently borne the brunt of a fierce scholarly backlash.

The story of the reaction against the Gauguin myth starts gently enough, with the fine work of the Swedish anthropologist and historian, Bengt Danielsson. Long resident in Tahiti, he published a series of works beginning in the 1950s that exposed the decidedly un-idyllic side of *fin de siècle* French Polynesia and the equally unheroic spirit of its most famous artist. In these works, Danielsson described the

demographic collapse of colonial Polynesia, the extent of missionizing and Christianization, the impoverishment of Maohi (native) material culture during the *fin de siècle* and the destruction of indigenous ways of life by Western commodities and French law. He was equally relentless in his pursuit of the historical Paul Gauguin. With the collaboration of Patrick O'Reilly, he collected and republished articles written by Gauguin for the Papeete journal *Les Guêpes* (*The Wasps*) which indicated that the artist had loose morals and feet of clay. When it came to attacking injustice and defending right, O'Reilly and Danielsson concluded, Gauguin was inconstant at best and hypocritical at worst. Finally, in 1967, Danielsson wrote an article that exposed Gauguin's impoverished language skills; the Tahitian words and phrases in the artist's titles are consistently ungrammatical and mis-spelled.[6]

Danielsson's intent, in large part, was to debunk Western myths about Tahiti, not to highlight the duplicity of Gauguin. Indeed, while remaining undecided as to the ultimate merit of Gauguin's art (Danielsson was not an art historian), he saw Gauguin as a keen and insightful observer of Polynesian society. Whatever the artist's indiscretions, his ten years' residence earn him continued respect, Danielsson implicitly claimed in *Gauguin in the South Seas* (1965), as a committed protagonist of Tahiti and its people. No such reserve of good feeling, however, was available to critics and art historians in the 1980s engaged in the project of exposing the cultural domination and physical violence effected by nineteenth- and twentieth-century colonialism and imperialism. If modern art was seen by earlier generations as an expression of universal freedom, it was now understood by many—especially feminist and post-colonial scholars—to be an instrument of European racism and patriarchy.

II

The emergence in the 1960s of a powerful feminist movement, and the concomitant development of a feminist critique of art history has challenged patriarchal assumptions and changed our fields of vision. Few writers today are so unselfconscious as Rey and Andersen in their championing of Gauguin's masculinity. Linda Nochlin alerted a generation of readers and students to the "genderedness" of modern vision, and to the figuration of liberation in solely masculine terms. Carol Duncan also contributed to this insight, which she summarized in a pathbreaking article from 1973: "Once we raise [the question of the social relation between the sexes] . . . a most striking aspect of the

avant-garde immediately becomes visible: however innovative, the art produced by many of its early heroes hardly preaches freedom, at least not the universal human freedom it has come to symbolize . . . but [rather, it speaks] of the fantasies and fears of middle-class men living in a changing world."[7]

By the late 1970s, the feminist critique of modern European art and literature was buttressed by insights derived from the emerging discipline of colonial and post-colonial studies. Edward Said's *Orientalism* (1978) was particularly influential in helping to effect a sea change in scholarly consideration of the relationship between Europe and its former Middle Eastern, North African and Indian colonies. According to Said, many apparently disconnected bodies of literature, fields of historical inquiry and even diplomatic machinations could be seen as expressions of a common and oppressive ideological tendency called "Orientalism." Though the book has been criticized by the literary critic Aijiz Ahmad among others for its implicit construction of a one-dimensional "Europeanism," its force and clarity nevertheless impressed scholars in many disciplines, including art history.[8]

In a pair of brilliant and polemical assaults upon art historical complacency, Abigail Solomon-Godeau (1989) and Griselda Pollock (1993) applied some of the lessons of feminist and post-colonial scholarship to the life and art of Gauguin. They argued that Gauguin traveled to Tahiti not as a helpless exile or refugee, but as a colonist under the flag of the French Ministry of Marine and Colonies. They stated in addition that he largely maintained his French habits of dress and diet (by the time of his death he was consuming half a liter of cognac a day), and that his behavior toward his successive *vahines* (wives, women) was more a matter of bourgeois masculine libertinage than of sexual reciprocity. They further argued that Gauguin knew little about Tahitian religion and (following Danielsson) less of the native language, that his several diaries, essays and treatises were either ghost-written or outright plagiarisms from earlier exoticist authors, and even that his art was less original than it once seemed; its flattened forms and mystic images were cribbed, Solomon-Godeau claimed, from the work of Emile Bernard, Paul Cézanne and Odilon Redon, among others.[9] Far from championing Tahiti at the expense of France, they concluded, Gauguin upheld a version of primitivism that was indistinguishable from racism and misogyny. His vaunted artistic experimentation and self-imposed exile were thus no more than a self-serving avant-garde "gambit," in Pollock's phrase;[10] his heroic persona benefitted the cause of an imperialism synonymous with capitalism at its highest stage. If modern art was in fact, as several generations of art

historians claimed, the offspring of Gauguin (among others), then that child would better have been strangled in its cradle; its parent too must therefore merit only our most bitter obloquies.

Solomon-Godeau's and Pollock's impassioned summaries and criticisms of Gauguin's Tahitian art and life are in many ways plausible (I shall return to them in my discussion of sex and gender in Chapter Two), but I believe they are ultimately as misleading as the earlier benighted formulations. They reiterate mechanical formulations from Edward Said concerning the "Occident" and the "Orient," and fail to make use of the more complex formulations of subsequent post-colonial scholars, such as Gayatri Spivak and Homi K. Bhabha. These writers have argued forcefully that oppressed people (especially women) have been triply oppressed—by European colonial powers, by native patriarchies and by modern scholarship. Far from being merely passive victims, however, colonized peoples have historically employed some of the very Orientalist rhetorics described by Said as a means of forging collective identities and fashioning resistance movements. At the heart of colonialist discourses themselves, argue Spivak and Bhabha, lie potentially significant ambivalences and aporias. Colonial novels, artworks, letters, and official documents may in fact, Bhabha argues, be "hybrid" texts that "reverse the effects of the colonialist disavowal [of native worth], so that 'denied' knowledges enter upon the dominant discourse and estrange the basis of its authority."[11] Rather than buttressing repressive regimes, colonial arts and literatures may actually undermine their ideological legitimacy, or at least offer potential paths for future cultural and political resistance.

Failing to heed this post-colonial injunction to listen to the voices of the colonized (or "subaltern"), Solomon-Godeau and Pollock leveled non-European difference; they treated Tahitian *vahines* as if they were Pacific versions of Moroccan Harem women or "Hottentot Venuses."[12] Yet the history of both women's culture and the development of sexual and gender identities—male as well as female—follows a distinctive path in Polynesia, as it does elsewhere in the non-European world. The conditions, circumstances and even underlying ideologies of colonialism and imperialism in the Pacific, no less than in the Middle East, India, the Magreb and sub-Saharan Africa, are concomitantly unique. The language and practice of local resistance to imperialism are thus also immune to broad generalization; their complex histories are especially germane to comprehending the life and art of Gauguin.

Understanding the iconographic particularity and formal specificity of Gauguin's Tahitian artworks is equally necessary for a satisfying account of his career. Here scholarly achievement has been considerable,

with outstanding studies by Richard Field, Ziva Amishai-Maisels, Jehanne Teilhet-Fisk and the authors of the 1988 exhibition catalogue *The Art of Paul Gauguin*; these writers, however, have little recognized Gauguin's success in representing *fin de siècle* or what is sometimes called "neo-traditional" Tahiti.[13] In painting after painting, Gauguin depicts the complexity of colonial identity; he shows Polynesian women of the past and the present wearing missionary dresses and *pareus* (native skirts), comporting themselves like Parisian prostitutes and Tahitian queens, and assuming traditionally masculine and feminine guises. His models recline, sit, stand, walk, swim, gossip, sing, dance, carry loads, think, pray, sleep and dream. In the same works, a figure may be at once human and divine, animal and totem, alive and dead, child and adult. Men are less often depicted by Gauguin than women, but when they are, they display a gender ambiguity that reveals some uniquely Tahitian sexual verities and some uncommon European practices and traditions. The landscape settings for Gauguin's Polynesian works are at once fanciful and highly specific; geography and light may recall paintings from Brittany, Arles and Martinique while at the same time depicting particular locations on the western coast of Tahiti where the artist passed most of his time.

The titles of Gauguin's paintings are themselves instructive about the artist's sensitivity to neo-traditional identity. In blatant disregard of the sensibilities of colonial officials who were seeking to inculcate in the natives a love of French language and learning, Gauguin insisted on using Tahitian titles for most of the paintings he exhibited in Paris. However, as Danielsson noted, he did so without any real understanding of the syntax or grammar of the tongue. His Tahitian was written (and presumably spoken) with a heavy French accent, in the same manner that his painted and written renditions of Polynesian history, religion, and social and sexual life remained Francophone in intonation. This very inflection—which may be termed Gauguin's "hybridity"—is what makes his art so historically salient.[14] Gauguin's art compels renewed attention today not despite but because of its complex engagement with what the anthropologist Nicholas Thomas calls "colonialism's culture."[15] Gauguin was in the avant-garde of colonialism and thus engaged in evil works, yet he was viewed by most of his fellow colonials as a discredit to France. He was a vigorous defender of indigenous rights, but is regarded by many Polynesians today as an archetypal sexual tourist. A figure representative of imperialism at its apogee and anti-imperialism at its birth, Gauguin stood unsteadily astride two historical eras and developed a form of modern painting adequate to that personal and political disequilibrium.

This book situates Gauguin's art and thought in Western social and intellectual history and Tahitian cultural practice: Gauguin's artworks are considered within the framework of both European and Oceanic tradition; his writings are understood to address French and Polynesian concerns equally; his behavior is placed within the arenas of colonial and indigenous manners. In order to highlight the compound character of *fin de siècle* Tahiti, and the complexity of avant-garde identity, each chapter of the book examines an ideology or practice in which European and native cultures may be seen in collision and interaction.

Chapter One, "Exotic Scenarios," surveys the predominant conceptions of primitivism, exoticism and racism to which Gauguin was heir. The artist sampled each of these, and his decision to emigrate to Polynesia in 1891 exposes the complex matrix of his sources and ideas. Chapter Two, "Sex in Tahiti," compares French and Polynesian theories of sex and gender, examines the social significance of the Tahitian *mahu* (transvestite), and discusses Gauguin's interest in the French literary tradition of the *androgyne*. Gauguin's notorious painting *Mana'o tupapa'u* (*The Specter Watches Over Her*) is then described as an attempted synthesis of European and Polynesian models of sexual liminality. In fact, Gauguin himself was a sexually liminal figure in Tahiti. The skirt he wore was masculine and feminine, and the product of French and Polynesian design. The chapter ends with an extended discussion of Gauguin's manifesto for his second Tahitian period, the allegorical *Where Do We Come From? What Are We? Where Are We Going?* Chapter Three, "Death in the Marquesas," examines Gauguin's engagement in colonial politics in Tahiti and the Marquesas, and his position within the nascent indigenous resistance movements. The chapter ends with a narrative of the artist's death, highlighting Gauguin's position at the confluence of conflicting colonial rhetorics of race, sex and power. A brief conclusion addresses the perception of Gauguin in the contemporary Pacific.

Immediately after his arrival in Papeete on 12 June 1891, Gauguin began to observe and record the distinctive patterns of the colony's society and culture. By July, however, his estrangement from the French settler élite was well under way. One source of the tension leading to this estrangement was his accurate perception that race was used as a justification for the oppression of the natives.

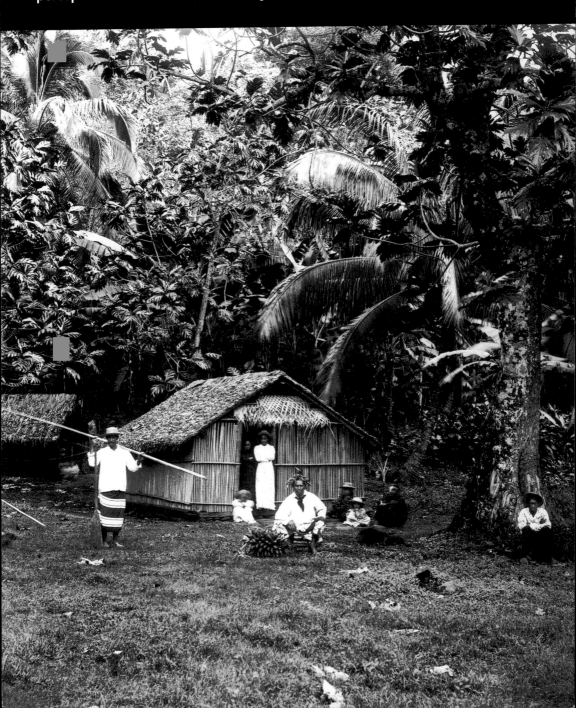

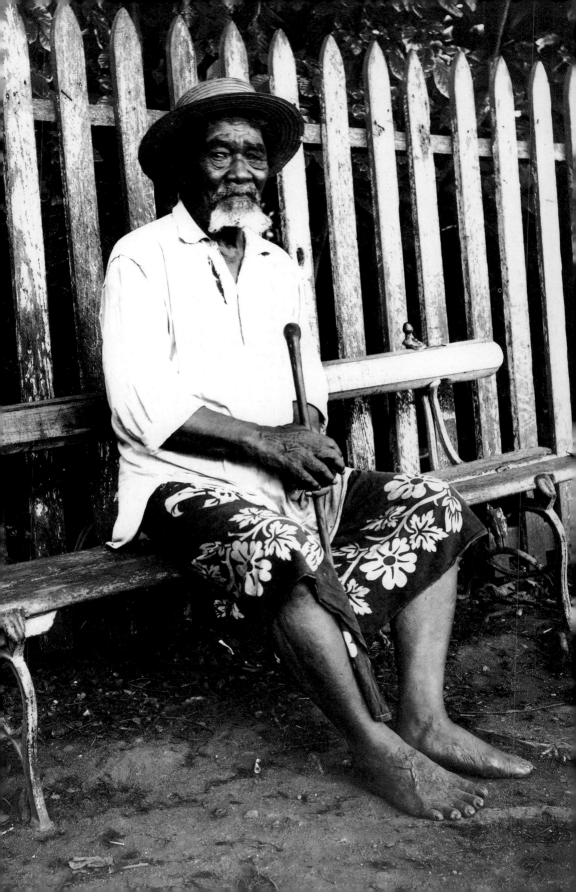

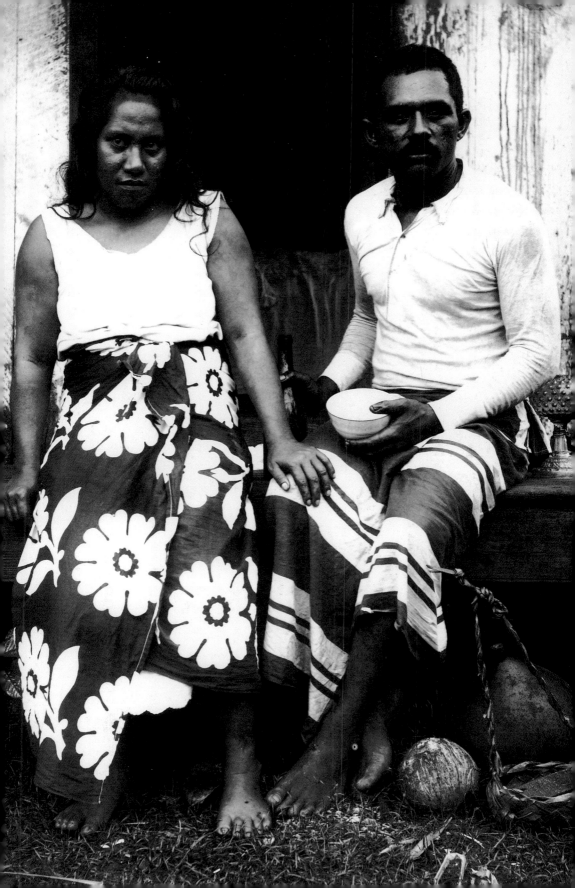

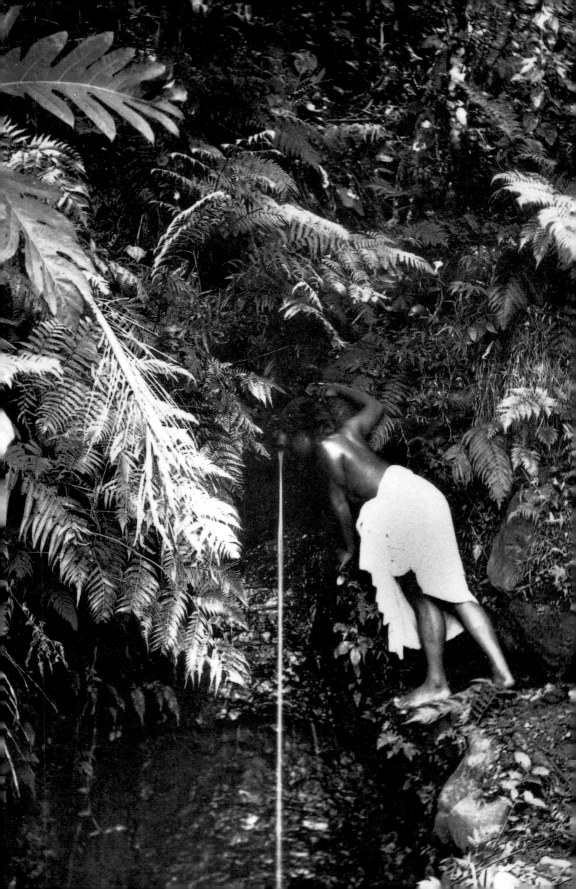

From the moment Paul Gauguin set foot on Polynesian soil on 12 June 1891, a tangled colonial dance was begun. The reluctant performers of this hybrid *chahut* were an eccentric Symbolist painter, a few starchy bureaucrats and some proud Tahitian women, men and children. To this day, it remains unclear which of the partners was leading. Gauguin's friend, the French naval lieutenant P. Jénot recalled the moment of disembarkation and the small tumult that followed:

> As soon as Gauguin disembarked [at Papeete], he attracted the stares of the natives, provoked their surprise, and also their jeers, above all from the women ... What focussed attention on Gauguin above all was his long, salt and pepper hair falling in a sheet on his shoulders from beneath a vast, brown felt hat with a large brim, like a cowboy's. As far as the inhabitants could remember they had never seen a man with long hair on the island ... That very day Gauguin was renamed *taata vahine* (man-woman), which the natives made up ironically, but which provoked such interest among the women and children that I had to chase them from the entrance to my cabin. At first, Gauguin laughed when told of this, but after a few weeks, with the help of the heat, he cut his hair in the same style as everyone else.[1]

Gauguin might have trimmed his hair because of the heat, but two additional reasons seem as likely. Sartorial eccentricity, the artist no doubt discovered, was bad for business in Tahiti. Wearing the Wild West costume and long hair of Buffalo Bill, Gauguin cut an odd figure among the frock-coated settlers and administrators from whom he wished to receive portrait commissions. Colonial Governor Etienne Lacascade, for example, greeted the hirsute artist warmly within hours of his arrival, but had little more to do with him after that. Lacascade had actually been commanded by the under-secretary of the colonies in Paris to extend to the "mission de M. Gauguin" all possible facilitations, but the sight and manner of the artist must have persuaded him otherwise.[2] A haircut was thus a modest concession on Gauguin's part—though in the event vain—to moral propriety and future financial security.

This photograph by CHARLES SPITZ, Vegetation in the South Seas, was the source for Gauguin's painting, Pape moe (Mysterious Water) of 1893 (see p. 114)

A second and equally likely reason for Gauguin's makeover was his discovery that *taata vahine*—the term with which he had been mocked by Tahitian women and children—was the local designation for transvestite. The *mahu*, to use the more traditional term (see Chapter Two, "Sex in Tahiti"), is a third-sex figure in Tahiti, and, with variations, throughout Polynesia. He/she thus belongs among the large class of past and present sexually liminal persons, both non-Western and Western, that includes Indian *hijras*, Philippine *bayocs*, Bornean *manangs*, Native American *berdaches*, European mollies, tommies and Uranians and American drag queens. Gauguin had perhaps grown used to having his sexual status interrogated in France—one Paris critic referred to him in 1891 as an *éphèbe* and a pederast—but he must have been surprised to discover that he was an equally liminal figure in exotic Tahiti. A haircut and a change of clothes (light suits when among the French, and *pareus* or wrap-around skirts when among the natives) must have seemed like a smart approach to sexual and sartorial comportment in the colonies.

Yet financial success and sexual decorum were only two of the colonial concerns engaged and inflamed by the arrival of the notorious *décadent* among the bureaucrats and natives of *fin de siècle* Tahiti. The issue of Gauguin's racial identity was equally vexatious. Gauguin's peculiar costume—which he thought typical of American cowboys and Indians alike—his dark complexion, and his somewhat disreputable profession must have immediately marked him as racially no less than sexually marginal. Aesthetes or bohemians like Gauguin, or men without steady employ were often understood in France to possess unique (and degenerate) racial characteristics; in the colonies they were considered most likely to fall prey to tropical illness, or to become *encanaqué* (nativized). In the Tropics, racial health and stability and racial purity and hybridity, as well as the future prospects of the indigenous races were constant subjects of settler discussion and concern. In fact, an interest in race may be understood to have provided the accompaniment for the colonial dance performed on that particular warm June day in Papeete harbor. Race, like sex and gender, would subsequently become the implicit concern of much of Gauguin's art.

2 Exotics at Home

Emigration from the French *métropole* to a distant colony was a rare, but hardly unique occurrence in the late nineteenth century. Yearly

migrants to Tahiti probably numbered in the dozens, and there existed an assortment of published writings, official regulations and informal attitudes intended to promote settlement, to direct colonial policy, and to help newcomers rationalize their radical change of address. Like other colonists, Paul Gauguin was schooled in some of these texts, which generally were fashioned out of the linked rhetorics of exoticism and primitivism, and the larger discourse of race. In Gauguin's day, race provided the predominant intellectual and practical framework in which cultural, linguistic and physiological differences could be examined and expressed; because of its infinite adaptability it was also a highly effective colonial tool for substantiating any particular cultural and national hierarchy.[3]

Unlike most emigrants, however, Gauguin's perspectives on France, Polynesia and himself changed and deepened over time. What began as simple exoticism evolved into a more complex and critical primitivism, although it was often internally inconsistent and contradictory. Anticipating European anthropologists of the succeeding generation—Emile Durkheim, Marcel Mauss, Arnold van Gennep and Bronislaw Malinowski—Gauguin sought to explore and understand some of the commonalities of European and Oceanic religion, history and sexuality, and especially some of the profound cultural differences. This latter fascination with Polynesian difference was productive of some of Gauguin's most distinguished art and his most prescient writing; it was what marked him as a colonial outsider and primitivist. But before Gauguin painted the indigenes of Tahiti, he represented what he took to be the exotic races at home.

Even as a child and young man, Gauguin lived in places remote from France. He spent four years of his early childhood in Lima with his widowed mother Aline Chazal-Gauguin, and great-uncle Don Pio de Tristan Moscoso. (The experience was the basis for the artist's subsequent fanciful claim that he was "an Indian from Peru.") Later, as an enlistee in the merchant marines and the navy, he visited port cities in Europe, the Americas and the Pacific, including Bergen in Norway, Iquique in Peru, and Auckland in New Zealand, this last a city to which he would return during the course of his final passage from France to Tahiti in 1895. Gauguin liked to travel; he had, one might safely say, a great desire for difference, but until he lived in Tahiti, he had relatively little interest in learning much about the foreign lands and cultures he saw. This preference for difference combined with a more or less willful ignorance of historical and cultural particulars is called exoticism; it was extremely common in nineteenth-century France.

As a mature artist, Gauguin resumed his quest for the exotic whether he was in or out of France, traveling from Paris to Brittany in 1886, to Panama and Martinique in 1887, to Brittany again in 1888, to Arles in 1888, yet again to Brittany in 1889–90 and finally to Polynesia in 1891. His art reveals an equivalent peripateticism: in the half decade from 1881 to 1886 he graduated from a Degas-inspired naturalism to Impressionism to Synthetism. The nineteen paintings he exhibited at the last Impressionist exhibition in 1886 are a case in point: they were highly eclectic in subject and style, including a spare, Degas-like *Bathers* (1885), an exuberant homage to Renoir called *Still Life with Vase of Japanese Peonies and Mandolin* (1885) and several landscapes

Bathers 1885

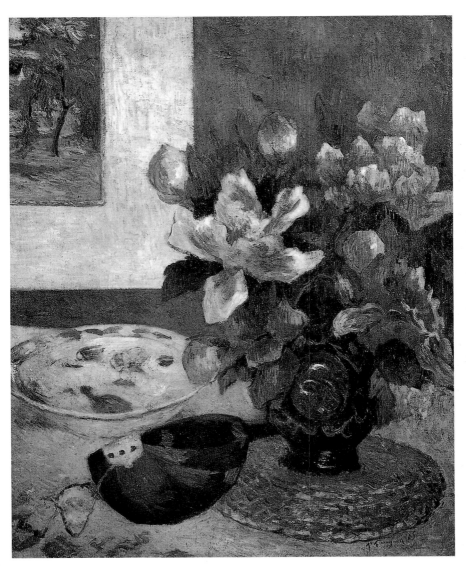

Still Life with Vase of Japanese Peonies and Mandolin 1885

that emulated the fragmented touch and elevated perspective of Camille Pissarro, including *Road from Rouen* (1884) and *Edge of the Pond* (1885). *Sleeping Child* (1884), exhibited in late 1884 in Oslo anticipates the artist's later full-bore Synthetism; its somnolent subject-matter, odd juxtaposition of a child's head and an eighteenth-century Norwegian tankard, and inclusion of a Japanese indigo wallpaper background mark a withdrawal from the quotidianism of naturalist and Impressionist painting and an ostentatious synthesis of exotic sources. Writing in 1889, the critic Félix Fénéon looked back at Gauguin's paintings from this period and remarked upon their "mysterious aspect," and "tendency to archaism . . . testifying to a taste for the exotic."[4]

Sleeping Child 1884

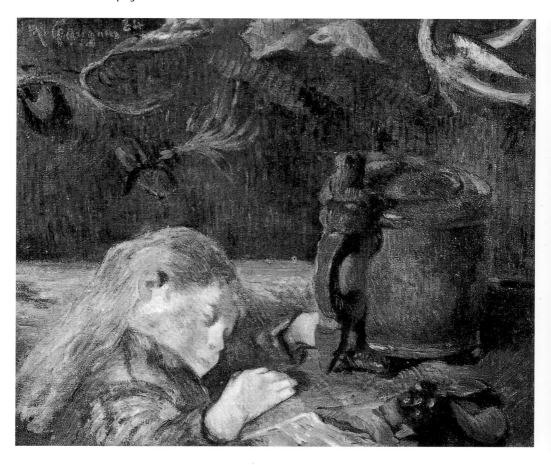

Gauguin's most significant flirtation with the exotic prior to his trip to Polynesia was displayed in his Breton period paintings and ceramics. When Gauguin visited Pont-Aven in Brittany in the summer of 1886, he was immediately attracted to what he believed was the simplicity and superstition of a people bypassed by modernity. Standing before fields of golden-orange buckwheat, beside the lichen-encrusted towers of medieval churches and amid the wide, wind-blown stretches of sandy beaches, Gauguin thought he detected the sounds, patterns and even the scents of ancient ways of life. "I like Brittany," Gauguin wrote during his second visit to the region in 1888, "it is savage and primitive. The flat sound of my wooden clogs on the cobblestones, deep, hollow and powerful, is the note I seek in my paintings."[5] In works such as *The Yellow Christ* (1889), *The Green Christ. The Breton Calvary* (1889) and *The Haystacks, or The Potato Field* (1890) Gauguin sought to marry his increasingly anti-empiricist and anti-naturalist art to a culture that, he believed, was equally resistant to the onward rush of positivist thought and material progress. Broad, flat zones of saffron-yellow paint interrupted by Prussian-blue outlines around figures, trees and hillsides; impassive faces with greenish hues recalling the worn surfaces of panels painted by the Italian primitive Cimabue; landscapes in which foreground, middleground and background are awkwardly interlocked and superposed suggesting spacelessness and great physical density: these are the characteristic procedures of Gauguin's Breton art, dubbed by the critic Albert Aurier in 1891 "Synthetist." "We are witnessing," the young critic wrote, "the agony of naturalism in literature and, simultaneously, the preparation of an idealist, even mystical reaction, we should wonder whether the plastic arts are revealing a similar evolution. One must therefore, invent a new term ending in -ist (there are already so many of them that this will make no noticeable difference!) for the newcomers whose leader is Gauguin: Synthetists, ideists, Symbolists, as one likes best."[6]

In Brittany, Gauguin found the sanction he sought for his pre-conceived ideas about the ideality of art and the value of cultural syntheses. "Art is an abstraction," he wrote to the painter Emile Schuffenecker in 1888. "Draw art from nature as you dream before it, and think more about the act of creation than the final result; that is the only way to ascend toward God—to create like our Divine Master."[7] The countryside of Brittany appeared to abound in such abstractions. The many late medieval roadside Calvaries in the region were roughly hewn but composed with a complex syncopation. The distinctive Breton costume with its vivid patterns of black and white and its

elaborate embroidered ornamentation gratified Gauguin's Synthetist penchant for flat, decorative surfaces. The seasonal religious processions and pageants called *pardons* persuaded the artist that he was visiting a land in which faith in the "Divine Master" was as clear and pronounced as the landscape motifs in his paintings. Perhaps by living among the primitive Breton people and by painting Breton subjects, he could return to his own imagined exotic origins.

So long as Gauguin's vision remained fixed on the physical surface of his surroundings, and his mind remained preoccupied with well-established clichés about the Breton soil and people, his exoticism was undisturbed. In Brittany, the artist could sustain his vague notion that Synthetist art was the appropriate expression of a simple, popular culture born of the lives and aspirations of honest peasants and modern

The Haystacks, or The Potato Field 1890

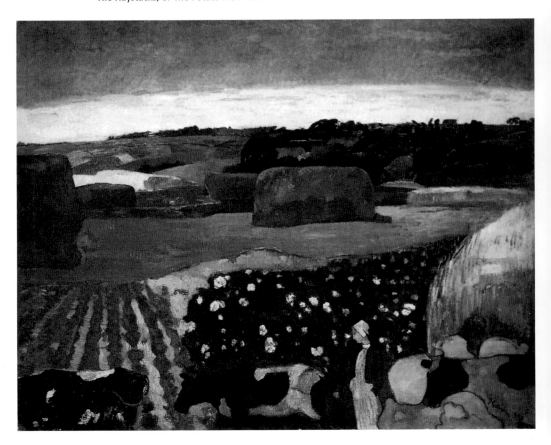

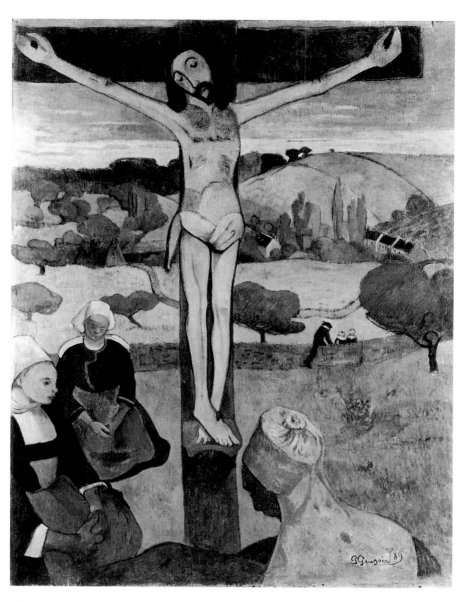

The Yellow Christ 1889

artists alike. He could, in addition, thereby avoid reckoning with the forces of modernity that had made life in Paris with his wife, Mette Gad, so very dispiriting: a depressed market-place that reduced artists to mere hawkers and peddlers of unwanted fancy goods, and an institution of marriage that was "nothing other than a sale [of women] . . . contrary to our democratic principles of freedom and brotherhood."[8] Exoticism was, for Gauguin as for so many others, an elaborate rhetoric of dreams, forgetfulness and withdrawal from modernity.

Brittany was not, indeed, the land that time forgot, and Gauguin began to understand that fact even as he continued to claim otherwise in letters to his friends and family in Paris. The unique local costumes, he gradually recognized, were not vestiges of an ancient pagan past, but modern and highly articulated expressions of local kinship ties and a newly emerging ethnic solidarity. The *pardons* were as much intended as tourist attractions as public expressions of religious faith, and the admired sculptural groupings—such as the remarkable Calvaries at Notre-Dame-de-Tronoen, Guimiliau and Nizon (the latter depicted in *The Green Christ. The Breton Calvary*)—well post-date the medieval period. Gauguin's Breton exoticism thus depended upon an ignorance of historical and cultural facts and details that was difficult to sustain, especially since his exposure to cultural difference was intimate and of relatively long duration.

Not merely a summer tourist, Gauguin passed the winter of 1889–90 at the inn of Marie Henry at Le Pouldu, a small town perched dramatically on the ocean near the mouth of the River Laita. There, he sought to gain the knowledge necessary to see beyond the mere façades of Brittany. The complex negotiation between cultural insiders and outsiders, for example, is explored in *Bonjour Monsieur Gauguin* (1889); the painting depicts an encounter between the cosmopolitan artist—clad in greatcoat, scarf, beret and clogs—and a cowled Breton woman in a heavy blue shift with grey apron. The two are separated by a gate and by the woman's evident mistrust or resentment. She replies to Gauguin's ingratiatingly tipped cap by walking to one side and prof-ferring the formal greeting that gives the painting its title. Gauguin had undoubtedly seen *Bonjour Monsieur Courbet* (1854) by Gustave Courbet the previous year during his trip to the Musée de Montpellier in the company of Vincent van Gogh, and found its compound image of artistic aggrandizement and alienation apposite for his present circum-stances. Like Courbet, Gauguin had an outsized ego, but saw himself as a victim. In his painting, he becomes the wandering Jew of serialized novels and popular broadsides, friendless and rejected, condemned

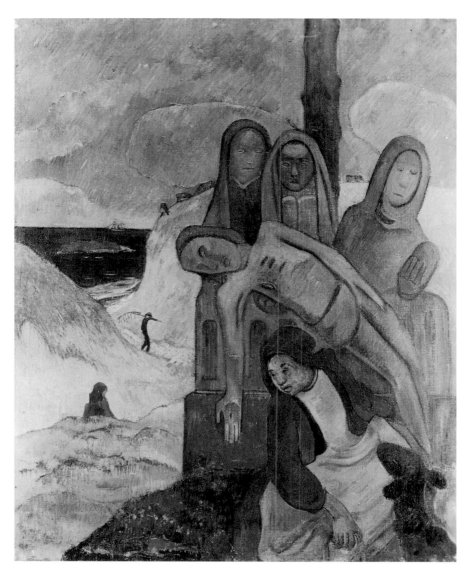

The Green Christ. The Breton Calvary 1889

forever to walk the earth. Indeed, Gauguin's financial position was as uncertain as his cultural location; he left Le Pouldu in November 1890 without paying his hotel bills, and later unsuccessfully sued Marie Henry for the recovery of paintings left as security.

The logic or paradox of exoticism tends to set in motion a kind of insatiable regression: the more one is immersed in the exotic, the more one discovers sameness, and the more one seeks ever greater difference. Gauguin's Breton art reveals something of this aesthetic and ideological vicious circle; his later paintings, especially those painted at Le Pouldu in 1889 and 1890, including *Bonjour Monsieur Gauguin*, are more strange, sober, despairing and often abstract than earlier efforts. The anti-naturalist compression and concentration of figures and landscape motifs, the near elimination of light and the emphasis upon Synthetist, or Art Nouveau linear patterning, as in *Beach at Le Pouldu* or in the

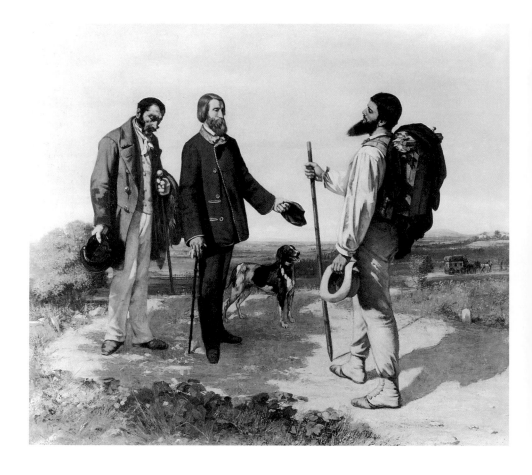

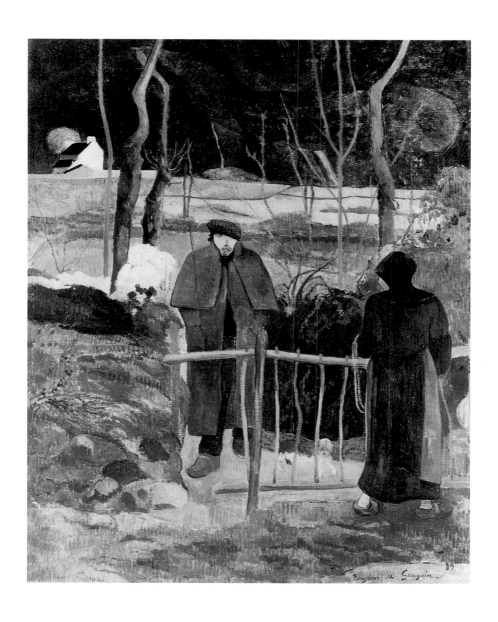

Above **Bonjour Monsieur Gauguin 1889**
Opposite **GUSTAVE COURBET Bonjour Monsieur Courbet 1854**

polychrome woodcarving *Be Mysterious* is indicative of this exoticist anxiety. Gauguin's art had attained a high pitch of abstraction. After 1890, he could no longer obey his own injunction to "be mysterious" in Brittany; he had learned too much about its contemporaneity and at the same time felt too keenly his own outsider status. He told a journalist in 1891 that in *Christ in the Garden of Olives* (1889), "There I have painted my own portrait . . . But it also represents the crushing of an ideal, and a pain that is both divine and human."[9] Gauguin would thereafter feel drawn to ever more distant lands. With the advice of friends and the example of the popular author Pierre Loti, he ultimately settled upon Tahiti as his exotic utopia of cultural difference. In Tahiti, as in Brittany, Gauguin struggled to understand his own contradictory position as someone both alienated from metropolitan culture and society, and yet representative of that same colonizing power.

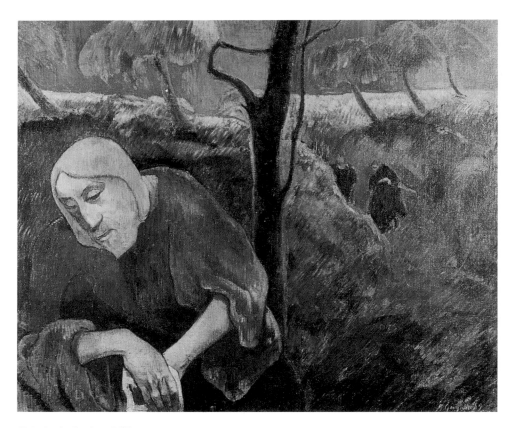

Christ in the Garden of Olives 1889

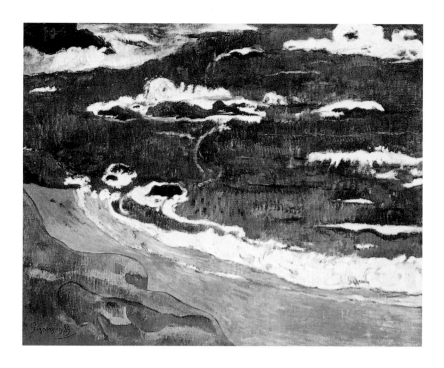

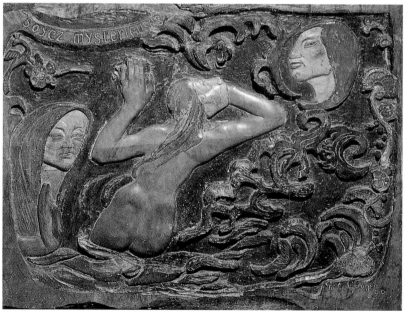

Top **Beach at Le Pouldu 1889**
Above **Be Mysterious 1890**

3 Savages Abroad

In late May 1888, Vincent van Gogh broached the subject of French
Polynesia in correspondence with fellow painter Emile Bernard.

> I have just read a book—not a beautiful one and not well written
> for that matter—about the Marquesas Islands, but sad enough
> when it tells of the extermination of a whole native tribe—cannibal
> in the sense that once a month, let us say, an individual got eaten—
> what does it matter!
> After which they annexed the two isles, which then became
> unutterably lugubrious!!
> Those tattooed races, Negroes, Indians, all of them, all are
> disappearing or degenerating. And the horrible white man with his
> bottle of alcohol, his money and his syphilis—when shall we see
> the end of him? The horrible white man with his hypocrisy, his
> greediness and his sterility.
> And those savages were so gentle and loving![10]

The anodyne representation of anthropophagy contained in Van
Gogh's letter recalls Michel de Montaigne's "On Cannibals" (1580),
perhaps the first European essay in exoticism, but the book he is
discussing is probably Max Radiguet's illustrated volume *Les Derniers
Sauvages* (1860) which was republished in 1882.[11] The book is full of
lurid accounts of Marquesan cannibalism and unusual sexual practices;
its chauvinism and racism are barely disguised and it provided
a justification for the brutal French annexation of the islands in 1842.
Van Gogh found little to admire in the book, "not a beautiful one and
not well written," except that it provided him with additional examples
of the greed and violence that he believed dominated the minds and
directed the behavior of modern Europeans.

The book reminded Van Gogh of the Martinique paintings of his
and Bernard's mutual friend Paul Gauguin, such as *The Harvest of
Mangoes* (1887).

> You are damned right to think of Gauguin. That is high poetry,
> those Negresses, and everything his hands make has a gentle,
> pitiful, astonishing character. People don't understand him yet,
> and it pains him so much that he does not sell anything, just like
> other true poets.[12]

Van Gogh's chatty movement from Marquesan cannibals in the
South Seas to "tattooed races, Negroes, Indians," and finally Caribbean

"Negresses" parallels Gauguin's own exoticist ethnology. For both artists, the non-European world consisted of a few French colonies—especially Tahiti, Madagascar and Indo-China—and a vast, inviting *terra incognita* populated by disappearing and pitifully beautiful natives. The two men thus had much to talk about when they established their joint residence at the Yellow House—the "Studio of the South"—in Arles in October 1888.

Soon after Gauguin's arrival, he and Van Gogh began serious discussion about establishing a "Studio of the Tropics." In a French equatorial zone, they believed, they could live cheaply, bask in warmth and sunlight, have unlimited access to beautiful women as both models and lovers, and prepare to bring before the eyes of an eager public the "gentle, pitiful, astonishing character" of their subjects. The precise shape and history of this indigenous "character" was a mystery to both

The Harvest of Mangoes 1887

men, and did not enter very much into their deliberations. Van Gogh and Gauguin encouraged each other in their exoticism—one might even say in their ignorance. Their vision of the French overseas territories was framed by the relatively narrow range of their experience of ethnic difference in the *métropole*, by their idiosyncratic reading and by their knowledge of art in the museums and the Salons. They were additionally able to draw upon Gauguin's early travels, his time in exotic Brittany, and his recent short trip to the Caribbean; in Panama and Martinique, the artist painted native men and women in their daily routines, but he also became quite sick, and hastily aborted his visit.

The general literary sources and intellectual outlines of Van Gogh's and Gauguin's exoticism are easily described: the essay of Montaigne mentioned earlier was surely known to them, as it was to most literate

ANNE-LOUIS GIRODET Atala at the Tomb 1808

EUGENE DELACROIX The Natchez c. 1823–36

Europeans, and they were probably acquainted as well with the exotic novels of the neo-Catholic writer François-René Chateaubriand. The latter's American Indian saga *Atala* was famously represented by Anne-Louis Girodet in *Atala at the Tomb* (1808) and by Delacroix in *The Natchez* (c.1823–36), a work shown at the great Romantic painter's retrospective at the Ecole des Beaux-Arts in Paris in 1885.[13] Artworks by the Orientalists Eugène Fromentin and J.-L. Gérôme were well known by the two artists (though the latter, a Salon favorite, was highly disparaged by both), and a large number of other exoticist artworks passed beneath their gazes at the annual Paris Salon exhibitions.[14] Paintings that dealt explicitly with Polynesia, however, were exceedingly rare in Paris, though there is at least an outside chance that either or both artists may have seen the paintings of the Russian-born Nicolas Chevalier (1828–1902) during their trips to England. Chevalier's Edenic

landscape manner and saccharine eroticism, displayed in such works as *Ataiamano, Island of Tahiti* (1871) and *Maori Girl, Hinemoa, in a Canoe* (1879), generated some modest publicity in London during the 1870s and 1880s, and stand in marked contrast to Gauguin's later, more stylistically experimental, and more emotionally ambiguous paintings.

In addition to European artworks, Van Gogh and Gauguin had the opportunity to see a number of non-European artifacts. The opening of the Musée des Missions Ethnographiques in Paris in 1878, and a little later of the Musée Ethnographique directed by E. Hamy made it possible for them to see a large number of miscellaneous works from West Africa and Oceania, including carved clubs, bowls, masks and figures. At the Exposition des Arts Anciens on the grounds of the 1878 Exposition Universelle, Gérôme organized a large display of art and artifacts from Oceania in order to reveal what he considered the ornamental genius of "peoples foreign to Europe."[15] Within the next decade, newly formed collections of Oceanic art were donated to these and other ethnographic museums. Scholarly publications, travel books and exoticist novels also proliferated. The French Ministry of Marine and Colonies issued a series of almanacs timed to coincide with the opening

NICOLAS CHEVALIER Maori Girl, Hinemoa, in a Canoe 1879

of international exhibitions in Paris in 1878, Antwerp in 1885 and Paris again four years later.[16] Popular and colorful traveler's accounts were written by Lady Brassley (1882), M. Mativet (1888), Léon Henrique (1889) and Dora Hort (1891). The forced abdication of King Pomare IV of Tahiti in 1881 and the subsequent annexation by France of the island and its dependencies accelerated interest in the Pacific. Then, as now, art and tourism followed the flag.

The most important literary source for the exotic, tropical musings of Van Gogh and Gauguin was *The Marriage of Loti* by Julien Viaud (a.k.a. Pierre Loti) which was published in 1880. In March 1888, Van Gogh wrote enthusiastically to his sister Wilhelmina about the new book he had read: "So I can imagine, for instance, that a present-day painter should do something like what one finds described in Pierre Loti's book *Le Mariage de Loti*, in which a picture of nature in Otaheite is drawn. A book which I warmly recommend you to read."[17] In all likelihood, Van Gogh also introduced Gauguin to Viaud's book, and a few weeks after his arrival in Arles, Gauguin wrote to Emile Bernard in Brittany: "I am somewhat of Vincent's opinion, that the future belongs to the painters of the yet unpainted tropics."[18] From that moment forward, the thought of more or less permanent escape from Europe became an obsession for Gauguin; *Loti* thereafter was both a fulcrum for the artist's dreams about life and love in the Tropics, and a model of bourgeois exoticism that the artist would ultimately resist by means of an increasingly pronounced primitivism.

Viaud's novel is written in the form of a diary; it describes the vicissitudes of a romance between the British midshipman Harry Grant, rebaptized Loti, and a fourteen-year-old Tahitian named Rarahu. The plot is rudimentary, episodic and circular: 1) Loti meets and falls in love with a young Tahitian named Rarahu, but then leaves her because of naval obligations. 2) After a brief adventure in the Marquesas, Loti returns to Tahiti and to Rarahu. Soon, however, he understands the great racial divide between them and departs Tahiti in pursuit of love and excitement in Honolulu, Vancouver and San Francisco's Chinatown. 3) Loti returns to Tahiti, in search of a long-lost nephew. He reunites with Rarahu, but becomes convinced that despite her conversion to Protestantism, she is irredeemably savage, doomed like the rest of her race to extinction. 4) Loti departs from Tahiti and Rarahu forever, seeing her once more, however, in his dreams, and later learning of her horrible death.

Loti is a veritable compendium of exoticist clichés. Viaud's favorite words are "strange," "exotic," "bizarre," "mysterious," "savage," "weird"

and "incredible," and his paradisical descriptions of the tropical land-scape connote a stereotypical realm of sensual liberty and epicurean delight. Indeed, Viaud's *alter ego*, the character Pierre Loti, precisely embraced cliché and the typical; his goal in travel, as the historian Tzvetan Todorov has written, was the "collection of impressions" and the concomitant avoidance of Polynesian history and politics.[19] "The air was charged," Loti writes, "with heady and unfamiliar perfume; quite unconsciously I abandoned myself to this enervating existence, over-borne by the Oceanian spell."[20]

Indeed, the imagery as much as the narrative of *The Marriage of Loti* consists of short, exotic vignettes, effectively forbidding close examination of either the physical or cultural landscapes of Tahiti. The shallowness of the characters in the novel equally precludes the reader from imaginative identification. Loti in fact is the only figure to whom the reader is given access; his thoughts and peregrinations become the reader's sole concern. Thus the gap between Loti and the indigenous Tahitians, like the oceans between Europe and Polynesia, is vast and unbridgeable. Loti is the narrator of his story; he describes the differ-ence between himself and Rarahu as a difference of species:

> She was to all intent my little wife; I loved her truly. And yet there was a great gulf between us—a great gate forever shut. She was a little savage; between us two who were one flesh there was a radical difference of race and utter divergence of views on the first elements of things. If my ideas and conceptions were often impenetrably dark to her, so were hers to me . . . I remember what she had once said to me: "I am afraid lest the same god did not create us both." In truth, we were the offspring of two types of nature absolutely apart and dissimilar, and the union of our souls could only be brief, imperfect and stormy.[21]

Loti's words articulate a widely prevalent racism that is concomi-tant with most exoticist thinking; they might have been spoken by the celebrated French racial determinist Gustave Le Bon, who wrote in 1894: "Different races cannot feel, think, or act in the same manner, and . . . in consequence, they cannot comprehend one another."[22] Le Bon's words in their turn remained influential for more than a genera-tion. In Frederick O'Brien's account of life on the Marquesas Islands in the footsteps of Gauguin (1919), he wrote that his initial emotional and intellectual identification with the native people had to be based upon a false impression: "Savage peoples can never understand our philosophy, our complex springs of action. They may ape our manners, wear our

ornaments, and seek our company, but their souls remain indifferent . . . From our side too, the abyss is impassable."[23] For Le Bon and Loti, as later for O'Brien, segregation was the necessary result of ethnic difference. Europeans and Polynesians can mate but they cannot reproduce, for their hybrid offspring will be both culturally and biologically sterile—white men and *kanaka* (South Sea) women are the creation of different gods. At the end of *The Marriage of Loti*, Loti must return home to England and Rarahu must die in Tahiti.

The most significant marriage in Viaud's novel therefore—one that had been in preparation for decades—was between exoticism and racism: belief in the existence of profound racial difference made impossible any deep knowledge of native ways of life. Anthropology in the modern sense—with its preference for cultural relativism and goal of attaining a deep, structural and sympathetic knowledge of other peoples and cultures—thus remained an impossibility for anyone schooled in the racist tradition of Loti and Le Bon. Racist thought left its traces on the art of Gauguin as early as 1889. Between the artist and the Breton peasant woman in *Bonjour Monsieur Gauguin* or *The Green Christ. The Breton Calvary* there stood, in Loti's words, "a great gate forever shut." Gauguin's partial success in prising open the closed gate of race was to be one of his major achievements during the more than ten years he spent in Polynesia.

4 The "Golden Age" of Racism

The life of Gauguin was roughly contemporaneous with the two generations of European writers, artists and intellectuals who invented "the science of race."[24] In 1853, the last year of young Paul's residence in Peru, Joseph Arthur de Gobineau published the first volume of *Essai sur l'inégalité des races humaines*. The book proposed an elaborate hierarchy of peoples and a theory of degeneration; it became a primer for racists for a hundred years. In 1871, during the brief term of Gauguin's military service, Darwin published *The Descent of Man* which described "the competition of tribe with tribe and race with race."[25] More than a decade later in 1884, during a period of financial and familial instability for Gauguin, Friedrich Engels in England published *The Origin of the Family, Private Property and the State* which provided a historical materialist account of the development of the state and patriarchy. In 1894, the year of Gauguin's exhibition of paintings at La Libre Esthétique in Brussels, Gustave Le Bon published

his *Lois psychologiques d'évolution des peuples*, perhaps the most widely read of all treatises on racial determinism. Finally, a year before Gauguin's death in 1903, the politician Maurice Barrès achieved a great success with his racist and xenophobic *Scènes et doctrines du nationalisme*, in which he decried the foreign "flood that is about to submerge our race."[26]

No elaborate account is needed to explain why the nineteenth century was the golden age of racial theories. The maintenance of slavery and the conquest and extirpation of native peoples required ideological support. Racism—the theoretical systematization of social hierarchies and hatreds based upon perceived differences of race and ethnicity—provided a significant part of colonialism's rationale: If white Europeans were endowed by God or evolution with superior brains, limbs and organs of increase, then specific acts of usurpation were likely to be preordained; if European white men (who sometimes called themselves "Aryans" or "Caucasians") represented the culmination of God's act of Creation, then their claims of dominion over women and non-whites were expressions of high moral purpose.

Racism was the product of a versatile metaphysic and a highly malleable conception of empirical science; it engaged with seeming dispassion the materials, methods and ethics of Enlightenment reason for the purpose of maintaining temporal power and augmenting material riches. At the end of the eighteenth century, the philosophers David Hume and Immanuel Kant and the French naturalist Georges Cuvier all made fundamental contributions to the notion that humans possessed immutable racial characteristics which predisposed them to greater or lesser physical achievement and moral or intellectual worth. Their ideas, and especially those of the three generations of writers that followed were put to work by political and military leaders and by popular, nationalist propagandists. The re-establishment of slavery in the French colonies during the Bourbon Restoration was buttressed by the work of Cuvier and G. L. Buffon; the maintenance of slavery in the US from the time of the upholding of the Fugitive Slave Act in 1842 until Emancipation (1863) was furthered by the writings of G. Glidden and R. Knox, and the extension of British imperialism was supported by Matthew Arnold and John Beddoes. There are thus many racisms, and they are distinguishable by their particular national traditions and by their expression of local needs and uses.

Nineteenth-century French racism had its origins, as the anthropologist Claude Blanckaert has shown, in the writings of the English-born biologist and philologist William Edwards.[27] It was Edwards who in the

1820s and 1830s perceived race as an all-pervasive natural phenomenon that determined physiology, culture and history. No longer merely an accidental circumstance observable by travelers and ethnological researchers, race was now a historical and biological fact that fixed the past, present and future of every human population. Edwards demonstrated by a series of experiments that human racial character-istics—moral no less than physical—were unalterable, and though hybrids could be observed in nature, successive offspring always returned to form.

Later French theorists rejected many of Edwards's conclusions concerning the unalterability of racial types while nevertheless still upholding the deterministic character of race. In the 1850s and 1860s, De Gobineau's and B. A. Morel's theories of hybridity and degeneration, for example, charted the effects (sometimes beneficial but mostly dire) of racial mixing, and upheld the prevailing notion of a clear hierarchy of peoples and nations. If certain indigenous communities—such as the Tahitians and Marquesans—were dying from the effects of European contact, the cause was not colonial aggression or imported disease, but racial feebleness. If generation after generation of French urban workers were poor, sick and imprisoned, the cause was not economic exploitation but the racial impoverishment of the laboring and criminal classes. If a small number of European artists and writers found them-selves to be outcasts from dominant institutions, it was because of their own moral and racial degeneracy. (Paul Gauguin, Paul Verlaine, Stéphane Mallarmé, Emile Zola and a number of other artists and poets from the *fin de siècle* were regularly labeled *maudits*, *décadents* and even degenerates.) In the 1890s, Gustave Le Bon in France and Max Nordau in Germany succeeded in greatly popularizing scholarly ideas about moral and physiological decadence, and thereby helped to establish the foundations of twentieth-century sociobiological racism.

De Gobineau, Morel, Le Bon, Nordau and the rest were neither con-sistent nor systematic in their writing. They grouped physical, linguistic and cultural differences within the category of race, and mixed into the same soup the incompatible doctrines of Darwin, Spencer, Lamarck and even the Bible. In Léopold de Saussure's *Psychologie de la colonisation française* (1899), race is treated as the sum of history, religion, commerce, language and physical bearing; it predetermines a colonized people's propensity to civilization yet in no way precludes their ultimate assimilation into the mainstream of history.[28] The problem with current national colonial policy, he stated, was that it was forged from the enlightened universalism that was part of the French nation's racial

heritage. Most indigenous peoples were racially incapable of so rapid an assimilation into civilization. Patience and gradual economic development was De Saussure's recipe for a successful colonial policy.

For the patriotic propagandist Maurice Barrès, race and nation were essentially indistinguishable terms. Culture and history were the blood that coursed through a nation's veins, and a person could no more change his nationality than change his blood type. To the socialist and anti-imperialist Jean Jaurès he replied: "You would prefer that the phenomena of heredity did not exist, that the blood of men and the soil of the land had no impact . . . What are your preferences worth against [these] necessities?"[29]

The language of French national and racial superiority continued to be heard in subsequent decades, especially in writings by artists, poets, scholars and critics in the years during and just after World War I. In 1916, Amédée Ozenfant described Cubism as part of the "purist plan of cleansing the language of the plastic arts of parasitic expressions";[30] two years later, Guillaume Apollinaire described modern art as above all "the expression of a race."[31] As late as 1941, French "anthroposociologists" buttressed anti-Semitic and Nazi-inspired race laws with biological scientism.[32] Even today, race has not lost its cachet; there are sociologists and sociobiologists in Europe and North America enthralled by the idea of tracing racial origins and measuring racial difference.[33] Their work has been consciously trumpeted by right-wing demagogues such as Jean-Marie Le Pen and Patrick Buchanan, and unwittingly echoed by cultural nationalists such as Louis Farrakhan.

Pierre Loti's particular racism, like Gustave Le Bon's, derives from a jumble of pseudo-scientific sources, but is generally a version of polygenesis, the popular nineteenth-century theory that began by stating that certain observable differences between human population groups— such as skin color, physical stature, type of hair, etc.—were as profound as differences that existed between species. It then followed that humanity must have arisen not all at once at a single place, but rather, independently at a number of discrete locations and times. Thus too, there must exist a competition for survival among the separate human species or races. "Indo-Europeans" in Le Bon's phrase, are uniquely capable of civilization, advancement and conquest; the "primitive races" on the other hand—including Australian Aborigines, Pacific *kanakas*, and African blacks—are incapable of progress; according to polygenesist theory, they represent examples of arrested development, unhealthy inbreeding or infantilism.

In contact with "a superior people," Le Bon writes, "the primitive races are inevitably condemned to disappear at an early date."[34] Polygenesists maintained that successful mating between superior and inferior races was impossible. While "hybrid" children were undoubtedly produced—the evidence was visible in every colonial outpost—future generations, it was believed, either reverted to the dominant type or were infertile; in either case the "primitive races" tended toward extinction.[35] Thus, at the conclusion of *Loti* we see no mourning for the death of Rarahu. Her death, like that of her race, was preordained by evolutionary biology and history. Sober reflections on the baleful inevitabilities of nature were alone what was demanded. Loti's melancholy remarks are examples of what Renato Rosaldo calls "imperialist nostalgia," the yearning for what one is directly responsible for destroying:[36]

> My poor little savage friend!—Often when I awoke at night . . . her image rose before me with its indescribably sweet sadness; and with a vague hope of forgiveness and redemption—and all was at an end, sunk in the mire, lost in the gulf of eternal destruction.[37]

Loti's novel, replete with references to decadence, evolution, race, death and sexual libertinism was bound to find a responsive reader in Gauguin.

Apart from the ambiguous remark about the "yet unpainted tropics" in the letter to Bernard cited above, Gauguin's first reference to *Loti* is contained in a cruel letter to his wife Mette from early 1890:

> May the day come—and perhaps soon—when I can flee to the woods on a South Sea island, and live there in ecstasy, in peace and for art. With a new family, far from this European struggle for money. There, in Tahiti, in the silence of the lovely tropical night, I can listen to the sweet murmuring music of my heart, beating in amorous harmony with the mysterious beings of my environment. Free at last, with no money troubles, and able to love, to sing and to die.[38]

The last two sentences of Gauguin's letter contain clear allusions to *Loti*; Rarahu was always singing, the narrator claims, and the young woman's songs were said to reveal both the dark secrets of the Tahitian night and the hidden recesses of the Maohi heart. Gauguin's references to "the struggle for money" and "money troubles," however, were indications that the artist was seeking a more thoroughgoing break with Europe than Loti's exoticism could provide. He was not merely seeking new, exotic motifs in order to attract buyers and reinvigorate

a soft French art market; he was hoping instead to establish a self-sustaining artistic colony in a primitive, distant land.

By the late winter of 1890, Gauguin appears to have gained sufficient knowledge of Tahiti to begin to consider Loti's idyllic and decadent dream-world a practically achievable destination. Determined to leave France as quickly as possible, he shared his ideas with several artist-friends in addition to Van Gogh, including Emile Bernard, Jacob Meyer de Haan and Emile Schuffenecker, his companions from Pont-Aven. In letters to them from the spring and summer of 1890, Gauguin wavered, however, between travel to three different French colonies—Tahiti, Tonkin or Madagascar—uncertain as to the costs and benefits of each. He wrote first to Van Gogh in late May: "Do you remember our former conversations in Arles, when we spoke of establishing the atelier of the Tropics? I am about to put this plan into effect if I can get the necessary bit of money together in order to create the establishment . . . Those who will want to come later will find there all the materials in order to work at a very small cost. And at the atelier of the Tropics [I] will perhaps become the Saint John the Baptist of the painting of the future, invigorated there by a more natural, more primitive, and, above all, less spoiled life."[39] Van Gogh's reply to Gauguin, if there was one, is not preserved, but on 17 June he wrote to his brother Theo:

> I am very glad that Gauguin is going away with De Haan again [to Brittany]. Naturally I thought the Madagascar project almost impossible to put into practice, I would rather see him leaving for Tonkin. If he went to Madagascar however, I should be capable of following him there, for you must go in twos or threes. But we aren't that far yet. Certainly the future of painting is in the tropics, either Java or Martinique, Brazil or Australia, and not here, but you know that I am not convinced that you, Gauguin or I are the men of that future.[40]

Van Gogh's letter suggests that he and Gauguin briefly expanded their list of possible exotic destinations to include Java, Martinique, Brazil and Australia. A month later, however, Gauguin wrote to Bernard concerning Madagascar: "What I want to do is to set up a studio in the *Tropics*. With the money I shall have I can buy a hut of the kind you saw at the [1889] Universal Exhibition. An affair of wood and clay, thatched, near the town but in the country. This would cost almost nothing. I should extend it by felling trees and make of it a dwelling to our liking, with cows, poultry, and fruit, the chief articles of food, and eventually it ought to cost us nothing to live. Free . . . "[41] Gauguin then

added that in addition to being closer to France (and thus permitting cheaper passage): "Madagascar offers more attractions by way of types, mysticism and symbolism. There you have Indians from Calcutta, tribes of black Arabs, and the Hovas, a Polynesian type."[42]

In the letter to Bernard, Gauguin assumes the stance of the ethnographic tourist, who desires to sample a variety of human "types" or races as quickly and effortlessly as possible. He was apparently intrigued as well by the *mélange* of cultures that would be on offer in Madagascar, hoping perhaps to gain insights into the common origin of all races and religions, a subject to which he would later return in his unfinished treatise "Modern Thought and Catholicism" (1902). The house he proposed to build for himself—"of wood and clay, thatched . . . [and extended] by felling trees"—was itself originative; it was a version of the archetypal "primitive hut" described by Marc-Antoine Laugier in his famous *Observations sur l'architecture* (1753) as the likely savage origin of Classical architecture. In such a dwelling, Gauguin and his cohorts would live easily, modestly and cheaply, like the simple men and women of the primitive past and the exotic present.

However, Gauguin's interest in Madagascar as a window onto the primitive past was in competition with his racial and prurient concerns. The same mixed sentiments were mobilized during his several visits to the Exposition Universelle of 1889 held at the Esplanade des Invalides. There, the artist viewed the acclaimed Museum of Habitation with its reconstruction—down to the inclusion of actual natives—of Malagasy, Tonkinese, Egyptian, Tunisian, Javanese, Tahitian and many other villages. "You missed something," Gauguin wrote to Bernard in March 1889, "in not coming the other day. In the Java village there are Hindoo dances. All the art of India can be seen there, and it is exactly like the photos I have. I go there again on Thursday as I have an appointment with a mulatto girl."[43] True to the *Loti*-esque exoticist dream, women were as easily available at the fair as music, dance, food and habitation. A "mulatto girl"—a racial hybrid—was a particularly rare specimen and therefore an especially great erotic attraction for Gauguin.

Nearly a year after the Exposition, Gauguin remained under the spell of those hybrid "Hindoo" dancers, and he was now uncertain about the relative merits of Java, Madagascar and Tahiti. At this time, Emile Bernard too fell under the spell of *The Marriage of Loti*. With the additional buttress of a recently published handbook on the French colonies by Léon Henrique, the young artist revived his older friend's interest in Tahiti.[44] By the fall of 1890 therefore, the vague dream of flight to Tahiti, born two years earlier in Arles and nurtured by *Loti* and the

Exposition Universelle of 1889, had grown into firm resolve. Gauguin's letter to the Danish painter J. F. Willumsen reveals "a mind made up":

> As for me, my mind is made up; in a little while I shall go to Tahiti, a small island in Oceania, where material life can be lived without money. There I want to forget all the bad things in the past and die unbeknownst to people here, free to paint without any glory for other people. And if my children can and want to come and join me, I will then declare myself completely cut off [from France]. In Europe, terrible times are in store for the generation to come: a kingdom of gold will prevail. Everything is rotten, man and art alike. People are constantly being torn apart.

After his stinging prophecy of the coming of a corrupt European "kingdom of gold," Gauguin returns to clichéd rhapsodies about a timeless golden age in Tahiti; his words are again derived from *Loti*:

> Out there, at least, beneath a winterless sky, on marvelously fertile soil, the Tahitian need only lift up his arms to pick his food; thus, he never works. In Europe however, men and women satisfy their needs only by toiling without respite, while they suffer the pangs of cold and hunger, a prey to poverty; the Tahitians on the contrary, are the happy inhabitants of the unknown paradises of Oceania and experience only the sweet things in life. For them, living means singing and loving.[45]

Gauguin's letter to Willumsen exposes a familiar exoticism, yet also exhibits the tenets of a new critical primitivism that would supersede it. What Gauguin desired more than simply racial exotica, sexual titillation or a warm climate was a primitive, anarchist utopia, a land where money was unnecessary, and where mutual aid was the basis for a free and independent life. This would ultimately require a far more thoroughgoing engagement with native culture and society than exoticist sentiments permitted.

Gauguin's pattern of initial attraction toward and then growing repulsion from the racism of *The Marriage of Loti* is revealed in a series of letters, journal entries and paintings extending over nearly a decade and a half. Prior to his emigration from France to Tahiti in 1891 he was, as we have seen, an almost unalloyed enthusiast for *Loti* and racist exoticism; "a great gate" was forever shut between himself and native Breton women. Subsequent to that travel, his enthusiasm for *Loti* waned, and the stamp of racism began to fade from his art and thought although it never entirely disappeared.

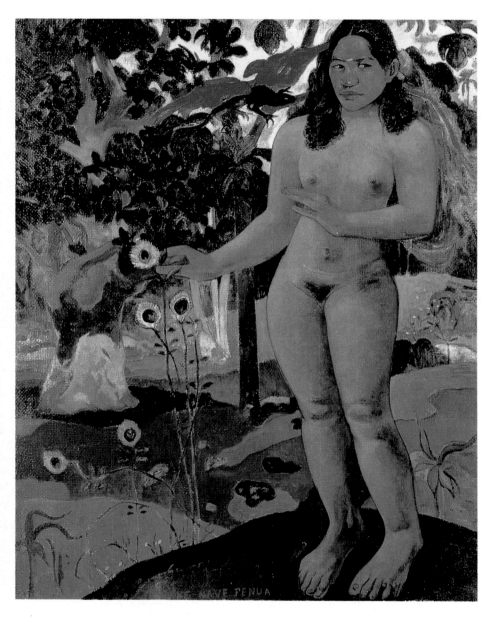

1 Te nave nave fenua (The Delightful Land) 1892

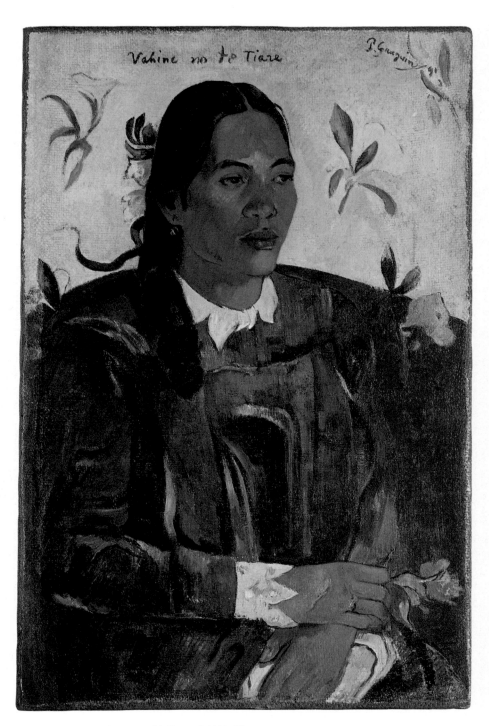

II Vahine no te tiare (Woman with Flowers) 1891–92

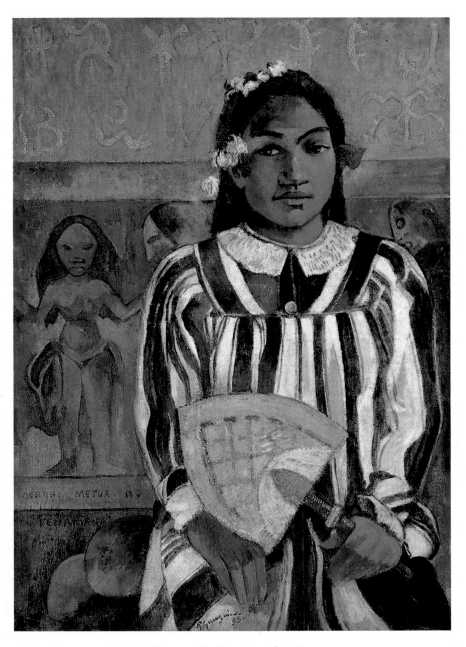

III Merahi metua no Tehamana (Tehamana Has Many Parents) 1893

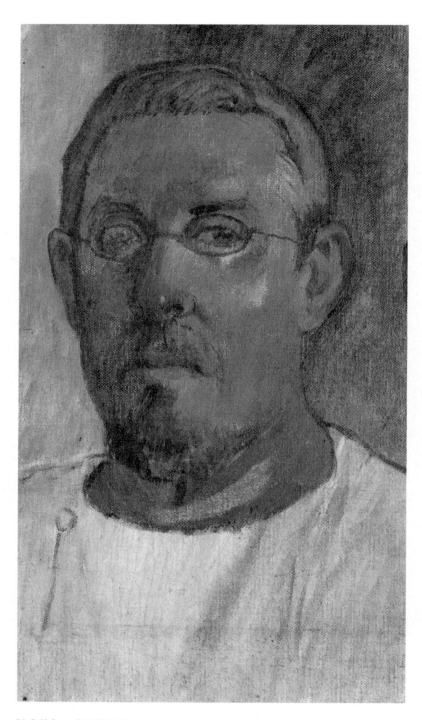

IV Self-Portrait 1902-03

Immediately after his arrival in Papeete, Gauguin began to observe and record some of the distinctive patterns of Tahitian culture and sociability. A letter to his wife Mette written on 13 June 1891, just three days after his arrival, reveals his initial efforts to insinuate himself into élite circles:

> Thanks to the *Figaro* article [18 February 1891, by Octave Mirbeau] and to some letters of recommendation, I am known already. Very well received by the Governor and the Secretary for the Interior . . . I want to have as many acquaintances as possible. I think I shall soon have some well paid commissions for portraits . . . Tomorrow I am going to see the Royal Family.[46]

By July, however, the artist's estrangement from the French élite was well under way, and by the fall it was nearly complete. In September, Gauguin was living in Paea, thirteen miles south of the capital city, and a month later in Mataiea, a further twenty-five miles distant. "I am beginning to think that everyone in Paris is forgetting me," he wrote in November to Daniel de Monfreid, "as I get no news and here I live very much alone, speaking only the little Tahitian that I know. Yes my dear fellow, not a word of French." The precise reasons for Gauguin's ostracism from French Tahitian society remain unclear, but the artist's unconventional appearance and opinions could hardly have endeared him to the commercial and administrative élites. He subsequently rejected contact with colonial notables (with some exceptions) and sought instead to ingratiate himself with indigenous Tahitians.

In his autobiographical novel *Noa Noa* (1893–97), Gauguin accounted for the physical move from Papeete to Mataiea by describing it as a temporal move from modernity to olden times, that is from colonial Tahiti to Polynesia of *te mata mua*; he described it as well as part of a spiritual search for the savage and the primitive. After noting the death and funeral of the Tahitian King Pomare V, Gauguin wrote:

> Now there was one less king, and with him were vanishing the last vestiges of Maori [sic] customs. It was all over—nothing but civilized people left . . . Shall I manage to recover any trace of that past, so remote and so mysterious? . . . To get back to the ancient hearth, to revive the fire in the midst of all these ashes. And for that quite alone, without any support . . . My mind was soon made up. To leave Papeete as quickly as I could, to get away from the European center. I had a sort of vague presentiment that, by living wholly in the bush with natives of Tahiti, I would manage with patience to overcome these people's mistrust, and that I would come to Know them.[47]

If Gauguin was to recover for himself and his European audiences any trace of the Polynesian past—a past mirrored he thought in the ethnographic present—he would have to go out into the field and live among the natives. "You ask me what I am doing," Gauguin wrote in the same letter to De Monfreid. "It's rather difficult to say . . . As yet I have done nothing striking. I am content to dig into myself, not into nature, and to learn a little drawing; that's the important thing. And then I am getting together subjects to paint in Paris."[48] Like the twentieth-century ethnographer undertaking fieldwork, Gauguin surrounded himself with native life and culture and began to collect materials. "The proper conditions for ethnographic work," Bronislaw Malinowski wrote in 1922 about his fieldwork in the Oceanic Trobriand Islands, "consist mainly in cutting oneself off from the company of other white men, and remaining in as close contact with the natives as possible, which really can be achieved [only] by camping right in their villages . . . And by means of this natural intercourse, you learn to know [them] and you become familiar with [their] customs and beliefs."[49]

Less intellectually and financially prepared than Bronislaw Malinowski for ethnographic immersion, Gauguin nevertheless undertook to surround himself with native life and culture. At Mataiea he rented a small house that faced the bay and backed against some hills. There he remained for almost two years, passing time in the company of a handful of other colonists, native friends and informants. He read about Tahitian religion in a good, if somewhat outdated text by J.-A. Moerenhout called *Voyage aux îles du grand océan* (1837), carved what he called his "bizarre gods" in local woods, compiled a large portfolio of drawings (which he called his *documents*), and, by the time of his repatriation to France in July 1893, had painted some seventy works that treat Polynesian daily life, ancient religion and contemporary customs, among other themes.

In *Noa Noa*, Gauguin described *Vahine no te tiare* (*Woman with Flowers*, 1891–92) as his initial attempt to comprehend his own racial corruption and the Maohi people's unique racial purity:

> I began to work—notes, sketches of all kinds. Everything in the landscape blinded me, dazzled me . . . In the brooks, forms of gold enchanted me—Why did I hesitate to pour that gold and all that rejoicing of the sunshine on to my canvas? Old habits from Europe, probably, all this timidity of expression [characteristic] of our bastardized races—

To initiate myself properly into the character cf a Tahitian face, into all the charm of a Maori [sic] smile, I had lorg wanted to make a portrait of a woman who lived close by, who was of pure Tahitian race . . . *Vahine no te tiare.*

Gauguin inverts the usual racist paradigm here by describing his own origins as impure and his model's as pure, but in so doing resurrects the eighteenth-century model of the "noble savage." The composition of *Vahine no te tiare* and the posture of the figure is derived from Renaissance and early nineteenth-century prototypes. The half-length format, folded hands and arc behind the sitter are generally based upon Leonardo da Vinci's *Mona Lisa*, as is the model's psychological inscrutability. She sits calm and erect; the contours of her body are obscured by a regal blue missionary dress, and attention is drawn to her sharp features and unflinching eyes. The portrait also recalls George Catlin's widely reproduced portraits of Plains Indians, such as *White Cloud (Iowa)*, and projects some of the same qualities of virtue and stoicism.

Vahine no te tiare (Woman with Flowers) 1891–92

Tahitian Women (1891) depicts two identical women seated on a yellow plank floor or platform; the one in profile at left supports her body with her stiff right arm and folds her right leg beneath her extended left; the one in the pink and lilac missionary dress at right tucks her legs beneath her and grasps eight strands of palm leaf between the thumb and index finger of her left hand. (The latter manipulation is carefully observed; it is also visible in Henry Lemasson's photo of *Young Tahitians Making Straw Hats* [1896].) Beyond the women and the diagonal floorboards—and behind the women's heads—are three narrow horizontal zones of cool color, separated by wavering yellow bands. The upper area represents waves breaking against a coral reef; the middle depicts the calm green waters of the lagoon; the lower represents the volcanic gray-black sands of Mataiea.

Tahitian Women 1891

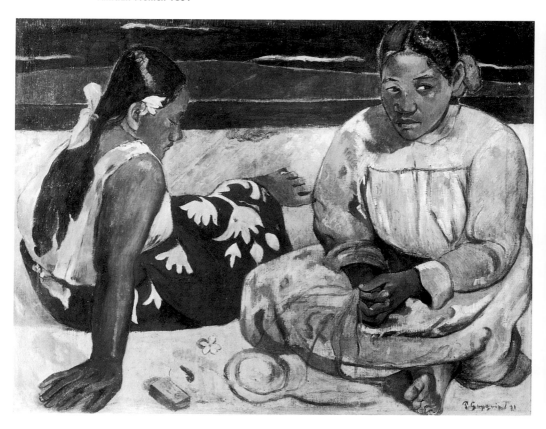

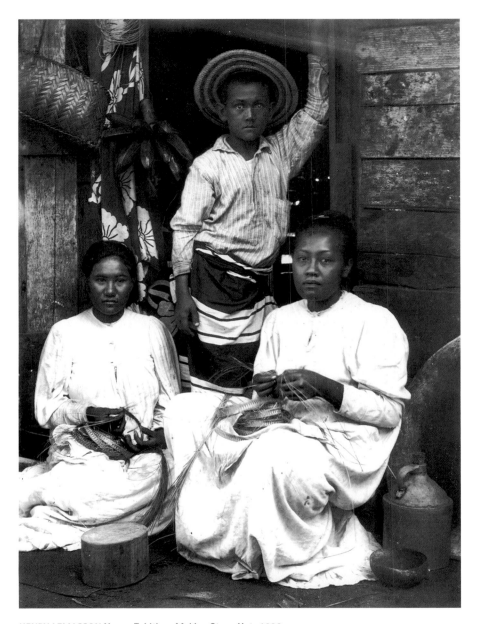

HENRY LEMASSON Young Tahitians Making Straw Hats 1896

Te nave nave fenua (*The Delightful Land*, 1892) is among Gauguin's most subtle and complex paintings from his first Tahitian period; it is both Gauguin's *Loti*-esque paean to racism and his statement of emancipation from that particular European stupidity. The young woman—probably modeled from the artist's lover Teha'amana—is a Tahitian Eve tempted by the blandishments of a serpent with enormous red wings. She is also a prophet, her posture inspired by a sculpted figure of Buddha from the façade of the Javanese temple of Borobudur. (Gauguin owned a photograph of the relief.) She grasps with her right hand the blossom of a spindly flower resembling a peacock feather, and places her left hand just beneath her right breast. The body sways as if in time to the rhythms of the unheard *upa upa*—for Gauguin, Teha'amana (like Rarahu) is always "singing and loving." *Te nave nave fenua* represents an "Edenic Eve," wrote Achille Delaroche in 1894, created by "the painter of primitive natures."[50]

Yet the resemblance to Rarahu is only superficial, and Delaroche's modest praise for the figure represented only one of several critical responses. "Why has the artist so far forgotten himself," wrote the critic François Thiébault-Sisson in 1893, "as to see in the Tahitian woman of today, as in the Tahitian woman of old, only a female quadrumane?"[51] Teha'amana's nude body is not conventionally classical or stereotypically beautiful in the manner of Loti's character: It is heavy and compact with broad shoulders, wide thighs and thick calves; it displays dark skin, jet-black head and pubic hair, and is disfigured by a polydactyl foot. Teha'amana's large hands and feet—the left foot has eight toes—prompted the critic to compare her to a "quadrumane," that is, a simian with feet adapted for use as hands. She is judged by Thiébault-Sisson to be lower on the scale of evolution; she is a monkey, at once licentious and degenerate, the perfect embodiment of European racist and exoticist ideas.

Gauguin's *Te nave nave fenua* is thus uncomfortably located on the margin of two racial regimes. The figure of Teha'amana/Eve is neither desirable nor repellent, neither Tahitian nor European, neither classical nor modern, neither black nor white, neither Venus nor chimpanzee and neither originative nor degenerate; she is in every way a liminal character who represents but does not resolve the contradictory perspective of the metropolitan male artist toward the colonial female subject whom he wishes to know in every sense of the word. Teha'amana's curious disfigurement is the most salient sign of her liminality; her foot highlights Gauguin's structuralist ambivalence about the explanatory significance of race. Teha'amana is both a child of nature and the product of culture.

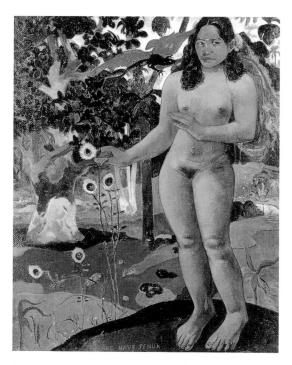

Te nave nave fenua (The Delightful Land) 1892

"In mythology," wrote Claude Lévi-Strauss in 1955, "it is a universal characteristic of men born from the Earth that at the moment they emerge from the depth they either cannot walk or they walk clumsily."[52] The best-known such autochthonous figure is, of course, Oedipus. The significance of the Oedipus ("swollen-foot") myth, Lévi-Strauss argues in "The Structural Study of Myth," an essay from the collection entitled *Structural Anthropology*, is that it expresses the contradictory archaic beliefs that humans are born both of the earth and of the union of women and men. By marrying his mother and killing his father, Oedipus both overvalues and undervalues his relation with blood kin. He is thus a liminal, mediating, or transformative figure who compellingly addresses an archaic cultural concern about origins, ancestry, kinship and inheritance. Lévi-Strauss's broad claim is the product of his effort—now widely discredited—to discover the structural, mental basis of mythic thought. Yet the anthropologist's universalism effectively serves to expose a similar strain of structuralism in the art and thought of his fellow Frenchman, Paul Gauguin. Gauguin was a Synthetist as we have already seen, attentive precisely to the

commonality of widely dispersed mythic patterns and motifs, whether they be found in Norwegian tankards, Japanese wallpaper, Breton costumes or the sculptural reliefs at Borobudur. His depiction of Teha'amana's polydactyl foot, like Lévi-Strauss's consideration of clumsiness, synthesizes alike European and non-Western mythology.

Similar issues are addressed as well in many of the legends collected by E. S. Craighill Handy in the course of his Marquesan expedition of 1920–21. Birth deformations, bruised heads and feet, the transformation of men and women into rooted trees and plants, the dismemberment of bodies and the dispersal of body parts are all motifs associated in these tales, as they are in Tahitian genesis mythology, with struggles over descent, kinship, lineage, exogamy and endogamy.[53]

The character of Oedipus, writes Lévi-Strauss, "provides a logical tool which relates the original problem—born from one or born from two?—to the derivative problem: born from different or born from same. By a correlation of this type, the overrating of blood relations is to the underrating of blood relations as the attempt to escape autochthony is to the impossibility to succeed in it."[54] The Oedipus story, like the many Polynesian stories of crippled and deformed bodies, may thus be seen in part as parables of consanguineous (natural) versus affined (cultural) identity. They are narratives that concern ways to balance relationships between blood kin and marriage partners or in-laws. Such tales had obvious critical salience for Gauguin, Lévi-Strauss and many other Synthetists and structuralists during the long "golden age" of racism; they served to undermine the dominance of nature and race, and to revalue the significance of culture and affinity in the determination of primitive and metropolitan identity.

In *Te nave nave fenua*, Teha'amana is at once an Eve born of the earth and a modern Tahitian born of a particular, historical union. She is not merely a primitive product of nature, but also a complex creature of culture, and like Oedipus, she highlights her binarism with her foot. Gauguin's peripateticism and his own family's colorful past made him especially alert to questions of racial and cultural origins; he pursued his inquiries into consanguinity and affinity in additional paintings of Tahitian women.

Merahi metua no Tehamana (1893), painted near the end of Gauguin's first Tahitian period, represents a richly historical Teha'amana, surrounded by the signs of old and new Tahiti. Behind the model are ripe mangoes grown on the island, an inscription copied from an Easter Islands tablet, and between these a framed frieze of dancers, whose placement and gestures echo the glyphs above. (The

Teha'amana c. 1893

figure with open arms at left appears to display the second part of the dance movement indicating *maeva*, or welcome.) The title of the portrait, best translated as *Tehamana Has Many Parents* is glossed by the passage in *Noa Noa* in which Gauguin describes his initial confusion at being introduced to his new wife's second mother. "The other one," the artist is subsequently told, "is also her mother, her foster mother."[55] Adoption and foster parentage in the Pacific are very common (the greatest example is Taku'u, an outlying Polynesian island in Melanesia, where all children are adopted at birth), and serves in general to reinforce affinity at the expense of particular consanguineous claims.[56] Teha'amana has many parents, according to Gauguin's portrait, strong affined ties, a rich ancestral past, and a complex colonial present indicated by fashionably hybrid attire, indigenous food and a still vital and evolving tradition of dance and music. Far from a picture of racial essentialism, it is an image of historical contingency and complex familial origins.

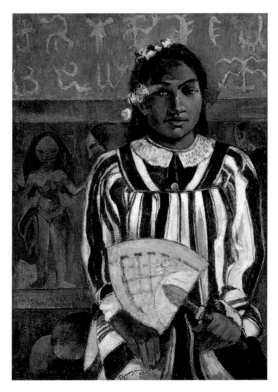

Merahi metua no Tehamana (Tehamana Has Many Parents) 1893

By the time Gauguin departed from Tahiti in the summer of 1893, therefore, Loti's stereotypical Rarahu was more important as a foil than a model.[57] The book had now come to represent those very bourgeois received ideas of Polynesia that Gauguin had sought to overcome. Whereas Rarahu was described by Viaud as "a little creature," Teha'amana in *Te nave nave fenua* was a veritable giantess. "This Tahitian Eve," Gauguin wrote in notes dated between 1896 and 1898, "is not some little Rarahu, listening to a pretty ballad by Pierre Loti . . . She is Eve after the Fall, still able to go about unclothed without being immodest, still with as much animal beauty as on the first day."[58] Strength, sexuality and confidence, not weakness, innocence and passivity were the traits Gauguin saw and wished to depict in Teha'amana and other Tahitian women. Whereas Rarahu's "business in life," Viaud writes, "was very simple: to dream, to bathe—especially to bathe—to sing and to wander through the woods," the Tahitian Eve was, we have seen, a far more complex and liminal creature. In an explicit rejection of the racist criticism of Thiébault-Sisson, Gauguin writes: "The feet of a quadrumane! So be it. Like Eve, the body is still an animal thing. But the head has progressed with evolution, the thinking has acquired subtlety, love has imprinted an ironic smile on the lips, and naïvely she searches in her memory for the 'why' of times past and present." The Tahitian body—naked, agile, powerful, erotic—is specifically adapted for a Pacific island life and culture that Gauguin supposes is ancient and slow to change, but the mind is no less adept than that of any modern European; it is capable of subtlety, irony and, like Gauguin himself, of asking questions about origins. Between the artist and Teha'amana, or between the modern artist and almost any other non-European man or woman, communication and exchange were now described as possible.

Gauguin returned to France at the end of August 1893 and from that December to September 1894, he undertook a somewhat different experiment in bicultural living; he cohabited in a studio at 6 rue Vercingétorix in Paris with a young Ceylonese woman named Annah. He painted her portrait in a frank and funny painting, improbably and ungrammatically titled in Tahitian, *Aita tamari vahine Judith te parari* (*The Child-Woman Judith Is Not Yet Breached*). The conception and composition of the painting were derived from a *mélange* of mismatched sources, including Dürer's *Virgin with a Monkey* (c.1495) and Cézanne's *Achille Emperaire* (1868). It may also have been inspired by the photograph of a *Nude* (c.1893–95) of similar age and ethnicity that originated in the circle of Toulouse-Lautrec. Both photograph and

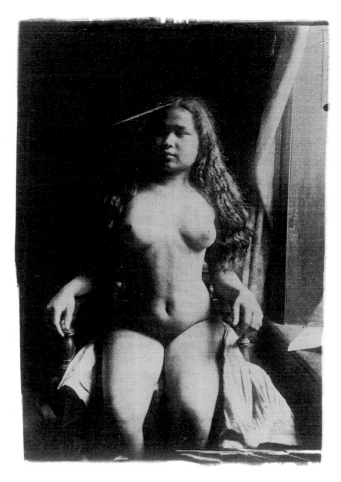

painting are sexually frank, though *Aita* is perhaps more so; the canvas emphasizes Annah's pubic region, belly hair, breasts and large feet, as she gazes confidently at the spectator. The Judith of the title is the thirteen-year-old daughter of the artist's friends and neighbors William and Ida Molard, and the virginity in question is an ironic reference to Gauguin's rejection of the child's erotic advances. Yet the painting obviously depicts not a white, but a dark-skinned girl, and not a virgin, but the artist's mistress. As if in ironic remonstrance of Thiébault-Sisson, whose harsh review was published a few weeks before, Annah is shown in the company of her pet monkey, named Taoa by Gauguin. The quadrumane generally apes Annah's posture, and gazes untroubled out of the picture to the right.[59] Taoa accompanied the artist and Annah wherever they went, as they ostentatiously trumpeted their disregard of

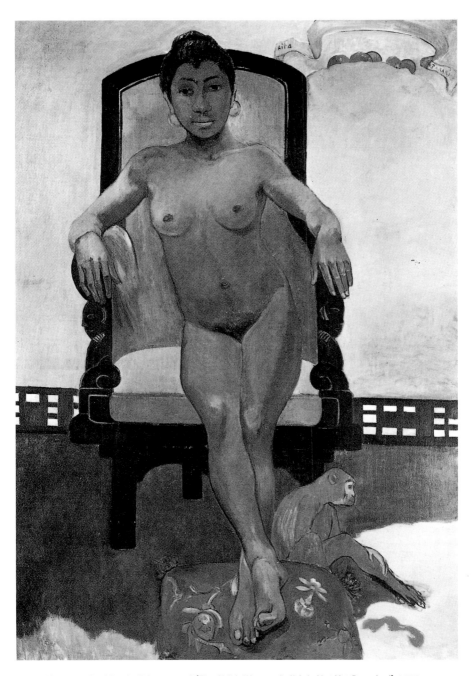

Above **Aita tamari vahine Judith te parari (The Child-Woman Judith Is Not Yet Breached) 1893**
Opposite **Photographer unknown, Nude c. 1893–95**

racial and moral convention. (The odd *ménage à trois* even promenaded along the docks of Concarneau in Brittany in the summer of 1894; there Gauguin and his party were assaulted by sailors and stevedores.) By the fall of 1894, the relationship between Annah and Paul had soured, and the two parted bitterly. Annah was later photographed posing in the studio of Alphonse Mucha. No one knows the fate of the monkey.

If Gauguin's perception of race grew more complex toward the end of his first Tahitian period, in Paris from late 1893 to the summer of 1895, and subsequently during his second Polynesian period between 1895 and 1903, that may be due in part to his growing understanding of the complexity of indigenous racial terminology. The "race" of indigenous persons is never a stable entity, at least according to local perception; the ascription of Tahitian, Marquesan, mixed-blood, white, half-Chinese or Chinese identity is contingent upon a host of factors, including consanguinity, affinity, social class, and economic relationship.[60] In *Portrait of Vaïte (Jeanne) Goupil* (1896) and *Tahitian Woman and Boy* (1899), Gauguin interrogates some of these ambiguities of colonial and racial identity. The first work portrays the nine-year-old daughter of one of the richest men in colonial Tahiti, the lawyer, journalist and politician Auguste Goupil. The young woman has an exaggeratedly pasty-white complexion, but is dressed *à la Tahitienne*, with missionary dress, a basket woven from pandanus leaves and a flower resting on her left shoulder. She is a young colonist affecting the dress and stiff posture favored by native women posing for their portraits. She has even taken, or been given, a native name for herself.

The second painting depicts an unidentified Tahitian woman sitting stiffly, perhaps uncomfortably in a Victorian rattan and wicker chair. She wears a missionary dress with a lace collar and an embroidered bib. A gardenia is tucked behind her right ear. She has broad square shoulders that appear to stretch the upper part of her dress. Standing behind her is an adolescent boy with short cropped hair, a plain, working-man's shirt, and a dark blue *pareu* visible below his waist. The two faces are almost expressionless, but their proximity invites physiognomic comparison. The one has a broad nose and lips, wide chin and close-set eyes; the other has a more aquiline nose, narrower lips and more widely spaced eyes. The one thus appears indigenous, the other "half-caste," or in French *métis*, and in Tahitian *afa*.

Yet the young man was probably characterized differently by contemporary Tahitians. His clothes, taut face and body, and general comportment suggest that he, like the seated woman, lives Tahitian-style; he would therefore, according to local semantics, be considered

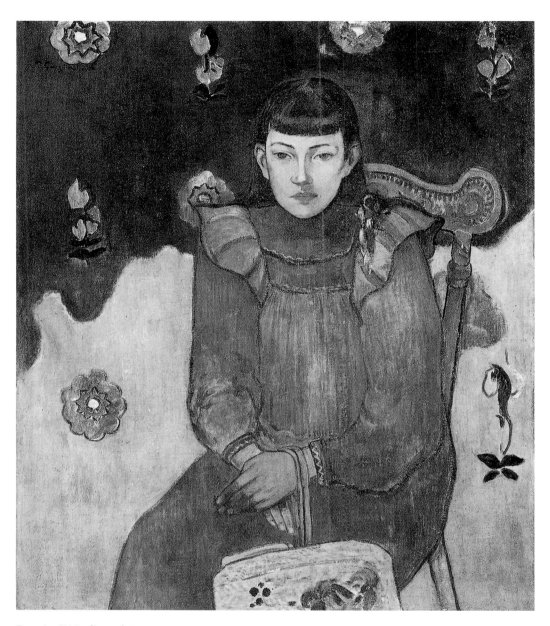

Portrait of Vaïte (Jeanne) Goupil 1896

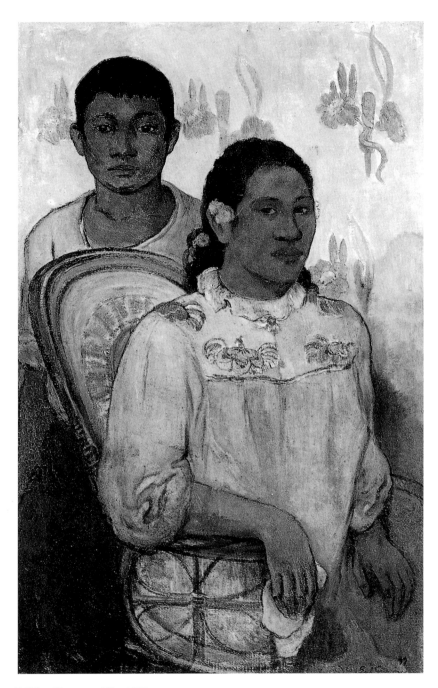

Tahitian Woman and Boy 1899

not *afa* but *taata Tahiti*, a native Tahitian. Racial terminology has great salience among Tahitians, but it is not determined by blood. It is highly context-specific, changing according to the relationship of the speakers. Someone who refers to him or herself as *afa* in a conversation with other natives, might become *taata Tahiti* in conversation with someone who is *popa'a* (white). Similarly, a long-standing white resident who is generally considered *popa'a* by natives may become *afa* in the context of a community of newly arrived settlers. Gauguin's *Portrait of Vaïte (Jeanne) Goupil* and *Tahitian Woman and Boy* are sober portraits that nevertheless inevitably invite consideration of racial identity.

If Rarahu was thus in many ways the antithesis of the Tahitian Eve, Annah, and the sitters in the two portraits cited above, the character of Pierre Loti was equally the opposite of Gauguin himself. Whereas the one sought impressions, surfaces, fleeting appearances and typicality, the other desired the timeless idea, symbolic structure, and the collective memory. While Loti pursued momentary sensations and novel experiences, Gauguin claimed to seek understanding and self-knowledge, and to discover his own savage nature. Finally, while Loti saw a "great gate forever shut" between himself and his native subjects, Gauguin increasingly perceived the possibility of attaining mutual understanding. He desired, he told Jules Huret in February 1891, "to be rid of the influence of civilization . . . to immerse myself in virgin nature, to see no one but savages, live their life, with no other thought in mind but to render, the way a child would, the concepts formed in my brain and to do this with the aid of nothing but the primitive means of art, the only means that are good and true."[61] If Loti was the product of generations of white Europeans or "Aryans," Gauguin was unquestionably hybrid or "bastardized"; he was at once aesthete, bohemian, decadent, colonist and "an Indian from Peru." He was a primitive seeking initiation into the arcana of other primitives.

In his journal, later published as *Avant et après* (in English, *The Intimate Journals of Paul Gauguin*) Gauguin speculated about the origins and future of the Marquesan race:

> Soon the Marquesan will be incapable of climbing a coconut tree, incapable of going up the mountain after the wild bananas that are so nourishing to him. The child who is kept in school, deprived of physical exercise, his body always clad (for the sake of decency) becomes delicate and incapable of enduring a night in the mountains. They are all beginning to wear shoes and their feet, which are tender now, cannot run over the rough paths and cross

the torrents on stones. Thus we are witnessing the spectacle of the extinction of the race, a large part of which is tubercular, with barren loins and ovaries destroyed by mercury.[62]

In these remarks written shortly before his death, Gauguin achieves a dialectical understanding of race and exploitation. Imperialism is at once a material and a cultural oppression; each informs the other. Certain cultural regimes—school, clothing and comportment—can change the physical body; a Europeanized body, in its turn—with soft contours, weak constitutions and tender feet—is incapable of sustaining the former indigenous culture. The result, to use the standard euphemism, is demographic collapse. Gauguin's perspective had finally changed from racist exoticism to primitivism. By immersion in the cultures of distant lands and societies, the primitivist gains a critical perspective on his own modern nation and people.

5 Primitiveness and Savagery

The history of the concept of the primitive may be distinguished from the history of the ideas of exoticism and racism, but there are a number of points of intersection. To begin with, all three are highly capacious terms. Exotic lands and people, we have seen, may be distant in place or time; they may attract or repel the visitor, and they may be judged to be worthy of either museological preservation or colonial conquest and destruction. The term race, we saw, was alternatively treated as synonymous with human, nation and species. Racism was treated as a branch of science, philosophy and ethics; it was an umbrella category that encompassed all manner of incompatible notions. The word primitive too is broad and flexible.

The etymology of the term is instructive: The English word "primitive," identical to the French feminine *primitive*, has its roots in the medieval Latin *primitivus* (meaning earliest, or oldest), in the Classical Latin *primus* (meaning earliest, or first), in the Attic preposition and conjunction *prin* (meaning before) and in the presumed proto-Indo-European *pri* (also meaning before).[63] The word "primitive" assumed its modern English and French form in the fifteenth and sixteenth centuries, when it came to mean earliest, first, originative and basic. The extreme chronological depth of the etymology suggests a corollary conceptual age, and in fact, the quest for knowledge of the primitive—of the pre-civilized, of otherness, of that which is basic, original and essential to humans, of what has been lost and what gained in the

creation of civilization—has preoccupied historians, as Arthur Lovejoy and George Boas long ago showed, at least since Herodotus.[64]

In none of the root languages cited here, do the term primitive or its cognates have a pejorative connotation. Only in the past half-century— during which time non-European peoples living in small-scale communities have been subjected to near complete extirpation—has primitive come to mean backward and retarded. In the late twentieth century, primitive has become synonymous with powerlessness, the cruelest rebuke of all in a world system that reveres economic and military independence and authority.

The modern history of ideas about the primitive begins with Jean-Jacques Rousseau. In *A Discourse on the Origins and Foundations of Inequality Among Men* (1755), Rousseau undertook a twofold interrogation of the primitive. On the one hand, he gathered what knowledge he could about ancient and contemporary peoples living in small-scale societies, and compared their systems of law and morality with those of modern Europeans. On the other hand, he also examined his own basic emotional and intellectual make-up in order to understand the blindnesses and prejudices that stood in the way of the achievement of full human equality and justice for all. For the *philosophe* therefore, the study of what he variously termed "original man," "natural man," "savage man" or "man in his primitive state," was a means to understand the depth and breadth of human virtue and to measure the distance the moderns have traveled from that original goodness. The sober conclusion Rousseau drew was that contemporary Europeans had constructed a system of law and government whose sole purpose was the preservation of property, inequality and, worst of all, slavery. The noblest instincts of the primitive community and men and women in the "state of nature"—compassion for others and the desire for self-improvement—had been perverted by modern society.

Denis Diderot's *Supplement to Bougainville's "Voyage,"* written in 1771 but not published until after the author's death, similarly praised the primitive and rejected the civilized. Diderot specifically celebrated the sexual freedom of Tahitians and condemned as wicked the European double standard. Envy, jealousy, coquetry and infidelity are foreign to Tahitian men and women, he argues, whose sexual openness and sharing is the natural expression of their love for children. What is more, European sexual depravity is judged by Diderot to be simply one instance of a larger disease: the enslavement of civilized men and women by their own private property. "We possess already all that is good or necessary for our existence," says Diderot's wise Tahitian. "Do

we merit your scorn because we have not been able to create superfluous wants for ourselves?"[65]

Neither Rousseau's nor Diderot's critiques of society were intended to pave the way for a return to the state of nature, as is sometimes thought. Their stances were highly rhetorical and based on scant knowledge of non-European peoples. Rather, their positions were offered for the purpose of constructing the model of a more just modern society upon the solid foundation of primitive virtue. The task of describing that future social order was taken up by Rousseau himself in *The Social Contract* (1762), and later by the French utopian socialists—including Henri Saint-Simon, Charles Fourier, "Père" Enfantin and Flora Tristan (Paul Gauguin's grandmother)—some two generations later. Yet despite its subsequent importance to the history of radical French and European thought, Rousseau's and Diderot's versions of primitivism—the generic name for the modern Western infatuation with the cultures of indigenous, tribal and conquered peoples—were not especially popular during an age of colonial expansion.

A. N. de Condorcet's evolutionary perspective in the *Sketch for a Historical Picture of the Progress of the Human Mind* (posthumously published in 1795) was the more typical Enlightenment and even Romantic view of primitive peoples.[66] Condorcet argued that the European nations (especially France) were harbingers of material progress and spiritual advancement. The historical task of Europe in fact was to bring "the sweet blessings of civilization" to "tribes living in a condition of almost total savagery." In time the latter peoples, he stated, "will be reduced in number as they are driven back by civilized nations . . . until they will finally disappear imperceptibly before them or merge into them." By virtue of his wholesale disparagement of non-European cultures therefore, Condorcet belongs outside the current of primitivist thinkers who, whatever their ultimate ideological purpose, always valued the indigenous societies they considered. His "progressivism" foreshadowed the work of the racial scholars discussed earlier—including W. F. Edwards, J. A. de Gobineau and G. Le Bon—who adopted a polygenesist and evolutionary approach to the study of non-European peoples and cultures. Following the path of Jean Baptiste Lamarck, they generally believed that human history paralleled biological history, that all present societies could be located on a uni-linear evolutionary scale from least to most advanced and that communication between backward and superior peoples was almost impossible. They also proposed that evolutionary changes occurred in great leaps, not in small steps, and that acquired cultural traits could be inherited.

In the second half of the nineteenth century therefore, primitivism (as opposed to exoticism and racism), was an aesthetic and intellectual ideology of toleration, and it was probably Lewis Henry Morgan, Friedrich Engels, Karl Marx, Paul Lafargue and later anthroplogists such as J. G. Frazer, Emile Durkheim and Claude Lévi-Strauss who came closest to being inheritors of the legacies of Rousseau and Diderot. Committed monogenesists, Morgan and Engels accepted the notion of a uni-linear and progressive social evolution, but at the same time claimed that primitive "barbarism" was a distinct cultural and economic mode that was both communal and democratic. "Man progresses in knowledge alone," Morgan wrote in 1857, and "all the capacities of the entire race existed potentially in the first human pair."[67] For Morgan and Engels, the task of enlightened people in the present age was to construct a modern society that possessed "democracy in government, brother-hood in society, equality in rights and privileges, and universal educa-tion." Such a society, they added with an assured and self-conscious embrace of primitive society, "will be a revival, in a higher form, of the liberty, equality and fraternity of the ancient gentes [clans]."[68]

Though Karl Marx, like Engels and Morgan, had little direct impact on the French cultural and intellectual community from which Gauguin emerged, his views on the primitive offer a useful lens though which to view the French scene. Marx was a progressive, arguing that the prole-tarian revolution could only occur in the context of an advanced industrial capitalism with a high degree of both division of labor and worker alienation. For this reason, Marx, in some of his early writings such as "Contribution to the Critique of Hegel's Philosophy of Law,"[69] and "The Eighteenth Brumaire of Louis Bonaparte" considered primi-tivism to be a purely reactionary stance that blinded revolutionaries to the particularity of their struggle. Celebrations of "antique ideals" and "primeval Teutonic forests" served only to prevent the scientific understanding of the revolutionary present and communist future. "The social revolution of the nineteenth century," he wrote in 1851, "cannot draw its poetry from the past, but only from the future."[70]

Yet Marx's own anthropology, discernible in his *Economic and Philosophic Manuscripts of 1844*, *The German Ideology* (1845–46) and *The Ethnological Notebooks* (c.1880) pulled him in a very different direction. In these texts, Marx freely speculated about human nature, which he called "species being," and about the organic and social traits that both connect and separate humans from other animals. The debt to Rousseau is especially profound in *The German Ideology*. In an often-quoted passage, Marx describes the freedoms that might one day be

possible in a communist society in which the division of labor was ended. His words recall Rousseau's celebration of the "golden mean between the indolence of the primitive state and the petulant activity of our own pride."[71] Marx writes:

> In communist society, where nobody has one exclusive sphere of activity but each can become accomplished in any branch he wishes, society regulates the general production and thus makes it possible for me to do one thing today and another tomorrow, to hunt in the morning, fish in the afternoon, rear cattle in the evening, criticize after dinner, just as I have a mind, without ever becoming hunter, fisherman, shepherd or critic.[72]

Communist society would be a revival, albeit in a more politically and technologically advanced form, of primitive communalism. It would be the social arena in which humans would rediscover their primitive, humanly defining, sensual, intellectual, and emotional capacities.

More than two decades later, primitivism re-emerged as a significant motif in Marx's work. In *The Civil War in France* (1871), he described the brief efflorescence in Paris of a society in which labor was reintegrated with intellectual and creative life, and humans once more discovered themselves to be both rational and sensual beings. The Paris Commune thus mirrored to some extent the primitive golden mean described in *A Discourse on the Origins and Foundations of Inequality Among Men* and *The German Ideology* with its limited division of labor and its communal ownership of property. Primitivism for Marx was no longer merely a matter of regression and self-delusion; it could now serve as a critical and historical model of cooperation and communalism. Though neither Marx nor Engels ever used the term "primitive communism" in their writings, they did believe—in common with many European thinkers of their day—that communally-held property, consensual decision-making and sexual equality were characteristic features of many past and present "primitive" societies that could be revived by future socialist societies.[73] Indeed the association of primitives with socialists was a feature of reactionary as well as revolutionary consciousness. French Communards of 1871 were regularly condemned as "cannibals," "primitives" and "savages" by their opponents in the government and press, and a particular justice was seen in their subsequent transport in large numbers to the French penal colony in *kanaka*-populated New Caledonia.[74] There, it was believed, virgin nature and actual primitives would exert a civilizing

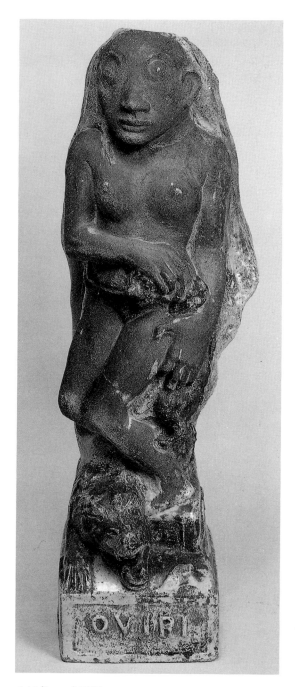

Oviri (Savage) 1894

force upon the unruly and savage radicals.[75] There the European communists would receive their chastisement from the true primitive communists.

The primitivism of Marx and Engels in *The German Ideology* and *The Civil War in France* bears comparison to similar ideas within the intellectual tradition to which Gauguin was directly heir. The socialists Marx and Engels, as well as the utopian socialists Flora Tristan, P. J. Proudhon and M. A. Bakunin, all stressed the need for solidarity and cooperation among the laboring classes, and for emancipation from economic monopolies and "the manifold divisions of labor in each country."[76] The French thinkers especially—from Saint-Simon to Lafargue—were keen to eliminate money, rent, lending, and the right of inheritance; these abolitions were seen as essential preliminaries to the general revolution. (Marx regarded this stance as a foolish idealism, that is putting the cart before the horse in such a way as to frighten off potential allies among peasants and the lower middle class.) Marx's son-in-law, Paul Lafargue, was an unusually keen primitivist, arguing in his *The Right to Be Lazy* (1885) and *The Evolution of Property from Savagery to Civilization* (1890) that money and exchange must be destroyed before the bourgeois state could be overthrown. He insisted moreover, that the goal of the revolutionary proletariat must be to "return to natural instincts" and to "restore to the human being of the future society the vigor and perfection of the senses which characterize the savage and the barbarian."[77] Lafargue's primitivist revival of Rousseau could not have been more explicit.

Paul Gauguin held many similarly anarchic views and regularly declared himself in opposition to property, civilization and the nation state. In a letter to Odilon Redon from 1890, Gauguin mapped the trajectory of his quest for "a state of primitiveness and savagery." He told his fellow Symbolist artist that after remaining a while longer in rustic Brittany, he would leave France and Europe far behind:

> The reasons you give me for remaining in Europe are more flattering than they are convincing. My mind is made up, although since I returned to Brittany I have modified my plans. Madagascar is still too close to the civilized world; I want to go to Tahiti and finish my existence there. I believe that the art which you like so much today is only the germ of what will be created down there, as I cultivate in myself a state of primitiveness and savagery.[78]

Gauguin described his emigration as a desperate flight from civilization. In Tahiti, he would "cultivate" his own "primitiveness and savagery,"

just as Jean-Jacques Rousseau's fictional Emile nurtured his senses and developed his morals through exercise, play, education and self-discovery amid the state of nature. "The education of Emile . . . " Gauguin later wrote, "remains the most difficult undertaking a man has ever attempted . . . Here [in Tahiti] the education of Emile takes place in the broad enlightening sunshine."[79]

In another late text, Gauguin wrote: "For the sake of country, men devour one another for base, material interests. What difference does it make to progress if the earth belongs to one flag rather than another?" Echoing Rousseau's words at the beginning of Part Two of *A Discourse on the Origins and Foundations of Inequality Among Men*, Gauguin then adds: "But what does matter is that the earth belongs to all, and not just to one."[80] Gauguin's "Studio of the Tropics" was to have been just such an anarchist utopia where the land belonged to no one and artists could live without money. Life was to be lived according to natural instinct, and food and shelter to be obtained without effort. It was to be a primitive, communal existence through which modern European savages could learn to live like real natives. Such in any case was the plan; the reality, as we have already begun to see, was far more complex.

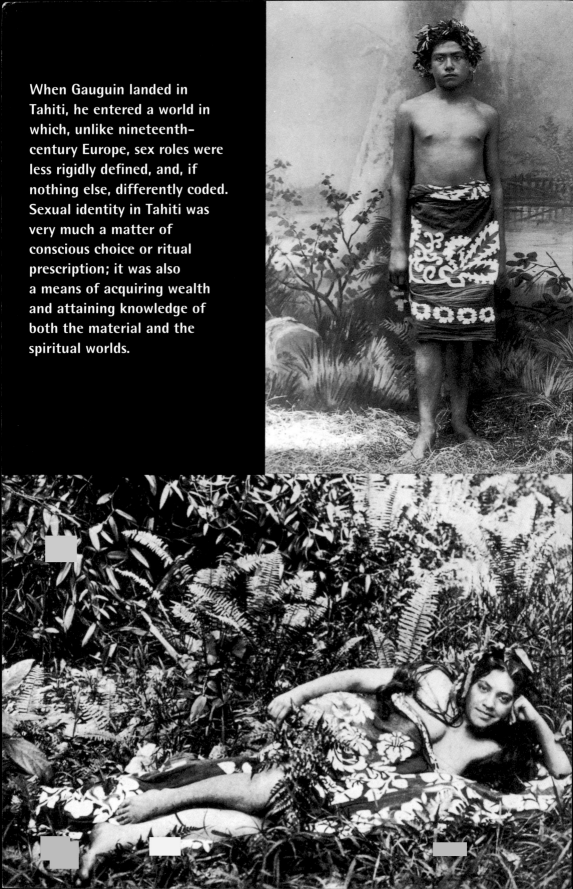

When Gauguin landed in
Tahiti, he entered a world in
which, unlike nineteenth–
century Europe, sex roles were
less rigidly defined, and, if
nothing else, differently coded.
Sexual identity in Tahiti was
very much a matter of
conscious choice or ritual
prescription; it was also
a means of acquiring wealth
and attaining knowledge of
both the material and the
spiritual worlds.

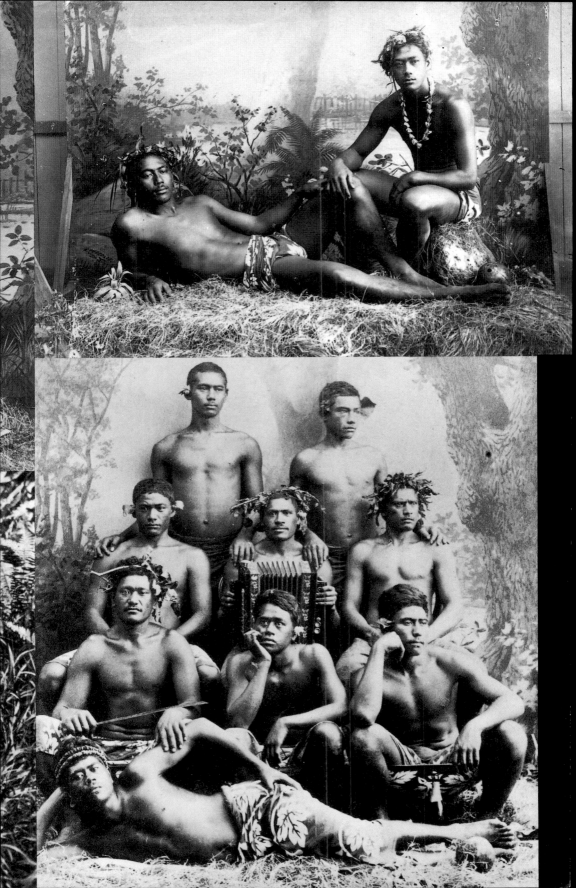

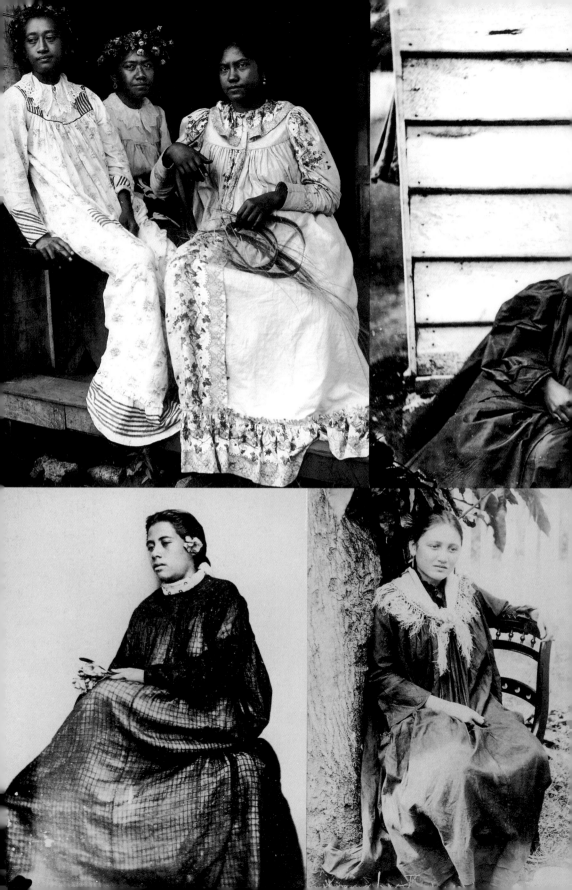

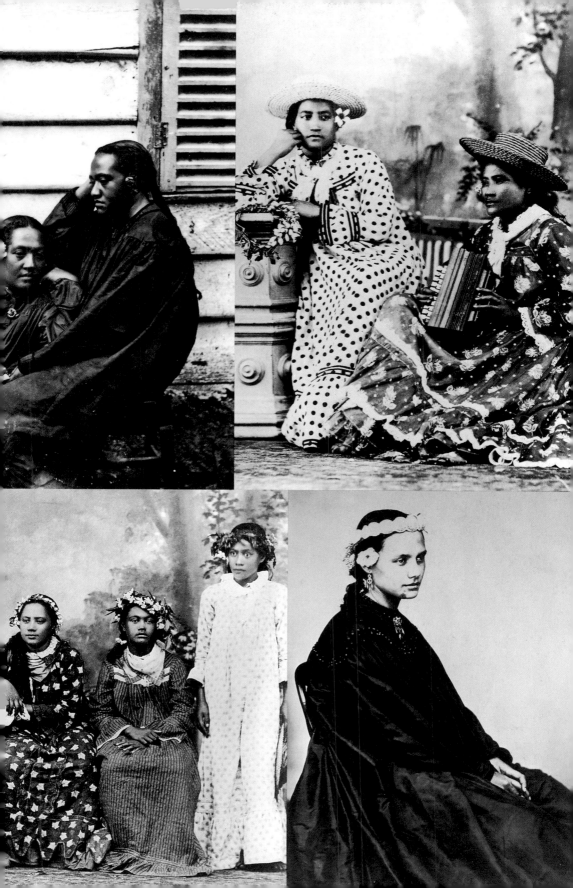

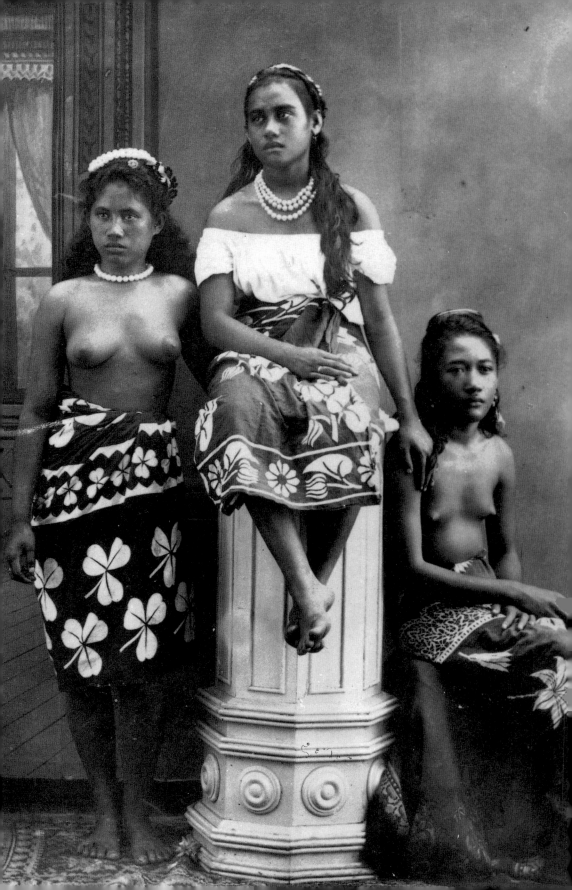

The tales of Gauguin and sex in the South Pacific have been generally one-dimensional. For admirers and antagonists alike, the story begins and ends with colonial and phallic certainty: European and Polynesian *vahines* are successively accessioned and deaccessioned as Gauguin wends his amorous way from Paris to Tahiti to the Marquesas Islands. All the women he meets along the way are his subjects; all lie supine before the master's brush. The liaison with Teha'amana, a young Tahitian woman described in the artist's autobiographical novel *Noa Noa* and represented in his painting *Mana'o tupapa'u* (1892), has been particularly laden with colonialist *idées reçues*.

narrow view of Gaugin

Art historians, biographers and travel writers have consistently probed the relationship for clues to the meaning of Gauguin's paintings, or for indications of the artist's attitudes toward native women. To some, Teha'amana was a modest and meek child-bride who introduced Gauguin to the mysteries of Tahitian culture and religion; to others, she was a helpless young woman sold as a sexual slave to the much older, syphilitic artist. The art historian Griselda Pollock concluded her recent published lecture on Gauguin with a discussion of *Mana'o tupapa'u* and an indictment of the artist's collaboration with colonial ideologies of racism and sexism: "[Teha'amana's] body is appropriated to signify [Gauguin's] desire as white man and artist. Any thoughts about Teha'amana, the Tahitian woman as subject—as a historically constituted and culturally specific feminine subjectivity—fall under his erasure."[1]

what is wrong with narrow view

In fact, biographical documentation is insufficient to permit any evaluation of the actual relationship between the painter and Teha'amana. Pollock's elision of the historical Teha'amana—assuming there was one—and the painted nude in *Mana'o tupapa'u*, thus repeats the categorical error of earlier masculinist scholars, biographers and novelists who mistook Gauguin's Tahitian fabulations for the real thing. Nevertheless Pollock is surely correct in her suggestion that *Mana'o tupapa'u* is a veritable manifesto of Polynesian sex. Gauguin discussed the sexual content of the work in several letters and diaries, and the picture achieved real notoriety from the moment of its first exhibition in Paris in 1894. The only other work that Gauguin discussed

Three young Tahitian women in a photograph by CHARLES BURTON HOARE or MRS. S. HOARE c. 1870–75 that reinforces Western male sexual fantasies

91

at comparable length, or that has received equivalent attention, is *Where Do We Come From? What Are We? Where Are We Going?* (1897–98), painted during the artist's second Tahitian period. Though considerably more chaste, it too addresses questions of sex; it is a Tahitian manifesto that synthesizes European and Polynesian notions of the dualism of matter and spirit.

I shall argue that *Mana'o tupapa'u* is an image of liminal sexuality in colonial Tahiti; a proper understanding of the work thus raises the possibility that Paul Gauguin—mocked as *taata vahine* or *mahu* upon his disembarkation at Papeete in the summer of 1891—may have identified with his young protagonist in previously unsuspected ways. Together with *Where Do We Come From?*, it highlights the existence in *fin de siècle* Tahiti of a multitude of gender positions beyond the two that predominated in Europe and North America, and suggests that Gauguin sought to position himself on the uncertain border between France and Polynesia.

thesis

2 Second Sex

During the nineteenth century, most scientists and philosophers were convinced of the incommensurable difference of women and men, and of the inferiority of the former to the latter. If women were excluded from the public spheres of business and politics, it was because they were disabled by nature; if men were uniquely empowered to rule over their wives and children, it was ultimately their embodied masculinity that was enabling. Partly in response to the emergent ideologies of personal and political freedom which arose in the wake of enlightenment and revolution, the institution of patriarchy was re-invented according to the tenets of bourgeois philosophy and, increasingly, comparative biology and evolutionary science. Philologists and social psychologists, such as Ernest Renan and Gustave Le Bon, were sexual determinists who insisted upon the racial and sexual feebleness of non-whites and women, and marshalled the new tools of craniometry and anthropometry to aid them in their work. "The average of the skulls of female Parisians," Le Bon wrote, "classes them among the smallest skulls with which we are acquainted, almost on a level with the skulls of Chinese women, and scarcely above the feminine skulls of New Caledonia."[2] As a result, he stated, women are intellectually inferior to men: "The difference in their logical faculties is alone sufficient to create between [men and women] an insuperable gap."

Although generations of feminists beginning with Mary Wollstonecraft held that culture, not nature, was the wellspring of women's subservience to men, dimorphic models of sex and gender prevailed until only quite recently. In France, Luce Irigaray, following some clues in the work of Simone de Beauvoir, upheld a version of the old binarism by describing woman as "the sex which is not one," that is, the sex which is defined by its difference from the masculine, but which is at the same time unrepresentable.[3] In the United States, in a highly influential article, Sherry Ortner argued that although biological differences between men and women only assumed importance in particular cultural contexts, women's unique reproductive capacities universally caused them to appear closer to nature.[4] Women were therefore symbolically associated with a domestic realm tied to biological reproduction, and denied access to the masculine spheres of power. Ortner's proposition was clearly less critical of biological determinism than it at first seemed. Though gender roles were described as socially constructed rather than inherent in biology, the near universal subordination of women to men—according to Ortner—suggested to many that society and culture were as fixed and immutable as nature. Ortner's radically dualistic view of gender, in other words, implied an equally dimorphic view of sex.

The last two decades of research have profoundly changed formerly prevailing scholarly views of both gender and sex. The anthropologist Marilyn Strathern, for example, in her studies of the Hagen people of the Papua New Guinea Highlands, has shown that the binary terms crucial for Ortner—female and male, nature and culture, individual and society, and private and public—are in fact European constructs with little validity in the Oceanic context. Among the Hagen, male and female identities may be understood as consciously chosen positions within a context of shared humanity. Moreover, Ortner's neat analog—female is to male as nature is to culture—simply lacks empirical foundation. Hagen men discover their maleness both in the domestic and the spiritual spheres; the women locate their femaleness in the realm of nurture, and in their heightened individualism. "But these two domains," Strathern writes, "are not brought into systematic relationship; the intervening metaphor of culture's domination over nature is not there."[5] In a later text, Strathern describes Hagen notions of male and female "not as motivating or mystical principles at work in society, but as conventional descriptions of the forms in which Melanesians make persons and things known."[6] Men and women possess male and female attributes that are highlighted and articulated in different

non dimophic society

contexts Sex in the Western Pacific, in other words, is less an identity than a means for understanding the world.

Anthropological research into complex, non-dimorphic sex and gender positionings has by now extended into every continent. Ife Amadiume and J. Loring Matory have documented the multiply-gendered subjectivities of African men and women. In Nigeria, they have shown, daughters can be made into sons, and wealthy women can take other women as their wives. The result of these and other studies has been to dismantle any universal categories of women and men, and to erect in their place a set of diverse, polymorphous and transient structures of meaning permitting an increased understanding of the specific modalities of patriarchal power and sexual oppression. Henrietta Moore has recently summarized the changing paradigm in *A Passion for Difference* (1994): "Sex, then, as far as we understand it within the terms of Western discourse, is something which differentiates between bodies, while gender is the set of variable social constructions placed upon those differentiated bodies. It is precisely this formula which obscures rather than illuminates when it comes to the cross-cultural analysis of sex, sexual difference and gender."

Perhaps the most influential summary and critique of the formerly prevailing dimorphic view of sexuality, however, has been that of Michel Foucault. In *The History of Sexuality: Volume I* he wrote: "The notion of 'sex' made it possible to group together, in an artificial unity, anatomical elements, biological functions, conducts, sensations and pleasures, and it enabled one to make use of this fictitious unity as a causal principle, an omnipresent meaning; sex was thus able to function as a unique signifier and as a universal signified."[7] Once the "fictitious unity" of sex was undermined, and the tendency to view sex and gender as binaries was disrupted, the historical and ethnographic record began to yield previously unexpected evidence of sexual diversity and creativity from all parts of the globe and all places in time. Homosexuality, lesbianism and transvestism departed from the circumscribed precincts of *psychopathia sexualis* and began to be understood cross-culturally as manifestations of love, religion, work, art and even kin-group solidarity.

Precisely such a culturally sensitive and historically specific analysis, it turns out, is required when examining the art, writings and life of the Frenchman Paul Gauguin in colonial Polynesia. Indeed, when Gauguin landed in Tahiti, he entered a world in which, unlike nineteenth-century Europe, sexual dimorphism had never been the reigning paradigm. As in Strathern's Melanesia, sex in Tahiti was very

much a matter of consciously chosen or ritually prescribed social location; it was also a means of acquiring and redistributing wealth and of attaining knowledge of the material and spiritual worlds. Gauguin was a participant (to put the matter chastely), in this non-dimorphic sexual world, and his art offers surprising clues, as we shall shortly discover, to its historical specificity and complexity.

But then, Gauguin was not unprepared for Polynesia. The binary model of human sex and gender had never held uncontested sway in Europe, not even in the late nineteenth century when the model was codified by a generation of "sexologists" that included Richard von Krafft-Ebing, Havelock Ellis and Sigmund Freud. (The latter would also be among the first to trouble the paradigm.)[8] Especially in Paris, marginal sexual types could be found in bewildering variety, from the *persilleuses* (effeminate male prostitutes) first documented by the police officer L. Canler in the 1860s, to the *tapettes* (or gossiping queers) described by J. K. Huysmans in his *Sodome de Paris* (n. d.), to the *amateurs* (men with a taste for boys) mentioned by the Symbolist writer Rémy de Gourmont.[9] Indeed, the term *troisième sexe* began to be applied during the second half of the nineteenth century to effeminate men who were sexually attracted to other men. These were individuals who possessed "a female soul enclosed in a man's body," to cite the German lawyer and early champion of homosexual (Uranian) rights, Karl Heinrich Ulrichs.[10] Also called *inverti*—the term favored by among others J. M. Charcot and Emile Zola—they were believed to possess sex drives and bodily configurations that marked them as a distinctive third sex.[11] Paul Verlaine in France and Oscar Wilde in England were two of the most celebrated (or notorious) *inverti* in Europe.

Gauguin was thus ideally positioned to represent sexual liminality in colonial Tahiti. His knowledge of the Romantic literary tradition of the androgyne—which he utilized, we shall later see, in his *Mana'o tupapa'u*—and his friendship with decadent *inverti* such as the poet Verlaine provided him with compelling models for picturing the Tahitian third sex. Gauguin in fact greatly admired Paul Verlaine and frequently cited his verses.[12] They often dined and drank together at the Café Voltaire, and Gauguin had a keen interest in the political ideas of the poet's former lover, Arthur Rimbaud. Verlaine and Gauguin were twice fêted together by Symbolist friends, and, on one of these occasions, they were subjected to a scathing review that appeared on the front page of *Le Figaro*. Painter and poet, wrote Henri Fouquier, were part of a circle of "*éphèbes*," distinguished only by their "vapidity and obscurity." (In Parisian argot of the day, *éphèbes* were effeminate men

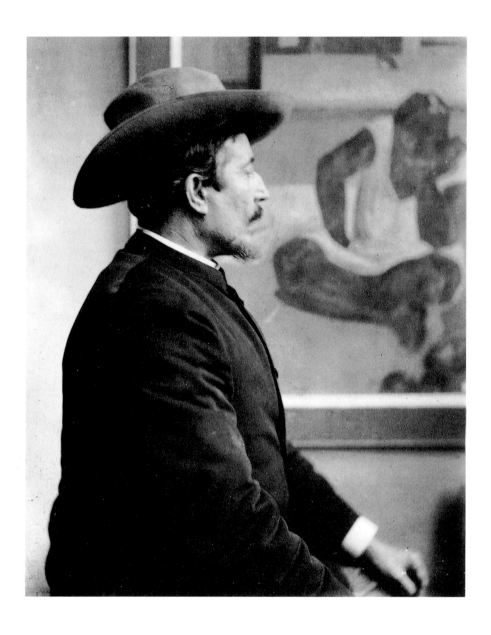

Above **Photographer unknown, Gauguin in front of Te faaturuma, Paris, Winter 1893–94**
Opposite **Photographer unknown, Paul Verlaine, Café François, Paris c. 1890**

who cruised certain of the covered passages of Paris.)[13] Fouquier then added, with alarm:

> Paris does not want to be another Byzantium, with its theologians of letters expounding upon words and theoretical pedantries, willfully forgetting both enemy and homeland, the homeland that some have made a career of disliking; nor to be populated with pale pederasts [insexuels]—long-haired or bald—who want nothing but to retard the French nation. These suspect cliques, where some ridiculously clothed high priests [hiérophantes]—abstractors of quintessence and vendors of gibberish—intoxicate themselves on pernicious incense burned under our very noses, only survive by hiding in the shadows.[14]

Neither poet nor painter, of course, sought inconspicuousness. On the contrary, by the time of his death in 1895, Verlaine had been crowned "Prince of Poets," and was better known for his dissipation than his art. Like Verlaine, Gauguin was labeled a *maudit* at the end of

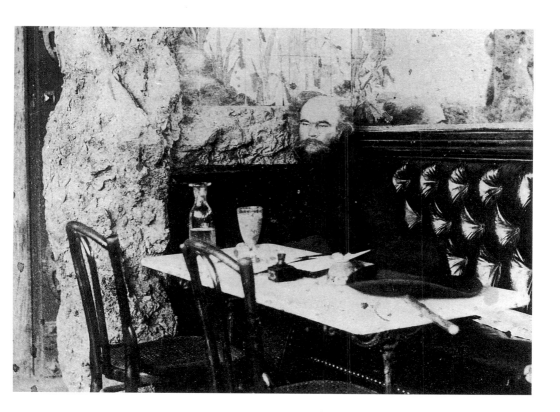

his life, and many of the same critical terms applied to the poet were aimed at the painter. "He is a barbarian, a savage, a child," wrote Jules Lemaître about Verlaine, " . . . except this child has music in his soul, and on certain days, he hears voices that none before him have ever heard."[15] In 1895, August Strindberg said: "Gauguin is the savage who hates the restraints of civilization . . . [he is] the child who takes his toys apart to make others." Gauguin's friend and printer Louis Roy, stated in 1903 that the artist's goal was, "to live only by the harmonies of lines and colors . . . [He was] sly as a savage and sometimes more ingenuous than a child."[16]

Like the foppish Verlaine, Gauguin cut an extremely bizarre and ostentatious figure wherever he went; his costume was a form of drag. He was alternately a Breton fisherman, an Inca, a cowboy, a white-suited colonial dandy, a Magyar and a Maohi. The artist Armand Séguin remembered Gauguin's appearance at Pont-Aven in 1894: "He invented everything . . . his odd suitcoat, the Persian cap, and the huge, deep blue cloak held together with precious carved ornaments and under which he seemed to the Parisians to be some splendid and gigantic Magyar, a Rembrandt of 1635, when he slowly and solemnly walked, with his white-gloved hand encircled with silver leaning on the cane he'd decorated."[17] The painter's friend and collaborator Charles Morice remembered Gauguin in Paris the same year:

> When he smiled Gauguin astonished one with the unexpected revelation of a naïve and almost childlike soul. But he rarely smiled, they were involuntary slips. Master of himself, the artist showed only the outward appearance of a great exotic lord—or else of an authentic aristocrat raised in the heart of lower Brittany by no less authentic peasants—or else of some tribal chieftain, miraculously spared tattooing, but surprised himself, at his European disguise.
> He had a taste for jewels, rings, brilliant fabrics. He always wore a Breton vest, embroidered in blue and yellow. And he loved to have around him the song of bright colors: on his walls, which he painted in bright chrome yellow; on his windows, which he transformed into stained glass; on his furniture, which he carved and painted. It was there, in his studio in the rue Vercingétorix, for example, in that environment attuned to himself by himself, that one had to see him to understand him.

In Tahiti, he affected a simpler, native dress, though his lodgings were quite as outlandish as in Paris. In 1898, the engineer Jules

Agostini chanced upon the artist's house and studio at Punaauia, south of Papeete:

> Taking the path closest to the shore, one soon sees a statue, some fantastic wood carvings and a house with thatched roof, where, like a new Robinson, an artist has come in search of rest. M. Paul Gauguin, the well-known Impressionist painter, has for the second time fled the cesspool of Paris for refuge at the breast of primitive nature.
>
> The costume of the recluse is of the most sober simplicity: a jersey with an ankle-length *pareu*; that is all.
>
> The walls of his small salon and studio are hung with canvases—neither classical nor conventional—in which the master appears to have locked up all the beauties generated by a prodigious nature beneath the radiant skies of this unforgettable island.
>
> The hermit passionately loves his corner of the world; there he has established his life, and there he intends to spend the rest of his career and to seek his eternal rest.[18]

JULES AGOSTINI Gauguin's house, near Papeete, Tahiti 1898

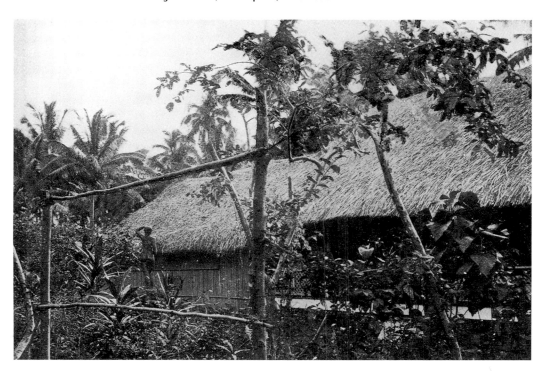

Gauguin was, however, an extremely restless Robinson Crusoe, whose curiosity extended to matters natural and unnatural alike. He was a master of invective and obscenity and enjoyed scandalmongering. In his polemical newspaper *Le Sourire*, he occasionally took the pseudonym Tit-Oil, a word which resembles the Tahitian terms for woman's breast (*titi*), shit (*titi'o*), retracting the foreskin (*tito'i*) and masturbation (*tito'ito'i*). Under this byline, Gauguin published a review of a play written by a native woman and performed at the Théâtre National de Bora-Bora, on the theme of incest and women's sexual liberation. "I must confess," he wrote, "that I am myself a woman, and that I am always prepared to applaud a woman who is more daring than I, and is equal to a man in fighting for freedom of behavior."[19] At the end of his life, Gauguin was ensconced in his decadent "House of Pleasure," its door-frame carved with male and female figures to recall a Maori *wharenui* (great house) or *pataka* (storehouse).[20] There, Gauguin championed inversion, perversion and decadent exhaustion of all kinds. In *Avant et après* (1903), he wrote:

> The syphilitic and the alcoholic will perhaps be the men of the future. It looks to me as if morality, like the sciences and all the rest, is on its way toward a quite new morality which will perhaps be the opposite of that of today . . . Breeches morality, religious morality, patriotic morality, the morality of the soldier, of the gendarme . . . The duty of exercising one's function, the military code, Dreyfusard or non-Dreyfusard. The morality of Drumont, or Déroulède [two notorious nationalist demagogues]. The morality of public education, of the censorship. Aesthetic morality; the morality of criticism assuredly. The morality of the bench, etc. My miscellany will change nothing of this . . . it's a relief.[21]

At about this time too, Gauguin painted a number of canvases that depicted men in long hair and outlandish costumes. *Marquesan Man in a Red Cape* (1902) and *Bathers* (1902) are identically sized pictures that appear to represent the same standing model. In the first painting, the principal figure wears a thigh-length, belted blue tunic beneath a long red *tiputa* (poncho). His long hair is adorned with frangipani and he is accompanied by two women in conference at upper left wearing pink and white *ahus* (shawls) around their heads and shoulders. These women are examples of Gauguin's joined-at-the-hip gossipers, recalling *Breton Women with Cows* (1888), *Les Parau Parau* (*Words Words*, 1891), *Two Breton Women on the Road* (1894) and *The Call* (1902). The diminutive orange fox and blue-green bird at the lower right mimic the

[handwritten margin note: Gauguin's challenge to French society]

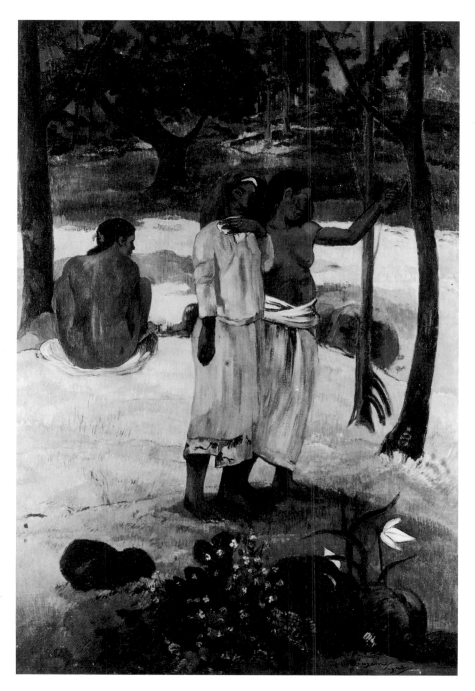

The Call 1902

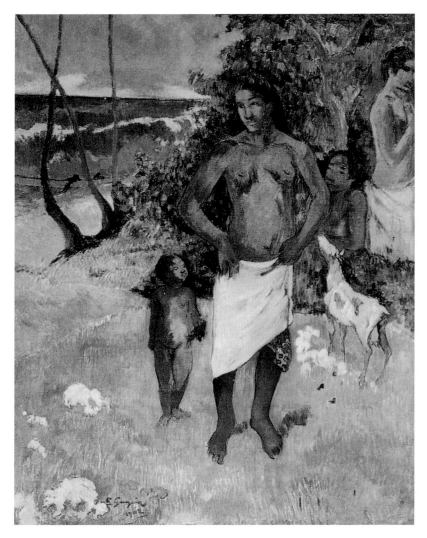

Bathers 1902

women's confidential glances. They too chatter about the flamboyantly costumed man standing near a stream in shady woodland.

Bathers shows a standing bather with long hair and the suggestion of breasts holding a man's *maro* (loincloth) before his thighs and genitals. Beneath the white cloth is a brilliantly patterned, orange and blue *pareu* peeking out at the bather's left knee. Like the *Marquesan Man*, the figure in *Bathers* is thus awkwardly attired. He too is accompanied by ancillary figures who gaze at the curious man, and by a strange

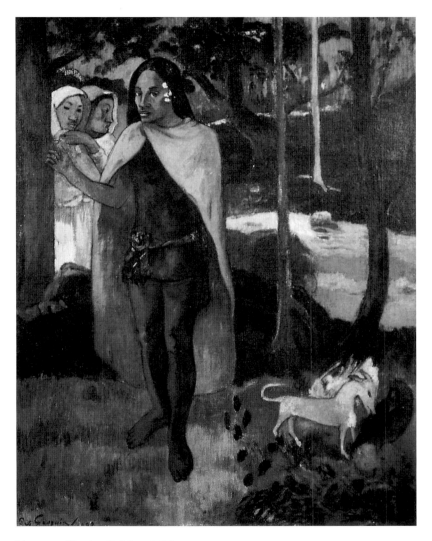

Marquesan Man in a Red Cape 1902

animal, a miniature white goat whose muzzle teases the bather's left forearm. The two paintings are pendants: One is cool and dark, the other warm and sunlit; one is painted with blocks of matt paint, the other with a flickering, almost Impressionist touch; one is mysterious, the other almost comic; one shows a clothed figure, the other a nearly naked figure; one suggests Breton woods, the other a Polynesian beach. The oppositions are crucial to the meaning of the pair; taken together they describe the composite nature of the Polynesian *mahu.* the Polynesian drag queen or gay

3 Third Sex

Mahus were first described in 1787 by James Morrison, a mutineer from HMS Bounty:

> [In Tahiti] they have a set of men called *Mahu*. These men are in some respects like the Eunuchs in India but are not castrated. They never cohabit with women, but live as they do. They pick their beards out and dress as women, dance and sing with them and are effeminate in their voice. They are generally excellent hands at making and painting cloth, making mats, and every other women's employment.[22]

Similar descriptions of Tahitian *mahus* are found in the diaries of William Bligh and John Turnbull from the last decade of the eighteenth century, and in the early nineteenth-century reports of the London Missionary Society.[23] Pictorial evidence, however, is scarce from this period until the twentieth century, though one possible exception should be noted. Between 1867 and 1870, Paul Emile Miot, a French naval officer on board the frigate *L'Astrée*, took a number of romantically posed photographs of Tahitian and Marquesan men and women. One of these, simply designated by the Musée de l'Homme *Two Men*, depicts a pair of shirtless, provocatively posed youths wearing floral wreaths. Their ostentatious and erotic self-presentation—and their large earrings—suggests that they may be *mahus*.

By the late nineteenth century, third sex figures were discussed only rarely and indirectly in accounts by travel writers, explorers, missionaries and colonial administrators. In 1871, for example, the engineer Jules Garnier provided a rough account of Tahitian gender liminality by conflating the two reigning stereotypes about Pacific peoples—their hypersexuality and their cannibalism. After describing the exquisite and complex toilet rituals of Tahitian women, he added: "But one thing shocks us, and that is to see men crowned with flowers in the manner of women . . . It is necessary to observe that Tahitian men are effeminate, and their sweetness appears to me more the sign of a degraded spirit than of a good soul; if they are no longer anthropophagous, it is only the fear of displeasing us that stops them, because one sees that they practice gratuitous cruelties far more odious than cannibalism itself."[24] The cruelty to which Garnier refers (to him it is literally unspeakable) can only have been sodomy. In the France of Garnier's day, as in Gauguin's Paris a decade or so later, there existed classes of pederastic men—generally described as

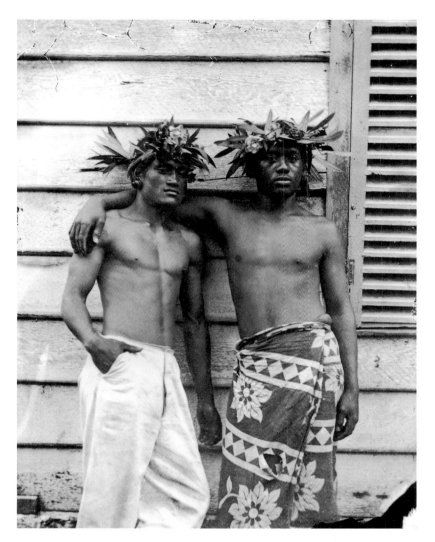

PAUL EMILE MIOT Two Men c. 1870

antiphysiques—who dressed as women and worked as male prostitutes; Garnier may have been describing what he assumed was their Polynesian equivalent.[25] Similar revilement, however, was apparently directed at all forms of Polynesian transvestism and gender liminality, and from the time of Garnier until the work of Ernest and Pearl Beaglehole in the 1930s, the ethnographic record concerning *mahus* is extremely meager.[26]

Mahus are today found in most Tahitian towns and villages, though a modern, Western-style gay subculture has also emerged. They generally have long hair, wear women's (or at least neutral gender) clothes and perform women's work, including weaving, quilting and other arts or crafts, light gardening, waiting at table and housework. One *mahu* with whom I developed a passing acquaintance during a three-week visit to Tahiti in 1995 worked in the central market of Papeete selling *pareus* and other dyed, painted or stitched textiles. Two other men, gaily festooned with *tiare*, *pareus*, tattoos and earrings made jewelry for sale at the annual Pirae craft festival. Others I encountered worked as hosts, waiters and bartenders at the posh Beachcomber Parkroyal Hotel. *Mahus* generally like to serve, rather than to be served: at a gathering of friends or family, the *mahu* typically gets up to clean spilled drinks, refill glasses, brush away flies, and clear away plates.

Mahus also often provide sexual services—especially fellatio (*'ote moa*)—for other males, particularly adolescents desiring quick and uncomplicated sexual pleasure. In most respects, however, *mahus* evade traditional functionalist categories; their appearance, activity and status cannot be fitted into a narrowly circumscribed social niche. Unlike Siberian Yakuts or Alaskan Inuits, they are not shamans, nor can their prevalence in Polynesia be said to constitute an "institution." They may have chosen their identities in childhood, or they may have been designated for the role by their parents; they may marry and father children in later life, or they may remain outside the system of social and biological reproduction for their whole lives; they often have sex with young men, but some have sex with women, older men, or have no sex at all; they may be morphologically "feminine" or they may be "masculine" in appearance though feminine in psychosocial identity; they are sometimes said to have become *mahus* because of having small penises, but are nevertheless also claimed to be unusually physically robust because of their regular ingestion of semen.[27]

In addition to *mahus*, it must be noted that in contemporary Tahiti, two other types of morphologically male, gender-liminal figures exist— *raeraes* and *pitaes*—and the three are not always easy to tell apart. *Raeraes* are transvestites who, like the *persilleuses* of nineteenth-century Paris, often work as prostitutes. They are visible every night in the side streets of downtown Papeete, especially along the Avenue Prince Hinoi, near the shabby hotel of the same name. In clubs and restaurants they may be seen arm in arm with young French sailors, and middle-aged bureaucrats and businessmen. (Despite their frequent recourse to theft, they—unlike the handful of female prostitutes—are

almost completely unmolested by the local police, who may well be their chief clientele.) *Raeraes* also participate as contestants and spectators in the annual transvestite competitions held at the Piano Bar and the Restaurant Waikiki. (More than fifty *mahus*, *raeraes* and *pitaes* showed up for the Grande Soirée de l'Election Miss Mode '95 on 15 July 1995 at the Waikiki.) *Pitaes*—whose name designates a kind of native bird—are apparently Western-style homosexuals. They are a comparatively rare species in contemporary Tahiti, however, and may be visible only in French or *popa'a* social spaces.[28]

Like their third sex counterparts elsewhere, such as the *berdaches* of the American Indian South-West, or the *hijras* of India, Polynesian *mahus* are at once esteemed members of their communities, and the butt of numerous jokes. Tahitian children may be affectionately chided for timidity by being called *mahu*, and Polynesian men may be described as *mahu*-ish if they display an unusual talent for craftwork or dancing, or if they take exceptional pleasure in chatting or gossiping with women. In Samoa, where third-sex people are known as *fa'afafine*, teasing has attained the level of an art form.[29] *Faipona* and *ula* are the names for styles of mockery employing puns, *double entendres* and simple vulgarities in contexts that involve *fa'afafine*. (*Pu* [hole], *mea* [thing] and *ufa* [asshole] are especially favored terms.) Similar ribaldry occurs among the *fakaleiti* of Tonga and the *pinapinaine* of Tuvalu.

In Tahiti too, sexual teasing and joking appear to be common in the company of *mahus*. Children, no less than women and men, learn to master the local billingsgate, and to make frequent and explicit reference to genitals, to masturbation and to supercision. (Reference to the latter putatively hygienic practice is implicit in some of the common derogatory terms for Frenchmen, one of which is *taioro* [smegma].)[30] At the Miss Mode '95 election, whole extended families—complete with infants, toddlers, adolescents and grandmothers—laughed, leered and pointed as one of the contestants unsuccessfully tried to hide the contour of his penis during the swimsuit competition. Another swimsuit contestant was wildly applauded for having managed to fashion a kind of vaginal cleft out of penis and scrotum, which had been tucked partially between his legs.

Vulgar laughter and teasing in this context is, to state the obvious, a form of entertainment, but it also has its social and political uses. *Mahus*, *raeraes*, *fa'afafines* and the like are comic, liminal figures who may be said to mediate, patrol or negotiate relations between different families, adjacent communities, and natives and foreigners. Young *raeraes*, as I indicated above, are frequently seen arm in arm with older,

foreign-born men or *popa'a*. They are also more peripatetic than even the average restless Polynesian, who regularly travels from one island to another in order to see relatives, exchange produce, or simply to enjoy a change of scene. One *raerae* I met at the bar of the Hotel Tahiti had traveled (in drag) from the islands of Wallis and Futuna and intended to touch all the islands of French Polynesia before deciding where to settle down and pursue the career of travel agent. (At the moment he/she was selling fine jewelry in a tourist shop across the road.) I knew him/her only as Chérie, and was impressed when the woman bartender fed him/her successive tumblers of complimentary whisky neat (shots were about ten dollars each), and insisted that he/she promise to return the next night. Chérie must have been thought to bring good luck, for despite his/her bad complexion, soiled string-shouldered dress and *pareu*, and obvious inebriation, every single one of the locals who entered the bar between 6:15 and 10:00 P.M.—perhaps twenty customers in all—made a point of entering into conversation with him/her. Chérie was also a frequent visitor to Faa'a International Airport, where he/she enjoyed greeting arriving and departing tourists.

By stimulating laughter and permitting themselves to be the butt of jokes, *mahus* and their ilk facilitate the development of complementary "respect relationships," as Radcliffe-Brown called them, within close-knit kin-groups and communities.[31] "Raucous laughter is best shared among kin" appears to be the guiding principle in Tahiti, and it is thus neither boredom nor perversity (though these have their roles) that encourages whole families to attend the annual Miss Mode competitions. To revamp the old saw, the family that laughs at sexually liminal outsiders together stays together. Indeed, to a surprising extent—and undoubtedly for a multitude of reasons beyond vulgar laughter at *mahus*—Tahitians have successfully maintained many of the traditional corporate structures of kinship and, to an equally great degree, have resisted French efforts to impose a system of individual land tenure.[32]

Mahus, as I stated earlier, do not constitute an indigenous "institution"; there are no hard and fast rules of comportment, behavior or function, and there can be little doubt that the forms and patterns of Tahitian sexual identity and behavior have changed over time. In fact, the protean nature of Polynesian gender liminality reveals that it is nothing less than a counter-example—one of thousands large and small—of the contemporary conservation of the primitive in the midst of the modern. The *mahu* is an ancient, traditional role, but its particular shape and content changes according to historical circumstance. The ritual castigation of Gauguin as a *taata vahine* in 1891 suggests,

indeed, that the improvisatory ingeniousness of Tahitian culture was fully operational during the *fin de siècle*. Far from genuflecting before white man and genius artist, the women and children in Papeete harbor were armed with sharply pointed verbal spars directed precisely where they knew they would do the most damage; we can only speculate about the teasing Gauguin received when he emerged in public, several weeks after his arrival, with newly shorn hair![33]

Even a decade later on the remote Marquesas, Gauguin was sexually teased and mocked. In *Racontars de Rapin*, written in 1902 less than a year before his death, Gauguin described his encounter with a blind and withered old woman, called, according to the anthropologist Robert Suggs, a *vahine hae*:[34]

> Then, without uttering a word, she examined me with her hand. I felt it first on my face, then on my body (I myself was also naked except for a *pareu* around my waist), a cold, dust-covered hand—with that coldness associated with reptiles. A terrifying feeling of disgust. When it reached the navel the hand parted the skirt and carefully squeezed the male member. "Pupa," (*popa'a*) she exclaimed with a grumble, then went off, always in the same posture, towards the bush in the opposite direction.[35]

Gauguin proceeded to explain that "when they reach adulthood, the male natives undergo, by way of circumcision, an actual mutilation which leaves a scar in the form of an enormous rim of flesh, enhancing the moments of pleasure . . . This vision obsessed me for two months and all the work I did before my easel was impregnated with it in spite of myself." *Primitive Tales* (1902) may be one of those obsessive works to which the artist refers. The figure at the left of the painting, reprised from *Still Life: Portrait of Jacob Meyer de Haan* (1889), is hunchbacked and grotesque, his hand is gnarled and grasping, and his eyes are fixed in a reptilian stare. He is at once the Dutch-born Jewish artist and friend of Gauguin, and the ugly old woman. At the center of the picture are two young women, one facing front and seated in the lotus posture of Buddha, and the other in profile with legs tucked beneath her. The latter figure, probably Tohotaua, wife of the prominent local healer Haapuani, has cascading red hair—bleached with lime extracted from coral rocks—indicating high social status and sexual availability.[36] Indeed, Gauguin is reported to have been on intimate terms with Tohotaua and may thus have been reminded by her of his own "deformity": his (presumably) uncircumcised penis would have been judged gruesome by native standards.[37]

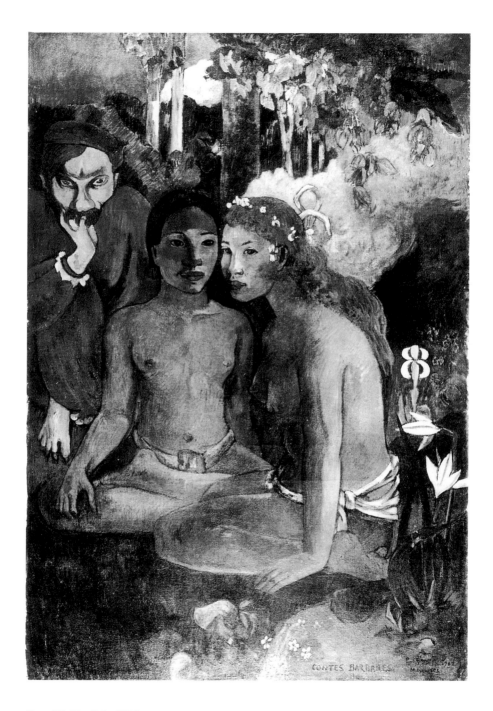

Above **Primitive Tales 1902**
Opposite **Still Life: Portrait of Jacob Meyer de Haan 1889**

Gauguin's anecdote and *Primitive Tales* appear to lack the humor that would be implicit in any actual mocking encounter between a white colonial and an old Marquesan. When the naked and hunchbacked woman grabbed Gauguin's uncircumcised penis, she was mocking him as she would have a cousin, an in-law or a *mahu*. She was in fact engaging him as a Maohi, even as she spat out the word *popa'a*. She may have been saying to him, in effect, "White boy, I know you, you may fuck my niece!" Gauguin apparently did not get the joke.

From the moment he stepped off the boat, in other words, Paul Gauguin's colonial prestige was under assault and his sexuality was in question. Dressed in 1891 like the cowboys he had seen the year before in Paris at Buffalo Bill's Wild West Show, Gauguin was immediately the recipient of an onslaught of vulgar jeering ("*Taioro!*") by the assembled women and children. His rapid expulsion from what passed for high society in Tahiti, and his subsequent failure to secure for himself a stable position within a native community left him culturally adrift and

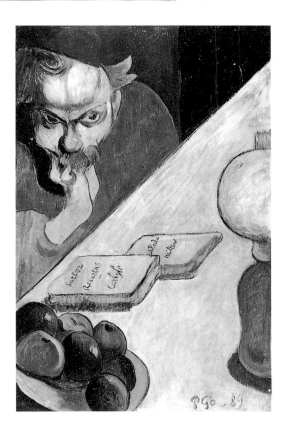

subject to mockery from all sides. Moreover, as a foreigner with evident *mahu*-ish tendencies (craftwork was generally considered feminine) Gauguin would probably have found more companionship among women, children and adolescents than among adult men. When he painted women ironing and weaving in *The Siesta* (1891–92) and *Tahitian Women* (1891), and children seated behind a table in *The Meal or The Bananas* (1891), he was probably painting the only indigenous world to which he had any intimate access. Tahitian women and children chat and gossip for the most part with other women and with *mahus*—not with men; Gauguin's very sexual indeterminacy or inadequacy may thus have permitted him a form of cultural intercourse—and therefore also a chance for rich and compelling artistic engagement— that few male colonials were ever granted. Additional clues to the nature of this intercourse are found in *Noa Noa, Mana'o tupapa'u* and *Where Do We Come From?*

The Siesta 1891–92

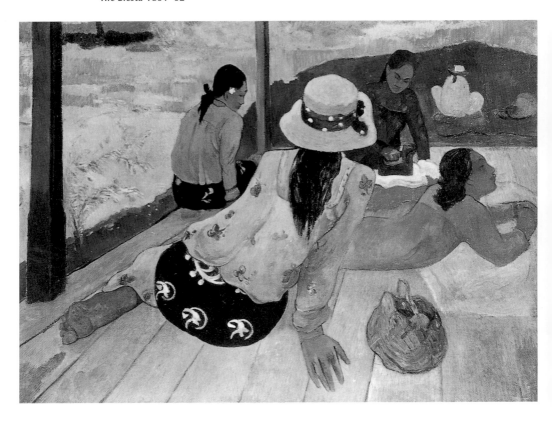

4 Androgynous Identities

Paul Gauguin self-consciously confronted the conflict between
Polynesian and European sexualities in a remarkable and often cited
anecdote from *Noa Noa*. The tale is complex, ambitious, in places
funny, and worth citing at length. Gauguin begins the story by
describing his friendship with a young man who frequently came to
watch him work:

> One day when, handing him my tools, I asked him to try a sculp-
> ture, he gazed at me in amazement and said to me simply, with
> sincerity, that I was not like other men; and he was perhaps the
> first of my fellows to tell me that I was useful to others. A child . . .
> One has to be, to think that an artist is something useful.

At the outset of an account that he knows will quickly become erot-
icized, Gauguin notes the significance of craft labor, age, rank and
social status in the relationship of a young Tahitian male and an older
French artist and colonist. Gauguin then quickly introduces the matter
of sex:

> The young man was faultlessly handsome, and we were great
> friends. Sometimes in the evening, when I was resting from my
> day's work, he would ask me the questions of a young savage who
> wants to know a lot of things about love in Europe, questions
> which often embarrassed me.

Gauguin describes here a sort of mini-symposium, with himself as the
erastes—the older lover who is the source of sexual instruction and
philosophical wisdom. As the tale unfolds, however, Gauguin finds it
expedient to surrender his position of authority. The sexual inter-
rogation puts the artist somewhat on the defensive, and his ignorance of
native flora provides him with the chance for an even fuller surrender.
He accepts the younger man's offer to guide him into the forbidding
tropical forests in order to find a particular wood suitable for carving.
Only a native, Gauguin reasons—a savage even—would have the devel-
oped senses requisite for finding the way though the dark and dense
thickets of the Tahitian highlands:

> We left in the early morning.
> The Indian paths in Tahiti are quite difficult for a European:
> between two unscalable mountains there is a cleft where the water
> purifies itself by twisting between detached boulders, rolling them

down, leaving them at rest, then catching them up again in a torrent to be rolled down further, and so on to the sea. On either side of the stream there cascades a semblance of a path: trees pell-mell, monster ferns, all sorts of vegetation growing wilder, more and more impenetrable as you climb towards the center of the island.

Pape moe (Mysterious Water) 1893

The deeper the two penetrated into the forests it seems, the further behind were left the old sexual hierarchies of Europe, and the closer beckoned an indigenous zone of polymorphous sexuality. Now Gauguin cuts to the chase:

> We went naked, both of us, except for the loincloth, and axe in hand, crossing the river many a time to take advantage of a bit of track which my companion seemed to smell out, so little visible, so deeply shaded.—Complete silence,—only the noise of water crying against rock, monotonous as the silence. And two we certainly were, two friends, he a quite young man and I almost an old man in body and soul, in civilized vices: in lost illusions. His lithe animal body had graceful contours, he walked in front of me sexless . . .

Next to this passage in the draft manuscript of *Noa Noa* (1893), Gauguin drew a box and inserted the following commentary:

> 1 The androgynous side of the savage, the little difference
> between the sexes in animals.
> 2 The purity entailed by seeing nakedness and by the easy
> commerce between the sexes.
> The lack of knowledge of vice among the savages.
> The desire to be for a moment weak, woman.

These remarks are not an afterthought, but a considered, quasi-anthropological gloss upon the adjacent text, which now assumes the form of an allegory concerning clothes, virtue and vice, European sexual dimorphism and savage androgyny. In the revised version of *Noa Noa* (Louvre Manuscript, 1893–97), composed with the assistance of Charles Morice, Gauguin expanded upon his marginal gloss, and offered a brief feminist tract on the subject of costume and sexual difference.

Sexual dimorphism, Gauguin argues in the revised *Noa Noa*, is not natural but cultural; it is the product of modern fashion, subsequently aided by the heredity of acquired characteristics:

> Among peoples that go naked, as among animals, the difference between the sexes is less accentuated than in our climates. Thanks to our cinctures and corsets we have succeeded in making an artificial being out of woman. She is an anomaly, and Nature herself, obedient to the laws of heredity, aids us in complicating and enervating her. We carefully keep her in a state of nervous weakness and muscular inferiority, and in guarding her from fatigue, we take away from her possibilities of development. Thus [she is] modeled

on a bizarre ideal of slenderness to which, strangely enough, our women have nothing in common with us, and this, perhaps, may not be without grave moral and social disadvantages.

Gauguin continues his explication of sexual difference in the revised *Noa Noa* by arguing, again in the manner of Lamarck, that lack of clothes, common exposure to the elements and the absence of a strict division of labor by gender in Tahiti produces androgynous bodies, and social egalitarianism as well:

> On Tahiti the breezes from forest and sea strengthen the lungs, they broaden the shoulders and hips. Neither men nor women are sheltered from the rays of the sun nor the pebbles of the sea-shore. Together they engage in the same tasks with the same activity or the same indolence. There is something virile in the women and feminine in the men . . . Man and woman are comrades, friends rather than lovers, dwelling together almost without cease, in pain as in pleasure, and even the very idea of vice is unknown to them.[38]

Gauguin's views on women and sexuality in these pages are unusually progressive, emphasizing—in the manner of Mary Wollstonecraft or Flora Tristan—the robust physical and erotic capacities of women and their equally great intellectual and moral resources. They mark a kind of pagan progression from his earlier views, contained for example in a letter to Madeleine Bernard from 1888, which emphasized the value of Christian asceticism and self-sacrifice for the achievement of women's and men's personal freedom:

> If . . . you want to be someone, to find happiness solely in your independence and your conscience . . . you must regard yourself as Androgyne, without sex. By that I mean that heart and soul, in short all that is divine, must not be the slave of matter, that is, of the body. The virtues of a woman are exactly the same as the virtues of a man and are the Christian virtues—duties towards one's fellows based on kindness, and always sacrifice, with conscience only for judge . . . Do in a proud spirit all that would help you to win the right to be proud, and do your best to earn your own living, which is the pathway to the right. But crush all vanity, which is the hallmark of mediocrity, and above all, the vanity of money.[39]

Gauguin then proceeded to suggest to Emile Bernard's sixteen-year-old sister that once she achieved spiritual independence, she could ask for

support from others. "Mutual service" was the phrase Gauguin used to describe this assistance, recalling the "mutualism" celebrated by the followers of the anarchist P. J. Proudhon.

In the South Seas, Gauguin jettisoned all talk of Christian virtue in discussions of men's and women's rights and responsibilities. At times in fact, he lapsed into mere libertinism. Gauguin's posture in *Noa Noa* is often significantly less admirable than the passages cited earlier might suggest. He repeatedly compares women to wild animals, for example, and in the revised text offers the following disturbing insight into women's sexual psychology: "All, indeed, wish to be 'taken,' brutally taken [*mau*, to seize] without a single word. All have the secret desire for violence, because this act of authority on the part of the male leaves to the woman-will its full share of irresponsibility."[40]

Gauguin's writings on the subject of women thus comprise an odd and contradictory record of feminism and masculinism. In his later texts—especially those compiled on the Marquesas—he was more consistently radical in his thinking about "the woman question," and more convinced than before of the oppressiveness of existing French law and custom. In the manuscript entitled "Modern Thought and Catholicism," from 1902 and intended for publication, he summarized his thoughts about the need to grant sexual rights to women, and to eliminate the double standard. Undoubtedly influenced by his observation of adoption and fostering practices in Polynesia, he also rejected Proudhonian notions concerning the sanctity of the nuclear family:

> If . . . this institution, marriage, which is nothing other than a sale, is the only one declared to be moral and acceptable for the copulation of the sexes, it follows that all who do not want or who cannot marry are excluded from this morality . . . Treated this way, woman becomes abject; she is doomed either to get married if fortune permits or to remain a virgin, which is such an unnatural condition, so monstrously indecent and unhealthy . . .
>
> If ever a society was barbaric and cruel, it is certainly today's society that, supposedly acting in the name of Christian morality, thus decides a woman's fate and thereby causes so much suffering . . .
>
> We state that any woman, who after all is our mother, our daughter and our sister, has the right to love whomever she pleases. She has the right to dispose of her body and her beauty. She has the right to give birth to a child and to bring him up herself . . . and she has the right to be respected just as much as any woman who sells herself only in wedlock (as commanded by the church). She

consequently also has the right to spit in the face of anyone who oppresses her.[41]

Gauguin's remarks also bear the imprint of his maternal grandmother, the great French socialist and feminist Flora Tristan, who was much in the artist's thoughts at the end of his life. In her *London Journal*, Tristan writes:

Yes, if you had not made of chastity a virtue and required it of women but not of men, women would not be spurned by society for having yielded to their hearts, and young girls who have been seduced, deceived and abandoned would not be reduced to prostitution. Yes, if you permitted women to receive the same education, to practice the same trades and professions as men, poverty would be their lot no more frequently than for men. Indeed, if you did not force women to submit to the abuses of paternal despotism and the indissolubility of marriage, they would not be confronted with the only alternative: to submit to oppression and infamy![42]

In Gauguin's original text of *Noa Noa*, the long feminist gloss on the subject of clothes and androgyny is absent, and the tale of the trek into the forest continues with a description of deep shades, the noise of rocks and cascading waters, and a "presentiment of crime":

From all this youth, from this perfect harmony with the nature which surrounded us, there emanated a beauty, a fragrance (*noa noa*) that enchanted my artist's soul. From this friendship so well-cemented by the mutual attraction between simple and composite, love took power to blossom in me.
And we were only . . . the two of us—I had a sort of presentiment of crime, the desire for the unknown, the awakening of evil—Then weariness of the male role, having always to be strong, protective; shoulders that are a heavy load. To be for a minute the weak being who loves and obeys. I drew close, without fear of laws, my temples throbbing.
The path had come to an end . . . we had to cross the river; my companion turned at that moment, so that his chest was towards me. The androgyne had vanished; it was a young man after all; his innocent eyes resembled the limpidity of the water. Calm suddenly came back into my soul, and this time I enjoyed the coolness of the stream deliciously, plunging into it with delight—"*Toe toe.*" he said to me, ("It's cold").

Gauguin's mythic tale of temptation and transformation sheds light on gender liminality in *fin de siècle* Tahiti, and on the complex question of the interaction of European and Oceanic sexualities. In the three paragraphs cited above, Gauguin first claims to possess a "composite" as opposed to a "simple" sex; he is like the androgyne described by Aristophanes in Plato's *Symposium* who is an offspring of the moon and possesses both male and female sexual organs. Then he imagines himself to be a woman ("to be for a minute the weak being, who loves and obeys"), and the adolescent to be an androgyne. Finally, the young androgyne is transformed back into a young man and the artist cools his ardor and concludes his vision by a ritual plunge into cleansing waters. Gauguin's anecdote may thus be glossed as follows: An adolescent Tahitian male seeking sexual knowledge from an exogenous *mahu* is himself perceived to be an androgyne who, by virtue of that very status, exposes the degraded nature of the other's sexual identity. However, as we have seen in subsequent editions of *Noa Noa*, the story is treated as an opportunity to expound upon the relation between sex and gender, and between European dimorphism and oppression and Tahitian androgyny and egalitarianism.

The episode has its comic as well as its philosophical aspects, and it also exposes something of the mutability of sexual identity in colonial Polynesia, and the contingency, or context-specific nature of prestige. A *mahu* who is mercilessly mocked in one context can be fully embraced and respected in another; a Frenchman who is teased and travestied in Papeete may gain a measure of respect when he exercises his feminine, artistic abilities in a small town some distance from the colonial center. The young man's high regard for the artist's profession ("he was perhaps the first of my fellows to tell me that I was useful to others," Gauguin writes) is consistent with the respect generally bestowed on gender-liminal persons when they are engaged in work for which they are traditionally suited, such as weaving mats, quilting, or painting barkcloth. The complex interplay of sexual identity and social prestige, exclusion and belonging, and vulnerability and power, is manifested in some of Gauguin's best paintings from his Tahitian period.

5 Sacred and Profane

Mana'o tupapa'u (*The Specter Watches Over Her*) depicts Teha'amana, the artist tells us, lying on her stomach on a bed, facing the spectator.[43] She reclines on yellow-white sheets, shaded with blue and violet, on

a mattress covered by a bedspread printed in blue with yellow fruit and flowers. The background is violet, pink, orange and blue, illumined with white and green sparks or light-bursts. Above and to the left stands a figure in profile—apparently an older woman—dressed in a black robe and cowl.

Gauguin provided an account of the genesis of *Mana'o tupapa'u* in the revised edition of his autobiographical novel *Noa Noa*:

> One day I was obliged to go to Papeete. I had promised to return that evening, but . . . I didn't get home till one o'clock in the morning . . . When I opened the door . . . I saw [Teha'amana] . . . motionless, naked, belly down on the bed; she stared up at me, her eyes wide with fear, and she seemed not to know who I was. For a moment, I too felt a strange uncertainty. Her dread was contagious: it seemed to me that a phosphorescent light poured from her staring eyes. I had never seen her so lovely; above all, I had never seen her beauty so moving. And, in the half-shadow, which no doubt seethed with dangerous apparitions and ambiguous shapes, I feared to make the slightest movement, in case the child should be terrified out of her mind . . . Perhaps she took me, with my anguished face, for one of those legendary demons or specters, the *tupapa'us* that filled the sleepless nights of her people.

The picture and the artist's written account of it appear to be a veritable encyclopaedia of colonialist racism and misogyny. That the young native woman is "terrified out of her mind" by "specters," suggests that she is ruled by emotion and mysticism and is incapable of disinterestedness and intellectualism, a characterization consistent with both scholarly and popular nineteenth-century stereotypes of Tahitian people. For example, in Herbert Spencer's *Descriptive Sociology* of 1874, Tahitians are described as possessed of: "volatile disposition and fugitive habits; cheerful, good natured, fond of jesting and humor; emotions apparently not so acute as ours; violent and merciless."[44] "The Tahitians are veritable children," Henri le Chartier wrote, "[and of a marked] fickleness . . . But the principal trait of their character is superstition: the solitude of the forest, the darkness of the night and especially spirits—*tupapa'us*—frighten them."[45] Moreover, Gauguin's association of the young woman's dread with his own rekindled desire affirms the misogynist canard that women long "to be 'taken,' brutally," as Gauguin wrote in *Noa Noa*.

Mana'o tupapa'u in short is a notoriously indecent painting that has invited the wrath of critics from its own day until now. It is a painting

which upholds colonial male prerogatives, yet it is equally, I suggest, a hybrid artwork which undercuts the dimorphic paradigm of sexuality upon which European masculinism depends. The posture and anatomy of Teha'amana, which emphasizes her boyishness, is derived from various androgynous and hermaphroditic prototypes, including the famous Louvre (formerly Borghese) *Hermaphrodite*. The antique marble was quite celebrated in the eighteenth and nineteenth centuries, and was the subject of Lady Townsend's famous quip, reported by Horace Walpole, that it represented "the only happy couple she ever saw."[46] Since Gauguin's day, the uncanny marble mattress beneath the figure, possibly by Gianlorenzo Bernini, has been equally admired.

Like the *Hermaphrodite*, the nude in *Mana'o tupapa'u* reclines on a mattress, crosses her legs and exposes her face and buttocks to the viewer. Moreover, both figures face right, an unusual orientation for nudes in the history of art, repeated later by Gauguin in his *Nevermore* of 1897. No less than Manet's *Olympia*, which Gauguin copied and admired above any other painting, *Mana'o tupapa'u* was probably intended as an assault upon the tradition of the European female nude. Teha'amana is *taata vahine*, or as Lady Townsend would have it, a "happy couple," sufficient unto themselves. Like Olympia, she both hides and reveals the phallus: It was Olympia's achievement, T. J. Clark has argued, to show that desire could be located in a woman's naked body—that in contravention of the masculine myth of the day, a flexed hand resting on naked pudenda might actually hide a desire as real and palpable as any man's.[47] Teha'amana possessed such a desire—local legend has it that she cuckolded the artist with great regularity—and Gauguin revealed her sexual autonomy even as he painted her in the guise of a frightened girl.[48]

"There is something virile in the [Tahitian] women," Gauguin wrote in *Noa Noa*, "and [something] feminine in the men." The young woman in *Mana'o tupapa'u*—like Gauguin himself—is *mahu*-ish; she is an "androgynous little girl" wrote the artist's friend and literary collaborator Charles Morice, an ideal union of the sexes recalling Théodore in Théophile Gautier's *Mademoiselle de Maupin*, Jean Valjean in Hugo's *Les Misérables*, and most of all Seraphita/Seraphitus in Balzac's novel *Seraphita*.[49] "In truth, neither sex is really mine," says Gautier's Théodore, "I belong to a third sex, a sex apart, which has as yet no name."[50] Jean Valjean too, whom Gauguin claimed for his *alter ego* in the self-portrait *Les Misérables* (1888), was a sexual hybrid inhabiting a liminal landscape. He was at once a father and a mother, and dwelled in the *constructions hybrides* of Paris—suburb, convent and sewer.[51]

"The soul of my mother," Cosette says in *Les Misérables*, "has passed into that man." He is "pregnant," a "grandmother" and, like the landscapes in which he makes his home, a "bit bastardized . . . composed of two natures," an "amphibian."[52] Gauguin embraced Balzac's amphibious and androgynous character, and represented himself in the self-portrait above "like Jean Valjean with his nobility and his sweet interior . . . [with the] background of the young girl with its childish flowers . . . "

Equally apposite to Gauguin's Teha'amana, however, is Balzac's beautiful young androgyne Seraphita/Seraphitus, briefly mentioned by Gauguin in his 1892 *Cahier pour Aline* alongside an extended discussion of *Mana'o tupapa'u*.[53] Gauguin's very introduction of Teha'amana in *Noa Noa*, "I had never seen her so lovely; above all, I had never seen her beauty so moving," was a paraphrase of a line spoken by Balzac's female character Mina about Seraphitus:

> "Never, never have I seen you so beautiful!" cried Minna, sitting down on a mossy rock and losing herself in contemplation of the being who had now guided her to a part of the peak hitherto supposed to be inaccessible. Never, in truth had Seraphitus shone with such brilliancy, or had her single expression animated every aspect of her face and her personality.[54]

Both Seraphita and Teha'amana are represented by their authors as illumined by unnatural light and both are considered vessels of the divine. Seraphita possesses a "look of gold," Balzac writes, "that rivalled the rays of the sun . . . she/he seemed not to receive but to give off light." "Sometimes at night," Gauguin writes, "flashes of light . . . played off Teha'amana's golden skin . . . Conversations about what happens in Europe, about God, about the Gods. She learns from me, I learn from her."[55] Seraphita and Teha'amana each offered their lovers a vision of the ideal: the one cracked the glass of the quotidian to expose Heaven and the Holy Spirit; the other undermined the stability of everyday sight (*noa*) and revealed the spiritual world of the dead (*mo'a*) that exists alongside the real and the living.

Gauguin's depiction of the androgyne Teha'amana—a sexually composite being who offers a vision of truth and the afterlife—is thus appropriately woven together in *Mana'o tupapa'u* with a representation of the spirit of the dead; each indicates the presence of the other. The sexual self-sufficiency of Teha'amana is matched by a spiritual completeness. She is shown within a Polynesian metaphysical and ontological nexus—signalled by the presence of the dark, older woman at the upper left and the strange light-bursts—from which the painter

and the rest of the *popa'a* audience is excluded. The old woman–
recalling the Afro-Caribbean Laura in *Olympia*–is a spirit of death,
"one of those legendary demons and specters," Gauguin writes, "the
tupapa'us that filled the sleepless nights of her people." She will be
repeated, with variations, in *Parau na te varua ino* (*Words of the Devil*,
1892), *Parahu hanohano* (*Frightening Talk*, 1892), *Te po* (*The Night*,
a woodcut, 1893–94) and *Te tamari no atua* (*The Child of God*, 1896).
In the latter painting, as Jehanne Teilhet-Fiske has shown, the seated
tupapa'u figure, shown facing an elaborately carved Marquesan house-
post, wears a dark shroud or cowl over her head and shoulders. She is
accompanied by a standing angel and cradles a new-born baby who
wears a halo. The infant is thus fated for early death like Gauguin's own
child by Pahura. In the foreground, a young woman sleeps after her
labor; she is bathed in light, while the *tupapa'u* with the child faces
away from light, and is directed toward a realm of darkness and death.

Te tamari no atua (The Child of God) 1896

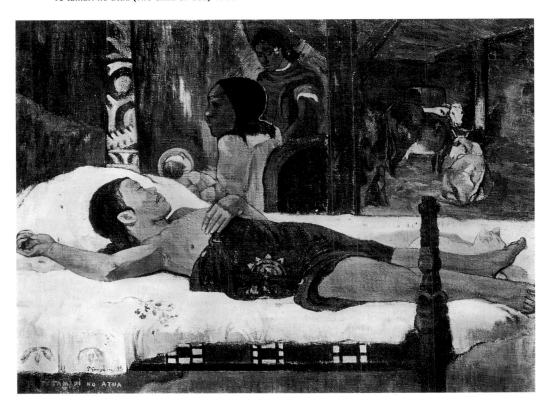

Gauguin's representation of Teha'amana in *Mana'o tupapa'u* is thus not wholly a mirror of Balzac's androgyne; it is a hybrid image, at once French and Polynesian. Gauguin appears to have recognized that spirits—also known as *mo'as* or *atuas*—played a crucial role in traditional Tahitian culture and religion. Indeed, spirits such as the *tupapa'u* form one half of what the anthropologist Douglas Oliver calls the basic "conceptual antithesis" of Polynesian culture, the other half of which is *noa*, meaning secular, worldly, human or non-sacred (non-*tapu*).

Another way of describing this cultural counterpoint is to say that a basic division exists between the realm of life, humans and light, *ao*, and the space of death, spirits, gods, demons, ghosts and night-time, or *po*. Yet to speak of a division here is not exactly right, for *ao* and *po* are really more like mirrored or reversible worlds that are also mutually imbricated. Living and dead live side by side in basic harmony, with each having the ability to make forays into the other's domain. Ghosts or spirits of the dead—*tupapa'u*—are routinely encountered in dreams, cemeteries or wild places, though they may also take on the form of animals and people that one sees in daily life. Healers or sorcerers, by the same token, known as *tahu'a*, are said to have the ability to cross over and communicate with spirits, and to cure illnesses caused by malevolent *tupapa'us*.

Roti Make is a healer in regular contact with spirits. "My grandfather gave me his *mana* when he died," she told me during my visit to her family home on squatted land outside Papeete, "and I use it to help me find plants and herbs for healing." Roti's calling was first revealed to her as a young girl when she stood at the bedside of her dying grandfather. Many years later, he appeared to Roti as a spirit or *tupapa'u* in a dream, and explained the magic healing power of various plants and herbs.

Roti is now a herb doctor (*tahu'a ra'au*) who combines elements of ancient Polynesian and New Age practice and has great faith in the healing power of her medicine. Whenever she exercises her skill, the knowledge of both "living" *tupapa'u* and of her long dead grandfather enters her mind and heart.[56] Thus neither matter nor spirit has the more secure ontological status among the Maohi of Tahiti, and neither may be described—as in Christian or Jewish mysticism—as occupying foreground or background, surface or depth, or upper or lower worlds. "The metaphysics," Marshall Sahlins writes in summary, "is just the opposite of Western distinctions of God, man, and nature, each occupying a separate kingdom of being."[57]

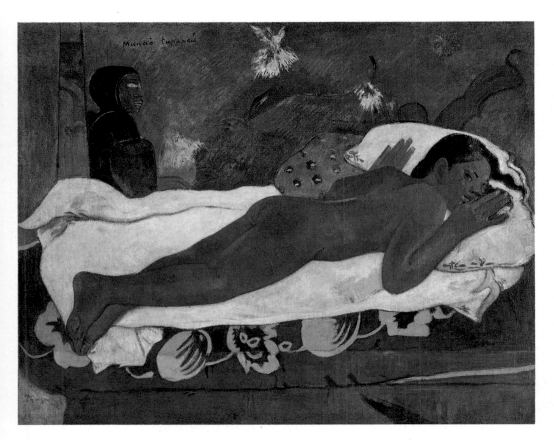

V Mana'o tupapa'u (The Specter Watches Over Her) 1892

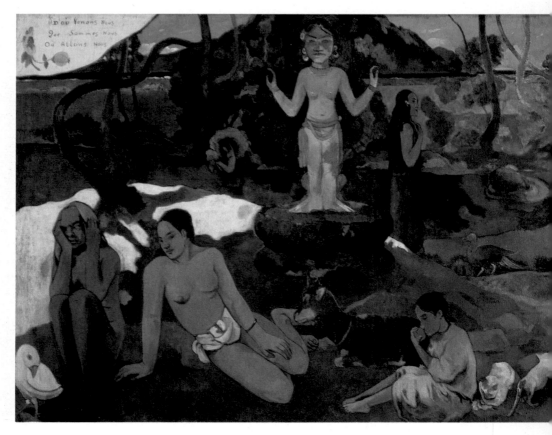

VI Where Do We Come From? What Are We? Where Are We Going? 1897–98

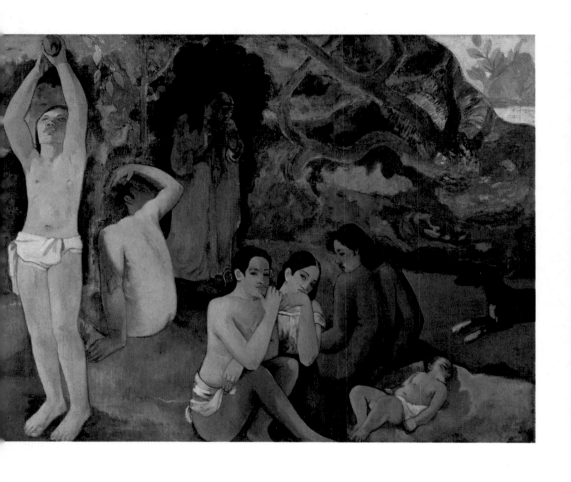

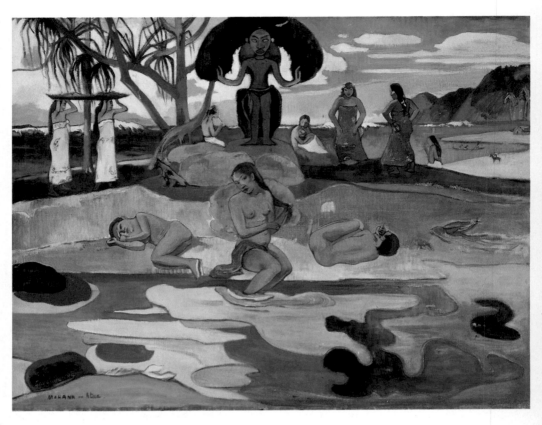

VII Mahana no atua (Day of the God) 1894

The dialectical relationship described here is temporal as well as spatial. Though spirits of the dead exist in the present, they also represent the past; they are the remembered souls of long dead ancestors, or of recently deceased friends; they may represent lineages and clans from olden times (*te matamua*) or even the offended spirits of ancient stone gods (*tiki*). This Tahitian belief system thus shares many features with the Hawaiian cult of ancestors (*kupuna*; in Tahitian *tupuna*). According to the Hawaiian ontology, the great gods (*akua*) of the past are the specific ancestors of living persons, and may yet return in the future.[58] History is a humanized terrain that lies constantly before, not behind one's field of vision; the past grows increasingly proximate, not more remote, during one's passage through life.[59]

In his essay of 1892 entitled "Genesis of a Painting,"[60] and in *Mana'o tupapa'u* itself, Gauguin reveals his general assimilation of this basic Polynesian sacred and profane dialectic into his own Symbolist thoughts and creative procedures.

According to Tahitian beliefs, the title *Mana'o tupapa'u* has a double meaning . . . either she thinks of the ghost or the ghost thinks of her. To recapitulate: musical part—undulating horizontal lines—harmonies in orange and blue linked by yellows and violets, from which they derive. The light and greenish sparks. Literary part—the spirit of a living girl linked with the spirit of death. Night and day. This aforementioned genesis is written for those who always have to know the whys and wherefores. Otherwise the picture is simply a study of a Polynesian nude.

Gauguin's explication is at once French and Polynesian. His discussion of the correspondence of music, color and spirit might have been inspired by Baudelaire or especially Balzac, whose character Becker in *Seraphita* says, in admiration of Emanuel Swedenborg:

Many noble souls will not admit his spiritual worlds where colors are heard in delightful concert, where language flames and flashes, where the Word is writ in pointed spiral letters . . . To know the Correspondences which exist between the things visible and ponderable in the terrestrial world and the things invisible and imponderable in the spiritual world is to hold heaven within our comprehension. All the objects of the manifold creations having emanated from God necessarily enfold a hidden meaning; according indeed, to the grand thought of Isaiah, "the earth is a garment."[61]

For French Symbolists and Gauguin, the relation of matter and spirit, visible and invisible, and finite and infinite was highly charged with emotion. At one moment the duality was irreconcilable; it represented, as Becker says, "two worlds unknown to each other."[62] At others, however, the contiguity between the two realms seemed so great that an ultimate identity might be proposed. "However abstract," Seraphita states, "man may suppose the relation which binds two things together, the line of juncture is perceptible." The artist's task is to explore the boundary and to achieve an art that obviates its own crude facticity and materiality. "Thus your visible moral universe," the androgyne argues, "and your visible physical universe are one and the same matter."

Mana'o tupapa'u had special salience for Gauguin precisely because it represented his dreamed-of Tahitian reconciliation of matter and spirit; it was the pictorial manifestation of his Synthetism and primitivism. Like the Polynesian *mo'a/noa*, or *ao/po*, or the *mahu* itself, it is constructed out of dualisms that in fact imply the existence of a liminal third term. "My share of the fish cooked," Gauguin writes in anticipation of Lévi-Strauss, "hers raw . . . Countless questions." Gauguin too was a mythographer who sought to understand the mediating third term that existed between a series of binaries: the young and desirable woman and the old and ghostly specter, the erotic and the spiritual, day and night, life and death, musical and literary, abstract and representational, orange and blue, yellow and violet. The final coloristic binaries (two of the three essential complementarities exploited by modernist artists in the last third of the nineteenth century) reveal that Gauguin was seeking to adapt his own European conception of form to the abstract dialectic of Polynesian spirituality.

In picture after picture, including *Fatata te miti* (*Near the Sea*, 1892), *Arearea no varua ino* (*The Amusement of the Evil Spirit*, 1892), and *Aha oe feii?* (*What! Are You Jealous?*, 1892), Gauguin placed jigsaw puzzle shapes of complementary and adjacent hues side by side in order to invoke coloristic third terms, zones of mediation that are phantasmagoric reflections of the surrounding material world. These passages occur especially in depictions of the surface of water, the liminal zones basic to Polynesian life. In *Mahana no atua* (*Day of the God*, 1894), Gauguin has juxtaposed and reconciled in a single narrative space several religious and pictorial traditions. In the upper third of the painting, women, men, and children are naturalistically depicted beneath an azure sky streaked with white clouds. Behind them are a line of breaking waves, yellow sand and a distant village with houses, a horseman and boaters. In the middle of this zone stands the monumental

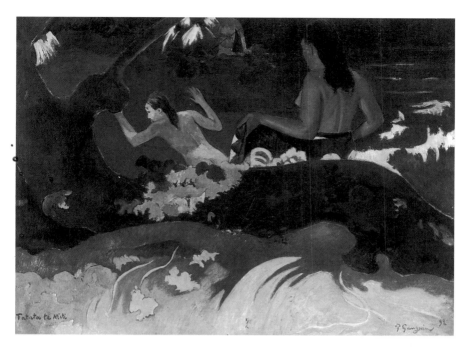

Fatata te miti (Near the Sea) 1892

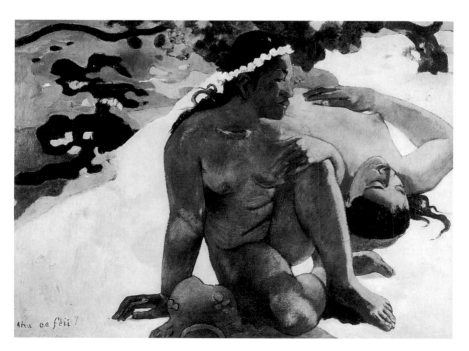

Aha oe feii? (What! Are You Jealous?) 1892

Buddhist figures from the relief of the Temple of Borobudur, Java c. 8th century

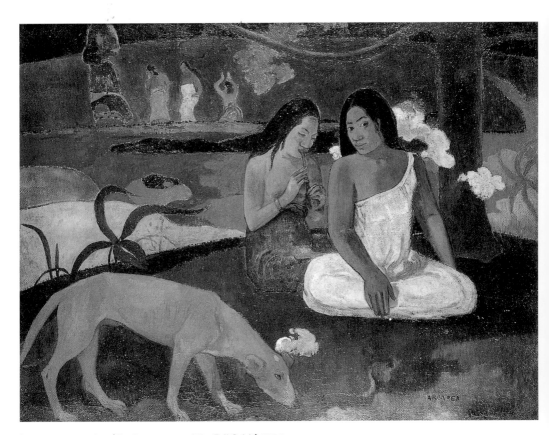

Arearea no varua ino (The Amusement of the Evil Spirit) 1892

statue of a god inspired at once by Easter Island megaliths, Buddhist figures from the temple of Borobudur in Java, and the feminine Polynesian deity Hina. In the middle third of the painting are three figures, sitting or reclining on pink sand. To the left, a child lies facing us with head resting on hands, legs bent and toes touching the water; to the right, another child facing away from us, is folded into a fetal posture; in the center a woman is facing us, posed in a graceful *contrapposto*: her upper torso is framed by a kind of green mandorla, her loins are accented by a red *pareu* and her calves are immersed in the prismatically colored water below. The water constitutes the lower third of the painting. Here again is that jigsaw puzzle pattern of colors which offers a distorted reflection of the three-dimensional, and multicultural world above. The lower third of *Mahana no atua* thus represents the abstract, anti-structural response to the illusionistic opposition of figure and ground seen in the two upper registers; it functions as a third term of representation between material and spiritual realms, just as the *mahu* is a sexual third term that mediates relations between different Polynesian communities and between natives and foreigners.

Te rerioa (*The Dream*, 1897) was painted during Gauguin's second Tahitian period, but it too represents the artist's attempted mediation of material and spiritual realms, and French and Polynesian metaphysical belief. The title is an archaism, according to Danielsson, and designates a nightmare not a simple dream (*moe moea*). Gauguin nevertheless intended it to mean *le rêve* and said so in a letter of 1897 to Daniel de Monfreid. "All is a dream in this canvas," he wrote. "whether it be the child, the mother, the horseman in the path, or the dream of the painter."[63] The rectangular picture shows two women, a sleeping child and a cat, all in a flamboyantly ornamented interior. The two women, whose postures generally echo those of the central figures in Delacroix's *Women of Algiers*, sit with legs crossed. The woman at right has her chin resting on her left hand as she gazes contemplatively past the implied viewer. She has just finished nursing a child; her dress has slipped from her shoulders and her nipples are swollen. The woman at left is shown in profile against a landscape; she wears a white dress and a *pareu* wrapped around her middle. In the lower left foreground, a child sleeps in an elaborately carved cradle upon which Gauguin signed his name and painted the title *Te rerioa*. Just above the child is a white and orange cat, its tail-end curling away from the viewer and its paws extending forward.

The setting for the figures in *Te rerioa*, probably Gauguin's own studio or bedroom at Punaaia, is fantastic. The walls are extravagantly

painted with brown grisaille panels at left and right and with a land-scape at the center that greatly resembles the artist's *Street in Tahiti* (1891). The left frieze represents two intertwined lovers and a figure emerging from, or turning into, a butterfly-shaped plant. Below them is a narrow panel—like a Renaissance predella—painted with gray and rose and showing a kangaroo and cavorting monkeys. The right frieze shows a standing figure of indeterminate sex with arms raised—perhaps recalling the dancing figure in the background of *Merahi metua no Tehamana* (*Tehamana Has Many Parents*)—turning into a lotus plant. Below the creature are two copulating rabbits.

Te rerioa was painted in less than two weeks, Gauguin tells us in his letter to De Monfreid, and the haste is apparent in the facture. The paint is thinly laid on the coarse-woven, hemp sackcloth, and colors are reduced to a relative few, dominated by bronze-green in the faces and bodies of the women, and yellow ocher in the woven floor mats and

Te rerioa (The Dream) 1897

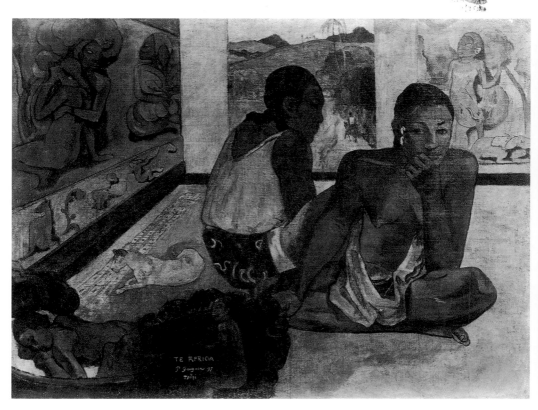

walls. Highlights of orange and vermilion appear in scattered locations across the canvas surface, lending further overall unity to the picture. One area, however, exists apart from the rest: the background landscape contains a wider range of tones, and a more vibrant array of color contrasts than the rest of the picture. It thus represents a window onto an alternative space and time within the entirely closed, aestheticized universe of the studio. The horseman in the landscape dreams of the women and child; they dream of the distant rider. The women dream of their own future and that of their child; the child dreams contentedly of its mothers. The women, painter, child and spectators all dream of the fecund and erotic utopia and accompanying drolleries pictured in the frieze. The dream in *Te rerioa* is thus not dual but multiple, and recalls the complexities of *Mana'o tupapa'u*: "She thinks of the ghost; the ghost thinks of her," writes Gauguin in his *Cahier pour Aline.* "To know the Correspondences," writes Balzac in *Seraphita,* "between the things visible and ponderable in the terrestrial world and the things invisible and imponderable in the spiritual worlds, is to hold heaven within our comprehension." *Te rerioa* like *Mana'o tupapa'u* represents an erotic dream of polymorphous pleasures and physical boundlessness.

6 Where Do We Come From?

Mana'o tupapa'u was the painted manifesto for Gauguin's first Tahitian period; it was included in the background of the *Self-Portrait with Hat* (1893–94) and was the subject of five woodcuts, two of which are the largest and most ambitious of his career as a printmaker. The painting entitled *Where Do We Come From? What Are We? Where Are We Going?* (1897–98) was the comparable manifesto for Gauguin's second Tahitian sojourn; it too features an androgyne, and proposes the correspondence between things visible and invisible, human and divine and European and Polynesian.

Gauguin's first mention of *Where Do We Come From?* occurs in a long letter dated February 1898 to Daniel de Monfreid. The text is purposely dramatic, and starts with the mention of a failed attempt at suicide: "I went into the mountains, where my body would have been devoured by the ants. I had no revolver, but I had arsenic, which I had saved up while I was so ill with eczema. Whether the dose was too strong, or whether the vomiting counteracted the action of the poison, I don't know; but after a night of terrible suffering I returned home."

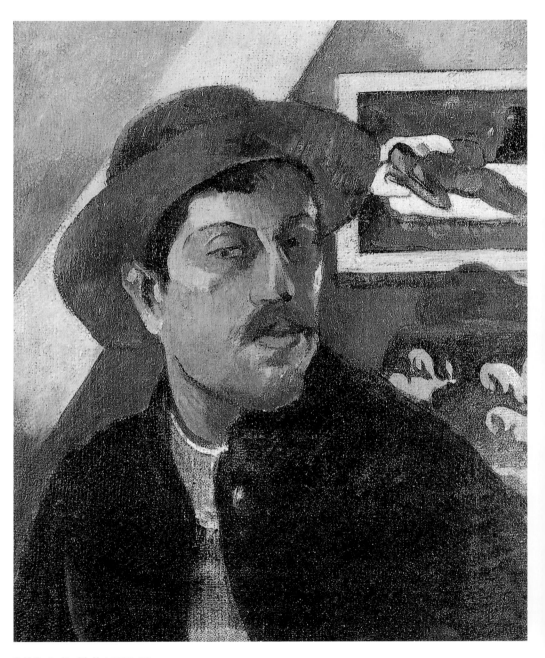

Self-Portrait with Hat 1893–94

Gauguin's narrative continues:

> But before I died I wished to paint a large canvas that I had in mind,
> and worked day and night that whole month in an incredible fever.
> To be sure, it is not done like a Puvis de Chavannes, sketch after
> nature, preparatory sketch, etc. It is all done straight from the
> brush on sackcloth full of knots and wrinkles, so the appearance
> is terribly rough.

The painting was the result not of cold calculation, Gauguin says, but of
an imagination fired from the confrontation with death's abyss. Failures
or imperfections in the execution of the work are to be excused—even
welcomed, he says—as traces of passion and genius.

> They will say that it is careless, unfinished. It is true that it is hard
> to judge one's own work, but in spite of that I believe that this
> canvas not only surpasses all my preceding ones, but that I shall
> never do anything better, or even like it. Before death I put in it all
> my energy, a passion so dolorous, amid circumstances so terrible,
> and so clear was my vision that the haste of the execution is lost
> and life surges up. It doesn't stink of models, of technique, or of
> pretended rules—of which I have always fought shy, though
> sometimes with fear.

Gauguin then proceeds to describe the work, emphasizing its
archaistic, fresco-like quality and its magical landscape setting. He also
enumerates its diverse dramatis personae: children, gossips, "figures"
(genderless), old women, farm animals, totemic and allegorical
creatures, and an idol. He concludes by describing the predominant
colors of the painting and by making a joke at the expense of the Ecole
des Beaux-Arts:

> It is a canvas four meters fifty in width, by one meter seventy in
> height. The two upper corners are chrome yellow, with an inscrip-
> tion on the left and my name on the right, like a fresco whose
> corners are spoiled with age, and which is appliquéed upon
> a golden wall. To the right at the lower end, a sleeping child and
> three crouching women. Two figures dressed in purple confide their
> thoughts to one another. An enormous crouching figure, out of all
> proportion, and intentionally so, raises its arms and stares in aston-
> ishment upon these two, who dare to think of their destiny.
> A figure in the center is picking fruit. Two cats near a child.
> A white goat. An idol, its arms mysteriously raised in a sort of
> rhythm, seems to indicate the beyond. Then lastly, an old woman

nearing death appears to accept everything, to resign herself to her thoughts. She completes the story! At her feet a strange white bird, holding a lizard in its claws, represents the futility of words. It is all on the bank of a river in the woods. In the background the ocean, then the mountains of a neighboring island. Despite changes of tone, the coloring of the landscape is constant, either blue or Veronese green. The naked figures stand out on it in bold orange. If anyone should tell Beaux-Arts pupils for the Rome competitions: "The picture you must paint is to represent, *Where Do We Come From? What Are We? Where Are We Going?*" what would they do? So I have finished a philosophical work on a theme comparable to that of the gospel.

Gauguin's formal description is nearly complete, omitting only the crouching dog at right, the standing and squatting figures beneath the left and right hands of the idol, and the large reclining woman in the left foreground. The latter figure, as well as the nearby bird with lizard, is a repetition of the composition entitled *Vairaumati* (1897).

HENRY LEMASSON Where Do We Come From? What Are We? Where Are We Going? outside Gauguin's studio, Tahiti 1898

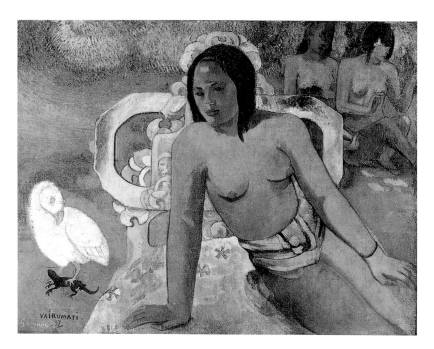

Vairaumati 1897

Gauguin returned to his discussion of the subject and form of the "large canvas" in a letter to De Monfreid from March 1898. Instead of a simple description, he cites the abstract elements of his work, and offers the sympathetic De Monfreid a brief lesson in Symbolist aesthetics:

> The cold calculations of reason have not presided at this birth, for who knows when in the depths of his being the work was commenced? . . . Sometimes I hear people say: That arm is too long. Yes and No. No, principally, provided as you elongate, you discard verisimilitude to reach out for mystery. That is never a bad thing. But of course all the work must reflect the same style, the same will. If Bouguereau made an arm too long, ah yes! What would be left him? For his vision, his artistic will only consists in that stupid precision that chains us to material reality.[64]

Symbolist painters must be consistent, Gauguin argues, in their violations of anatomy, contour and perspective. Like Van Gogh, who claimed that spontaneous drawing and arbitrary color were superior to "delusive precision," Gauguin rejected "that stupid precision that chains

us to material reality."[65] He much preferred mystery and what he called in the same letter "intense emotion" and "thought [that] comes up like lava from a volcano."

Where Do We Come From?, along with eight related paintings, was shipped to Paris in July 1898, and in November became the centerpiece of an exhibition held at the gallery of Ambroise Vollard. Despite the advanced promotion and publicity, the exhibition was a critical and financial disaster. Even critics sympathetic to Symbolism damned it with faint praise. Gustave Geffroy perceived a "too strongly held belief in artifice . . . [but] a very charming taste for nature."[66] Thadée Natanson in *La Revue blanche* summoned up little more enthusiasm. He approved the self-contained artifice of the separate parts of the large canvas, but found the whole disconnected and "obscure":

> Rendering homage once again to the profound, charming qualities that they evidence, let us note that the meaning that ought to emerge from the large canvas is at first difficult to grasp, and that furthermore, it does not confer sufficient unity upon the painting. The composition, in order to justify itself—since it does not do so materially enough—calls for comment: it remains obscure.
>
> Each of the motifs, on the contrary, needs no comment . . . each motif fills the frame that encloses it better, stands on its own as a full canvas, a self-sufficient object, and is generally more satisfying, more gratifying than its counterpart on the whole.

André Fontainas was somewhat more generous, and engaged with the Gauguin exhibition, praising at length the decorative abstraction and musicality of the exhibited canvases. However, the specifically Tahitian content of the pictures left him cold: "The essential thing, for I cannot see here an exact reproduction of Tahitian or Marquesan sites, is that the painter's art gives us the idea—false, true, it doesn't matter—of a warm, luxuriant primitive land . . . peopled by a grave, somewhat precious, and uncultured race." In addition, he roundly condemns the "large panel" for its "lean, colorless and rigid characters." Fontainas continues: "Nothing resides in such canvases save the evidence of deplorable errors, for abstractions are not communicated by concrete images if, in the artist's very dream, they have not first taken shape in some material allegory that, living, signifies them. That is the value of the lofty example that Puvis de Chavannes gives by his art . . . In the large panel that M. Gauguin is exhibiting, nothing, neither the two supple and pensive figures who are passing through it, nor the skillful evocation of a mysterious idol would reveal the allegory's meaning to

us, had he not taken care to write in a corner at the top of the canvas: Where do we come from? What are we? Where are we going?'"[67]

Gauguin was moved to respond to Fontainas's review, and did so in a letter dated March 1899. He began by agreeing with the critic that his picture could be faulted for technical errors, but nevertheless insisted that "violence, monotony of hues, arbitrary coloring and so forth . . . are deliberate." Such violations, he said, evoked feeling and emotion more surely than a delusive exactness of representation. Color like music, Gauguin writes, is a "vibration" which has the capacity to "reach what is most general and consequently most vague in nature: its inner power." He then added:

> Here, near my hut, in total silence, I dream of violent harmonies amid the natural perfumes that intoxicate me. My delight is enhanced by I know not what sacred and horrible ritual I sense in times immemorial. I breathe in the present the aroma of joy from earlier times . . .

In addition to sight, hearing and smell, Gauguin has added the Maohi sense of remembering to his synaesthetic panoply. Just as color can evoke tastes, music and the perfumes of exotic plants, so the memory of "times immemorial" can summon forth peculiar lines, tones and hues.

> To return to the panel, the idol is not meant as a literary explana- tion; it is there as a statue. Perhaps it is less a statue than the animal figures, and less animal-like, being an integral part of what I dreamed in front of my hut, along with the whole of nature that reigns over our primitive soul, the imaginary consolation for our sufferings insofar as these are vague and misunderstood in relation to the mystery of our origin and our future . . . When reawakening, once my work is completed, I say to myself: Where do we come from, what are we, where do we go? The reflection is no longer part of the picture and is therefore set out separately in language, on the surface around it—not so much a title as a signature.[68]

The painter speaks the title and the title speaks the painter; he is the dreamer and the dreamed. The painter depicts the past and the future, the living and the dead, and the seen and the imagined.

In a letter to Charles Morice from July 1901, Gauguin again discussed the meaning of his "large painting." He began by describing his present despair, and his wish to settle in the Marquesas, where the "savage surroundings . . . will revive in me, before I die, a last spark of enthusiasm which will kindle my imagination and form the culminating

point of my talent." He then compared his own approach to painting with that of Pierre Puvis de Chavannes:

> Puvis explains his idea, yes, but he does not paint it. He is Greek whereas I am a savage, a wolf in the woods without a collar. Puvis will call a picture *Purity* and to explain it will paint a young virgin with a lily in her hand—a hackneyed symbol, but which is understood by all. Gauguin under the title *Purity* will paint a landscape with limpid streams; no taint of civilized man, perhaps an individual.

Gauguin's comparison of his own approach to that of Puvis is at one level a fairly conventional Romantic critique of allegory. Allegory was a degraded form of expression, the Romantics and later the Symbolists believed, because it sacrificed the formal rigor and coherence of the artwork in the name of expressing something clearly external to it—a season of the year, a phase of life, a virtue, a religious conviction, a national or ethnic identity. For Gauguin it is not Puvis' young girl holding a flower who expresses purity, but the limpid stream, rendered in flat, decorative patches of pure color and somber tone. Gauguin's criticism of Puvis goes further by rejecting Western reason itself and embracing primitive instinct and emotion. He continues to Morice:

> Puvis as a painter is a scholar and not a man of letters, while I myself am not a scholar but perhaps a man of letters.
> Why, when they gather in front of a picture, will the critics seek for

PIERRE PUVIS DE CHAVANNES The Sacred Grove 1884

points of comparison with old ideas and other authors. Not finding there what he expected, he fails to understand and remains unmoved. Emotion first! understanding afterwards.

In this big picture:

> *Where are we going?*
> *Near the death of an old woman.*
> *A strange stupid bird concludes.*
> > *What are we?*
> *Day-to-day existence. The man of instinct wonders what all this means.*
> > *Where do we come from?*

Spring
> *Child.*
> > *Common life.*

The bird concludes the poem by comparing the inferior being with the intelligent being in this whole which is the problem indicated by the title.

Behind a tree are two sinister figures, shrouded in garments of somber colour, recording near the tree of science their note of anguish caused by this science itself, in comparison with the simple beings in a virgin nature, which might be the human idea of paradise, allowing everybody the happiness of living.

In the text above, Gauguin rejects the allegorical approach of Puvis de Chavannes, yet his large painting clearly invokes ideas and texts that are extra-pictorial. Like emblems and allegories from the Baroque age, such as Caravaggio's *The Seven Acts of Mercy* (1606), Gauguin's work is episodic and fragmented. "Each motif . . . stands on its own as a full canvas," Natanson correctly noted. The forms and figures are unusually "rigid," Fontainas recognized. Like Georges Seurat's comparably sized *Sunday Afternoon on the Island of La Grande Jatte* (1886), Gauguin's composition recalls Renaissance murals, late medieval fresco paintings, or the Phidian pan-Athenaic frieze. There is no single point of view from which all the figures are seen in proper scale or proportion. Each figure or ensemble—the large androgyne in the center, the women at right with hands on chin, and the child in the left foreground biting an orange—exists apart from all the others. There is no communication possible between one figure or group and another. Each landscape element—trees, stream, cave, breaking waves and distant mountains—conflicts with every other. Gauguin's large painting demands to be read like a book, but there is no gospel that stands behind it; therein lies its real obscurity.

In place of iconography, Gauguin offers idealist philosophy and cultural synthesis. As was the case with *Mana'o tupapa'u*, Gauguin found metaphysical sustenance in European Romantic and Polynesian sources. In this case the inspiration comes not from Balzac's *Seraphita* but from the nearly contemporaneous *Sartor Resartus* (1833–34) by Thomas Carlyle, a work which Gauguin is known to have owned. (The book was represented lying on a table between a bowl of fruit and Milton's *Paradise Lost* in Gauguin's *Still-Life: Portrait of Jacob Meyer de Haan*, 1889.)[69] In Chapter Eight, called "The World Out of Clothes," the philosopher Teufelsdröckh questions the validity of modern systems of thought and imagines an "undiscovered America" in which fresh philosophical questions can be posed. In this "Naked" and "Adamite" continent, appearances are understood to be mere clothes, and all surfaces only emblems. Teufelsdröckh then asks:

> Who am I: what is this ME? A Voice, a Motion, an Appearance;– some embodied, visualized Idea in the Eternal mind? . . . but Whence? How? Whereto? The answer lies around, written in all colors and motions, uttered in all tones of jubilee and wail, in thousand-figured, thousand-voiced, harmonious Nature . . . We sit as in a boundless Phantasmagoria and Dream-grotto; boundless, for the faintest star, the remotest century, lies not even nearer the verge thereof: sounds and many-colored visions flit round our sense; but Him, the Unslumbering, whose work both Dream and Dreamer are, we see not; except in rare half-waking moments, suspect not.

A few paragraphs later, Teufelsdröckh repeats his interrogatives, and describes his dream vision as painted with many colors, spread across the "warp and woof" of a canvas.

> But the same WHERE, with its brother WHEN, are from the first the master-colors of our Dream-grotto; say rather, the Canvass (the warp and woof thereof) whereon all our Dreams and Life-visions are painted.[70]

Gauguin's *Where Do We Come From? What Are We? Where Are We Going?* was precisely a "Life-vision" of many colors painted on coarse sackcloth. It was, like *Sartor Resartus*, a critique of "science itself, in comparison with . . . the human idea of paradise"; it was a picture populated with "unslumbering beings" that must have reminded the artist of the Polynesian *tupapa'u*. Like the philosopher Teufelsdröckh, Gauguin conceived a thesis on the subject of clothes. European clothes, he argued in *Noa Noa*, served to create sexual

differences and to separate humans from both their animal and spiritual natures. Social and sexual equality required native skirts wrapped loosely around waists; it needed men and women alike to wear flowers and earrings and to have bare feet. In such a primitive "undiscovered America" of "virgin nature," male and female bodies will lose their separateness, vice will end, and there will be an "easy commerce between the sexes."

Where Do We Come From? is a picture that seeks to discover and explore cultural universals. As he does in *Mana'o tupapa'u*, Gauguin superimposes Romantic and Polynesian ideas about the relation of the quotidian (*noa*) and the spiritual (*mo'a*). Moreover, he chooses for his basic subject a theme that seems equally drawn from Hebrew Genesis and Polynesian creation narratives. The figure at center who has not yet plucked the fruit from the Biblical tree of knowledge is an androgyne; he/she possesses spiritual purity. The "idol" is probably the goddess Hina, to whom Gauguin (mistakenly) attributed great significance in Tahitian cosmogony. In *Ancien Culte Mahorie* (1893), Gauguin copied

Page 55 of Noa Noa 1896–1903 Page 75 of Noa Noa 1896–1903

145

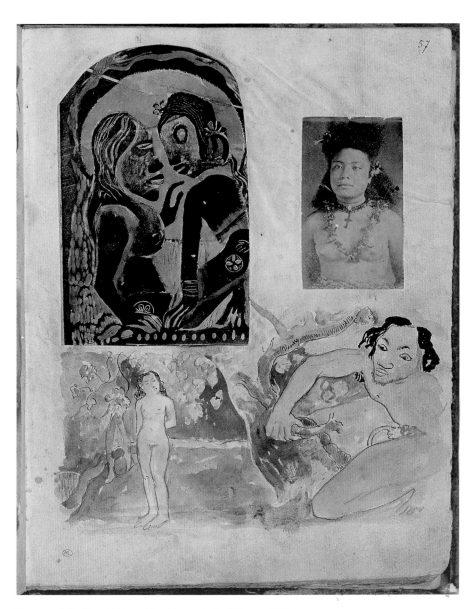

Page 57 of Noa Noa 1896–1903, with woodcut of Hina and Tefatou

a passage from *Voyages aux îles du grand océan* by the ethnographer and diplomat Jacques-Antoine Moerenhout (1837). The text describes the mystical union of the gods Ta'aroa and Hina into a single androgynous power:

> . . . and this idea of the coexistence of two principles which are God . . . One, soul, life or part intelligence of the deity, represented by the name Ta'aroa, is male; the other purely material and consisting in a certain way the body of the same God, is female, called by the name Hina, the two composed, by their union all that exists in the universe.[71]

Like the mystic being Seraphita/Seraphitus, or the young Teha'amana in *Mana'o tupapa'u*, or the central figure in *Where Do We Come From?*, the omnipotent Polynesian god described above is androgynous. It is the representation of spirit through matter, or the expression of "things invisible and imponderable" through clothes. "The earth is a garment," wrote Balzac, and Gauguin might argue, "So is sex."[72] In Tahiti and the Marquesas, Gauguin had no fixed sexual identity, but by virtue of that lack, he was able to compare the Polynesian *mahu* with his/her European counterparts, the *invertis* and the androgynes. Gauguin occupied no secure social, cultural or religious position, but by virtue of that very placelessness was able to observe some of the complex personalities, sociabilities and sexualities of indigenous Tahitians in an age of imperialism. By so doing, he functioned as an ethnographer, recording mentalities and cultural practices once thought valueless and today widely (and mistakenly) dismissed as extinct. Yet to call him an ethnographer is not quite right, for it implies the passive stance of a spectator and not the active perspective of the modern artist who understands that cultural traditions are made and remade in the present, not just recovered unchanged from the past. In Tahiti, Gauguin combined European and Polynesian ideas into a hybrid art that mirrored his own liminal stance on the contested border of sexual and colonial identity. In the Marquesas Islands, that position could not be accommodated, and the artist's position become ever more precarious.

Far from the French administrative and military center of Papeete, lawlessness and sentiments of independence were able to flourish. The residents of the remote Marquesas Islands appeared to enjoy their fierce reputation, and liked to tease credulous whites with tales of cannibalism.

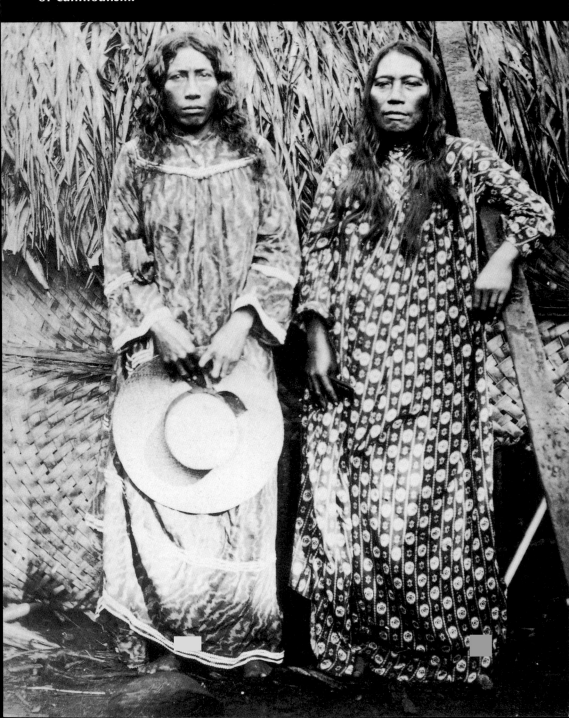

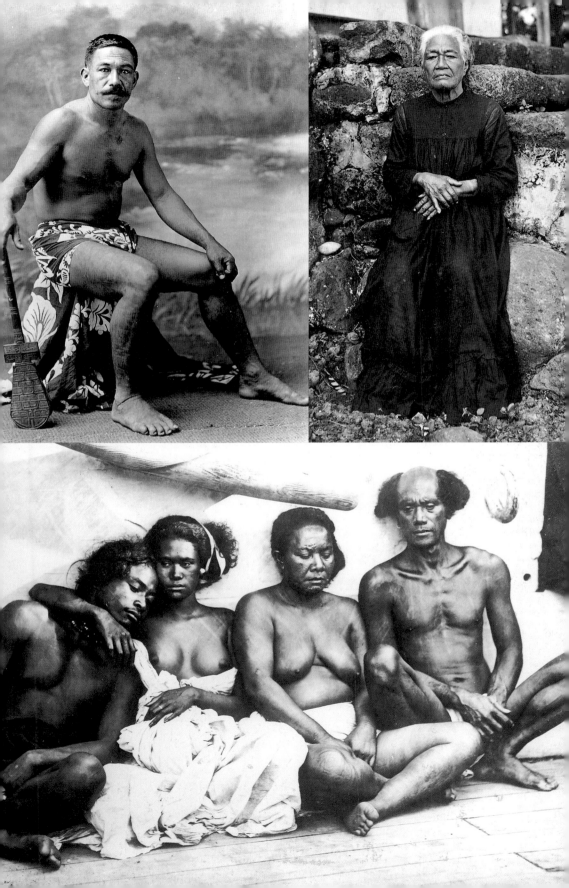

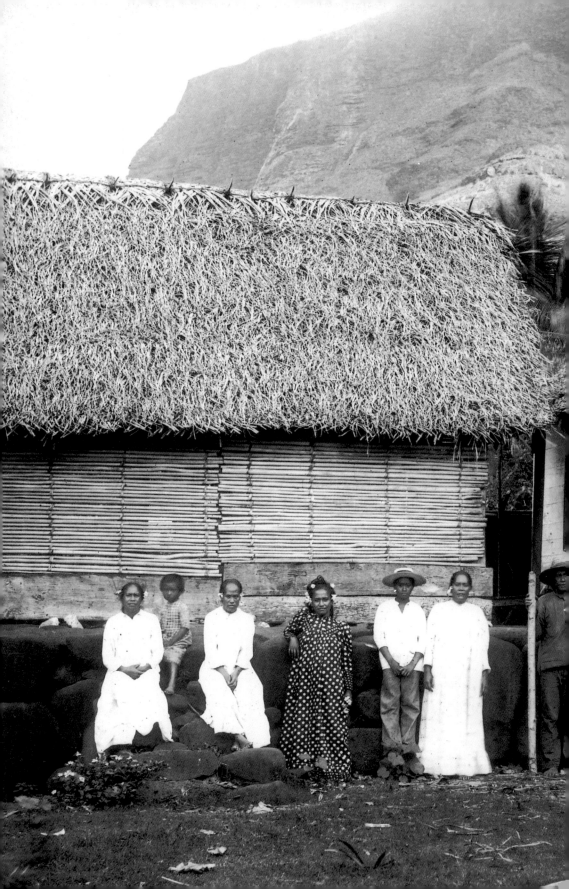

The last king of Tahiti, Pomare V (1839–91), was well-known for his drinking and his public abuse of the French. At a diplomatic reception in Papeete in early 1891, he was heard by the painter John La Farge exclaiming that he liked Americans well enough, but that the French were all damned. "This he said," La Farge writes, "in English, in a proper reminiscence of nautical terms of reproach."[1] The writer Henry Adams accompanied La Farge to Tahiti, and his recollection of the king differed only slightly. According to Adams, Pomare praised the visiting Americans, cast dirty looks at the various colonial officials posed about the room, and then called the Frenchmen "'b . . . [astards]' drawn from sailor's dialect."[2]

The population of Polynesia was small and dispersed during the *fin de siècle*, but anti-French insolence was intense and widespread. Evidence from travel diaries, newspapers, government files and official correspondence suggests that protest took myriad forms and did not pass unnoticed. Even tourists and pleasure seekers remarked upon the disrepute of the French authorities and the willingness of the natives to express their discontent.[3] In a widely sold travel diary entitled *Tahiti, Garden of the Pacific* (1891), Dora Hort wrote that the natives "do not suffer in silence and . . . the language among themselves is likewise of a most indelicate kind, and vulgar expressions are employed in the presence of children, who adopt the same style."[4] In the distant Marquesas, the unpopularity of the local police constabulary—the gendarmerie—was so great that officers believed their very lives in danger. On the island of Hiva-Oa, writes F. W. Christian: "A French gendarme . . . conscious maybe of holding his life upon no very secure tenure, rules [the natives] not perhaps always in justice, but with a rod of iron."[5]

In 1901, the Inspector of Colonies, André Salles, remarked on the many internecine conflicts in Tahiti between Catholics and Protestants, planters and merchants, sailors and gendarmes, settlers and natives. Everyone hurled the vilest of epithets, he complained. "Discord is everywhere," he wrote, "and the country suffers from it."[6] What made matters worse, he added, was the existence of a particularly vituperative opposition press, including the Catholic-sponsored newspaper, *Les Guêpes*, edited by Gauguin; it was singled out as one of the most virulent of the anti-government scandal sheets.

A French colonist in the Marquesas photographed by HENRY LEMASSON c. 1900

An exchange between Gauguin and a local schoolmaster and lexico-grapher, Georges Dormoy, in the pages of *Les Guêpes* conveys some-thing of the vulgarity of popular protest. After writing and publishing an article bitterly criticizing Dormoy's efforts to impose French educational norms on unreceptive and unprepared native students, Gauguin received and published the following reply:

> These days, it is customary, in the so-called opposition press, to insult and disqualify those who occupy or have occupied public office. *Les Guêpes* is not exempt from this impediment. It is up to you Monsieur Gauguin, to earn the money you receive to spread lies and slander. Strange occupation for an artist, to exploit human credulity with so little regard for truth and to trade so despicably in public *naïveté*!
> One final word: the so-called Tit-Oil [Gauguin's pseudonym] in your journal finds my face stupid; tell him that his face has always seemed to me too basically dumb to be moronic; I find it bestial.

Gauguin was wholly unchastened by the racist attack. (To be "bes-tial" is to be even more racially degenerated than simply "moronic.") His own rejoinder in *Les Guêpes* is as personally insulting as was the initial article and Dormoy's reply: "As far as I am concerned, I will respond to the epithet of despicable only in proportion to your miser-able personality; that is to say with utmost disdain, my reputation until this very day putting me beyond your reach. One day the world will laugh at this epithet, and the ridicule will fall back on you." Gauguin then finishes with a few more choice *ad hominems*:

> The same goes for your comment on Monsieur Tit-Oil. I have heard indeed that he had mentioned a stupid-faced bureaucrat in a satirical article, and you rightly recognized yourself. Admit, then, that Tit-Oil really showed great forbearance by describing only the face. Well, here you stand, condemned by one for having a bestial face, by the other for having a stupid one. Alas! It is a great pity.[7]

Such absurdities were typical in *Les Guêpes* (March 1899–August 1901), and in Gauguin's other scandal sheet, the self-published *Le Sourire* (August 1899–April 1900). The two papers in fact, were so filled with local allusions, petty political squabbles and personal insults that they are almost incomprehensible today. Political figures are provided with caricatural nicknames, whispered dialogues overheard in cafés are given lengthy interpretation, and official government edicts are treated with the same gravity as graffiti scrawled in toilets.

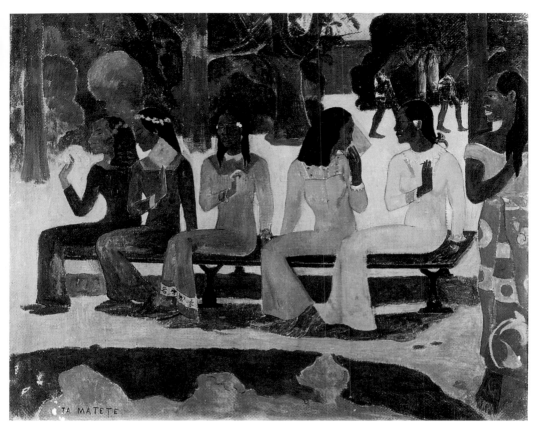

Ta matete (The Market) 1892

Anti-government sentiment was expressed in more than just verbal form. Natives flaunted laws and customs which promoted moral propriety, physical health and industry. Public inebriation, opium smoking, brawling, divagation of grazing animals across plantation lands, petty larceny, lewdness and even prostitution were all, at least in part, expressions of resistance. The women striking attitudes in Gauguin's *Ta matete* (*The Market*, 1892) are prostitutes posed like the figures in an ancient Egyptian wall painting.[8] The one in yellow at right holds a cigarette between the fingers of her right hand; two others proudly wield their health inspection certificates as if they were the painted fans of French society women.[9] Such behavior was inconsistent with order, stability, prosperity and the overall French *mission civilitrice*.[10] If Tahiti, the Marquesas and the rest of French Polynesia were to be effectively

governed by French magistrates, if trade was to be subjected to all metro-politan tariffs, and if native culture and language were to be supplanted by that of France, then order had to be established and maintained.

Anti-colonialism was expressed through spoken or written abuse, and acts of non-cooperation or petty criminality were sometimes mis-taken by governmental and merchant élites for laziness, immorality or hooliganism. "There exists today an important obstacle to agricultural and industrial development in these territories," wrote the economist DeLanessan on 4 April 1887 in the Papeete daily *L'Océanie française*, "and that is the laziness of the indigenes." Just as important, he said, as the effort of establishing habits of industry among the natives, was the task of destroying the generalized "*désir*" that structured native life and leisure. The pursuit of pleasure had to be replaced by a new desire to work ("*le goût de travail*"). "It is necessary to create in these people," he continued, "such needs that only the fruits of labor can satisfy." Yet despite law and ideology, native people persisted in indulging in activities that could not be easily accommodated within the system of manufactured needs sanctioned by a growing mercantile and plantation economy.

On 12 October 1889, for example, according to Papeete court records, a woman named Taui'a'manua was arrested for dancing an erotic *upa upa* in public without prior written authorization; she was convicted, fined and released.[11] Such arrests were common and judged essential to maintaining stability: they assured that the work of assimi-lating native to French culture would be unhindered by indigenous pride in Maohi tradition. These prohibitions also served to deny native people occasions to gather together in large numbers outside the Protestant and Catholic schools and churches. Polynesian dancing and singing (*himene*)—such as Gauguin painted in his *Upaupa* (*To Dance*, or *Fires of Joy*, 1891–92) and *Te fare himine* (*The House of Hymns*, 1892)—was increasingly circumscribed during this period within the narrow confines of Christian religious ceremonies, civic holidays and touristic displays. In fact, officially sanctioned Bastille Day performances of native song and dance were inaugurated in 1882, the very year of annexation; they have continued every year since. Gauguin's two paintings, on the other hand, represent unlicensed exhibitions of native *upa upa* and *himine*. Even today, song and dance are opportunities for Tahitians and other Polynesians to register their objections to nuclear testing and French colonialism.[12]

In general, the greater the distance from the French administrative and military center of Papeete, the greater were lawlessness and

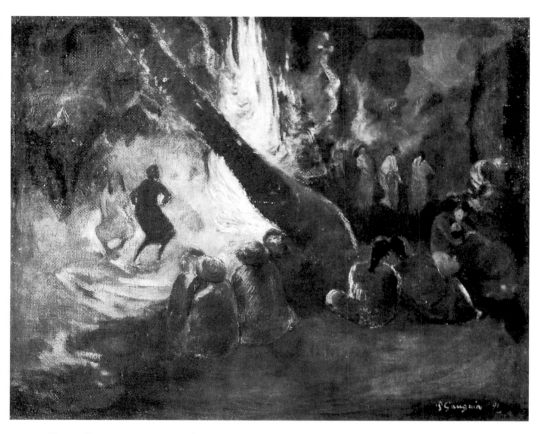

Upaupa (To Dance, or Fires of Joy) 1891–92

independence sentiments during the *fin de siècle*. Inhabitants of the Leeward islands of Ra'iatea, Huahine, Bora-Bora and Taha'a, who had managed by their wits to remain largely outside metropolitan administrative authority since the establishment of the protectorate in 1842, were in open rebellion against French rule during the 1890s, and there were fears that disorder would spread throughout Polynesia. In 1895, the government in Paris decided to seize control of the Leeward Islands once and for all, and dispatched for the purpose a military and diplomatic party led by Commissioner General Isidore Chessé. Much to the distress of many civilian and military notables, the eccentric Gauguin was permitted on board the warship *Aube* to witness the operation. He was the guest of the Colonial Governor, Pierre Papinaud, to whom he had been recommended by their mutual friend, Daniel de Monfreid. Gauguin's letters to William Molard from July and October

1895 describing the expedition are expressions at once of revolutionary tourism and anti-imperialism. In July he wrote:

> My ears are deafened by all the gossip about politics, which are very embroiled . . . Diplomatically speaking, after a lot of nonsense, everything is at a standstill. So we must have troops and shooting or give way to the natives, who are encouraged by the English. However all this hardly interests me. What is, for instance, a disaster for the trade of the colony is a windfall for me, that is the rate of exchange. Just think, they formerly gave me 125 Chilean francs for 100 French francs, whereas today, they give me 200, which considerably increases my little capital.[13]

In October he again wrote to Molard:

> How I pity you for not being here. I am sitting quietly in my hut. In front of me is the sea, and Moorea, which takes on a different aspect every quarter hour. A *pareu* and that's all. No such thing as suffering from heat or cold. Ah, Europe . . .
>
> Great political activity in Tahiti at this time. As you know, or maybe you don't, since 1890 three islands have been in a state of rebellion, claiming the right to govern themselves: Huahine, Bora-Bora and Ra'iatea. Monsieur Chessé came out here to bring the stray children back into the fold. Two of them gave in, and the warship took part in the reconciliation festivities, along with four hundred Tahitians, all the authorities, and myself. Believe me, we talked, yelled, and sang throughout four extraordinary days of celebrations, just like Cythera . . . Now there remains only to conquer Ra'iatea, and that's another matter, because it will be necessary to fire the cannon, to burn and to kill. A matter of bringing civilization to them, I am told. I don't know if I'll witness the battle; out of curiosity, I admit that I am tempted to. But on the other hand it sickens me.

In these letters, Gauguin exposes his opportunism and cynicism: He recognizes the barbarism of the *mission civilitrice*, but is happy to benefit from the resulting currency inflation and to participate in the parties; he is sickened by imperialist violence, but is drawn to the spectacle like a fly to a carcass.

At the height of the insurrection in 1897, Gauguin attempted figuratively to pitch his tent with the rebels. He wrote to his friend Charles Morice in Paris and asked him to try to publish the following (presumably fictional) interview with a Ra'iatean native:

Q: Why don't you want to be governed by French laws, the way Tahiti is?

A: Because we have not sold out, and also because we are very happy governed the way we are, with laws suited to our nature and our land. As soon as you move in somewhere, everything belongs to you, the land and the women, whom you leave two years later with a child on their hands that you don't care about. Everywhere there are officials and gendarmes whom we have constantly to ply with little presents, or else we are harassed in countless ways . . . We have a long acquaintance with your lies, your fine promises. Fines and jail as soon as anyone sings or drinks, and all that so as to give us so-called virtues that you don't practice yourselves . . .

Colonial oppression, Gauguin's real or invented informant says, takes the form of French sexual violations of native women, the prohibition of singing and drinking, and the installation of a hypocritical regime of moral order. Gauguin continued by asking his native informant about Ra'iatean prospects for survival in the face of powerful French weapons:

Q: But now if you do not give in and ask for mercy, the cannon will get the better of you. What do you hope for?

A: Nothing. We know that if we surrender, the most important chiefs will be sent to the penitentiary in Nouméa and since for a Maori [sic], it is a disgrace to die far from his own land, we prefer to die here. I am going to tell you something which will simplify everything. As long as you French and we Maoris [sic] are side by side, there will be trouble. Therefore you must kill all of us, then you will argue among yourselves, and that will be easy for you, with your cannons and guns.[14]

Two years later, Gauguin summarized his position on French colonialism in an essay on the poet Arthur Rimbaud for *Les Guêpes*. According to Gauguin, Rimbaud had been a fierce opponent of French corruption in Somalia and Ethiopia a decade earlier, and thus had anticipated the painter's own stance on colonization in Tahiti. Gauguin writes:

To colonize means to cultivate a region, to make a hitherto uncultivated country produce things which are useful primarily for the people who inhabit it; a noble goal. But to conquer that country, raise a flag over it, set up a parasitical administration, maintained at enormous cost, by and for the glory of the mother country alone—that is barbarous folly, that is shameful![15]

Gauguin appears to argue here that a benevolent colonialism is possible, but that in its present form, the policy is an abomination. A year later, Gauguin's stance was unambiguous, at least on paper:

> Well, my mind has set off on a journey. We are not in Oceania any longer but in Africa, that good continent which everybody wants to share, or rather to quarrel over, and which is so favorable to the adventurous heroes who come to trade, that land where they cut people's throats under the pretext of spreading civilization. When they are tired of firing at rabbits they fire at the blacks. The Boers fire at the blacks, saying: "Get out of here and make room for me." Heaven knows, the English do no worse; they only like to amuse themselves with a little sentiment. They used to sell slaves; now it is forbidden. No, I am only coughing [sputtering?]; go and see for yourselves.[16]

At the end of the decade, metropolitan officials feared that such anti-imperialist sentiments were gaining a foothold across Polynesia. Though the rebellion in Ra'iatea had been defeated, other hot spots remained, for example on Huahine, Bora-Bora and the Marquesas. The French Minister of the Colonies thus regularly sent commissioners on inspection tours of the islands to inquire into the local situation. In a letter dated 12 October 1898, the Colonial Governor Gustave Gallet wrote to the Minister in Paris concerning the Marquesas:

> The whole population of the Marquesas is still completely barbaric . . . Drunkenness persists in front of the very eyes of the administrators, to whom the natives say: "You and the other whites, what are you doing in our country? You have prohibited us from doing the two things that we like the most: eating human flesh and drinking fermented coconut juice."[17]

Gallet's remarks were undoubtedly intended to disparage the grievances of the Marquesans who in fact were subjected to the cruel caprice of an unsupervised gendarmerie stationed on the islands. The ascription of cannibalism to Marquesans was a favored method of dehumanizing them almost since the beginning of European colonization. Yet the particular sins mentioned by Gallet are probably indicative of the Marquesans' own strategies of struggle and resistance. Human sacrifice (in small scale) and cannibalism (more rarely) were in fact practiced by Marquesans during warfare in earlier periods of their history. Marquesans during the *fin de siècle* appeared to enjoy their fierce reputation, and liked to tease the credulous *popa'a* with tales of

cannibalism.[18] During his brief visit to the Marquesan island of Fatu-Iva while *en route* to Hiva-Oa in 1901, Gauguin was introduced to an old man who was once imprisoned for cannibalism. The two became friends, according to Gauguin, who writes in *Racontars de Rapin*: "Sometimes I ask him if human flesh is good to eat; then his face lights up with an intensely sweet smile (that smile peculiar to savages), and he reveals his formidable set of teeth."[19]

The matter of alcohol consumption was as much a concern to colonial officials and Christian missionaries as was cannibalism. The drinking of fermented juice from coconuts and oranges, as well as alcoholic tea made from roots (*kava*) was very common in the nineteenth-century Marquesas, and served both as an intoxicant during festivals and as an appetite suppressant.[20] In addition to their general convictions about the moral opprobrium of intoxication, the French authorities rightly observed that drinking led to political protest and sexual licentiousness. In April 1903, the Colonial Inspector, André Salles, reported to the Ministry of Marine and Colonies in Paris:

> The Marquesan natives continually indulge in drunken orgies in remote parts of the valleys. On such occasions, groups of forty–fifty persons fill the largest containers in their village with orange wine, and sometimes even use a canoe for the purpose. The men and women, completely nude, will then drink and drink, fight and copulate. The gendarmes know that it is very dangerous to arrive in the middle of such a feast. The painter Gauguin, who lives in Atuona and defends all the native vices, sees in these savage scenes no more than a simple amusement necessary to the well-being of the natives.[21]

More than a "simple amusement," Gauguin saw in these orgies an expression of his own and the Marquesan people's uncorrupted human natures. They were acts of insolence and political independence.

2 Marquesan Debauchery

The Marquesas consist of six major though scarcely populated islands, and a number of uninhabited islets. They are located in the South Pacific, 3,000 kilometers from Hawaii, 1,400 kilometers from Tahiti and about 450 kilometers from the closest other inhabited islands, the Tuamotu archipelago. (Thus they may be fairly considered remote.) Prior to 1800, the Marquesas possessed a robust population and an

extremely rich symbolic and material culture. Marquesan legends and folktales, collected by the anthropologists Karl von den Steinen in the 1890s and E. S. C. Handy in the early 1920s, are uncommonly vivid, corporeal and erotic, testifying to an indigenous "philosophy of sex . . . as *keu*, which means sport, or play."[22] (Handy's chief informant, Isaac Puhetete, also called Haapuani, happened to be a good friend of Gauguin.) Marquesan artworks were similarly focussed on the body. Tattooing attained a complexity and sophistication in the Marquesas unmatched anywhere else in the Pacific, and figural carving in wood and stone was equally highly developed. Gauguin saw only a handful of tattooed men and equally few examples of anthropomorphic art during his time on the islands, but nevertheless effectively described the Marquesan tendency to wrap a body or a form in a protective coat of images: "In the Marquesan," he wrote, "there is an unparalleled sense of decoration. Give him a subject even of the most ungainly geometrical forms and he will succeed in keeping the whole harmonious and in leaving no displeasing or incongruous empty spaces. The basis is the human body or the face, especially the face. Always the same thing, and yet never the same thing."[23]

By the time of Gauguin's arrival on the Marquesas Islands in 1901, the population had declined precipitously from earlier levels. The Marquesans suffered perhaps the cruelest colonial depredations of any Pacific Island at the hands of Spanish, American, English and finally French forces. Alternatively derided as godless cannibals and helpless children, Marquesans were attacked, imprisoned and killed in great numbers in the centuries between first contact in 1595 and French annexation in 1842. Their fragile ecology—already badly impacted by Polynesian settlement and clearing—was further undermined by early nineteenth-century sandalwood logging. What guns and ecological destruction had failed to accomplish, smallpox, tuberculosis and syphilis did, and by the end of the nineteenth century the French concluded that the Marquesans were approaching extirpation. The best course of action, successive colonial administrations cruelly concluded, was to isolate the few Marquesan children into "Preventoriums" in the hope of isolating them from what the colonialists believed to be the most dangerous contagion of all—the immorality and self-destructiveness of native families.

French colonialism was supported, as we have seen, by an ideology of racist exoticism. Writers such as Pierre Loti and Jules Garnier promoted settlement by employing what Gauguin called "a heap of adjectives" in their accounts of the beauties of Polynesian men and women.[24]

Page 168 of Noa Noa 1896–1903, showing Marquesan decorative motifs

At the same time, however, these authors sanctioned exploitation and extirpation by regularly describing native people as morally and physically degenerate. Garnier's *Océanie* (1871) typifies the first exoticist impulse:

> As the traveler crosses valleys and streams, he is enveloped by a refreshing and intoxicating atmosphere; as he, like the indigenes, abandons himself to a voluptuous *far niente*, as he casts his eyes on the animated and stirring native dances, accompanied by voices belonging to the youngest and most beautiful of these beautiful people, then he understands that such spectacles have served to inspire our explorers and poets to believe they had discovered in this new Eden, the realization of the sweetest dreams of man.[25]

Gauguin's seduction by this vision was one of the reasons he chose to move to Tahiti. The desire for erotic and masculine mastery, as well as for wealth and political power was likewise an inducement to many other immigrants; desire itself was, as Edward Said writes, at the heart of the colonial "male power-fantasy."[26] But the myth of the "new Eden" could be a hazard as well as a boon to the colonial enterprises. Erotic pleasures were not generally consistent with the other, and more necessary form of colonial desire: "*le goût du travail*." Order had to be maintained in the midst of the *far niente*, and law and ideology were tailored for the purpose: native women and men were marked by racial decrepitude, and any colonist who "went native" (*encanaqué*) was almost equally "bestial" and degenerate.

Colonists as well as natives, according to a succession of reports in the Papeete police archives, were prey to "laziness, drunkenness, gambling and excessively spending themselves with women."[27] Natives, as well as European working men and petty entrepreneurs, were highly susceptible, wrote the geographer Hercouet, "to drunkenness and all the other vices."[28] Prostitution of every kind, French writers agreed, thrived in French Polynesia: "What we would call restraint or decency in our countries," wrote Levaçon, the author of *Chez les Maoris*, "is something completely unknown to the natives down below. There, prostitution has attained the status of an institution, or better still, it has become a religion."[29] Prostitution in turn, led to venereal disease, illegitimacy, racial mixing, degeneracy and the death of the Polynesian race. Colonial authorities therefore condemned sexual unrestraint as much as they promoted its mythic image. The Marquesas Islands—where the erotic arts indeed occupied a privileged cultural niche—were an especial focus of this colonial ambivalence. In 1919, Frederick O'Brien described

his reluctant rejection of the sexual advances of a young "Atuona belle," and his subsequent reflection upon the Marquesas itself: "Whether . . . my Celtic blood sees portents where they do not exist, certain it is that as the stealthy charms of that idyllic place grew upon me through the days, something within me resisted it. I was ever aware that its beauty concealed a menace deadly to the white man who listened too long to the rustle of its palms and the murmur of its stream."[30]

Indeed descriptions of sexual extravagance have long been frequent in the reports of missionaries, traders, government agents and anthropologists from the Marquesas. "Women have freedom in the Marquesas," wrote Vincendon-Dumoulin and C. Desgraz with alarm in 1843, at the beginning of the period of French colonial rule: "Unlike the Orient, where men have harems, here it is women who enjoy that privilege. As among the ancient Bretons, one sees here ménages in which husbands live together in perfect harmony."[31] The two authors then proceeded to offer readers a phrenological analysis of Marquesan men and women in order to prove that they were almost wholly lacking in the faculties of reflection, compassion, sweetness and kindness but were over-endowed with impulsiveness and sensuality. In the same year, M. Dumoutier collected skull measurements which purported to prove that the Marquesan people's intelligence was generally subservient to their instincts, and that a great "sexual impulsiveness" prevailed among the native people.[32] In 1860, Max Radiguet stated in an illustrated and widely circulated account that: "Marriage on Nukuhiva Island . . . is not an eternally closed chain, but a flower garland that one wears lightly and that can be broken whenever it becomes too heavy."[33] Promiscuity was judged to be institutionalized in the Marquesas.

By the last quarter of the century, colonial accounts of Marquesan sexuality assumed a particularly ominous cast, as writers sought to attribute the depopulation of the Marquesas Islands to the sexual freedom of its people. "Marquesan girls of twelve to thirteen," wrote Admiral du Petit-Uhouargo to the Ministry of Marine and Colonies in 1880, "submit to diabolical orgies. Even children between the ages of eight and ten had [sexual] relations."[34] Robert Louis Stevenson in 1889 similarly noted the unsalutary licentiousness of Marquesan children: "The other day the whole [community of] school-children of Nuka-Hiva and Ua-pu escaped in a body to the woods, and lived there for a fortnight in promiscuous liberty . . . It is not possible to give details; suffice it that [Marquesan manners] appear to be imitated from the dreams of ignorant and vicious children, and their debauches persevered in until energy, reason, and almost life itself are in abeyance."[35]

A less fevered tone was assumed by Dr. L. Tautain in his article on Marquesan marriage written in 1895 for the journal *L'Anthropologie*: "[In the Marquesas there were] houses (*hae mako*) in which women gathered in order to amuse themselves by singing and dancing licentious songs." He continued:

These were their houses of pleasure [*maisons de plaisir*]. Here women enjoyed a bizarre privilege: they had the right to demand for themselves, without any possibility of refusal, any man who happened to pass. One should not make the great mistake of imagining that these women, who seem to occupy the position of our courtesans, were thereby scorned and condemned to perpetual prostitution. On the contrary, they were very highly regarded, and they took it upon themselves to marry only when they found someone who very much pleased them.[36]

Photographer unknown, Maori pataka (storehouse), Lake Taupo, New Zealand 1878

Tautain's tone of equanimity before the spectacle of unbridled female sexuality was rare. A more typically jaundiced view is found in a letter of 1898 written by Governor Gallet to the Ministry of Marine and Colonies in Paris. Gallet described at length the incorrigible and self-destructive habits of the "primitive and perverted beings" who inhabited the Marquesas:

> As for the family, it does not exist there. Marriages made by the missionaries and civil authorities hardly last two or three months. The best households always comprise a third man, the *pétcio* [sic] chosen by the husband to live on an equal footing with his wife [for her pleasure].
>
> At the age of puberty, the young daughters are generally initiated by their second fathers and then made to service all the other parents and friends in the vicinity, sometimes fifteen, twenty or even thirty individuals.[37]

Gallet's description of parental gang rape is improbable, to say the least, but his inflammatory language effectively conveys the near panic of colonial officials at their inability to police indigenous sexuality, or channel it into a desire for French commodities. "On Hiva-Oa," wrote F. W. Christian in his *Eastern Pacific Lands: Tahiti and the Marquesas Islands* (1910), "the nuns have an impossible task keeping the young girls on the straight and narrow path of virtue." In 1919, Frederick O'Brien stated: "The truth is that no value was, or is, attached to maidenhood in all Polynesia, the young woman being left to her

Lintel, right jamb and base carvings from "The House of Pleasure" 1902

own whims without blame or care. Only deep and sincere attachment holds her at last to the man she has chosen." O'Brien then added: "The Marquesan woman, however, often denies her husband the freedom she herself openly enjoys. This custom persists as a striking survival of polyandry, in which fidelity under pain of dismissal from the roof-tree was imposed by the wife on all who shared her affections."[38]

Precisely such accounts of polyandry (the institution of the *pekio*, or secondary husband), sexual initiation, female promiscuity, open marriage, *maisons de plaisir*, and insolence toward colonial authority lured the rebellious Gauguin to the Marquesas in the first place in 1901. In a letter to Charles Morice, Gauguin explained that peace and solitude could only be found among the cannibals on the Marquesas Islands: "I am laid up today," he wrote in July 1901, "beaten by poverty and especially the disease of premature old age. That I shall have some respite to finish my work I dare not hope: in any event I am making a final effort by going next month to settle in Fatu-Iva, a still almost cannibalistic island in the Marquesas. I believe that there, in savage surroundings, complete solitude will revive in me, before I die, a last spark of enthusiasm."[39] In the event, he settled in the town of Atuona on the island of Hiva-Oa, and resumed a life of art, libertinage and political agitation. "The House of Pleasure"– modeled from Maori meeting houses and the Marquesan women's *hae make*–was to be the temple of Gauguin's erotic and savage faith.

3 The Artist as Rebel

Within weeks of his arrival on the island of Hiva-Oa, Gauguin discovered that his particular enthusiasms were not welcomed by the local powers. Indeed, his actions and words were judged by some to be seditious. By mid-1902, colonial officials were so incensed by the artist's behavior and speech that they placed him under almost constant surveillance and began plotting ways to expel him from the Marquesas. (The irony of course is that the Marquesas Islands—along with New Caledonia—were themselves the usual destination for French political exiles.) One *agent provocateur* pithily expressed the general consensus when he dubbed the artist a "bad colonist."[40] Dossiers were compiled recounting Gauguin's support for boot-legging and tax avoidance, and claiming in general that he bore a "heavy responsibility" for the increasingly widespread pattern of indigenous resistance to colonial rule.[41] Indeed, Gauguin insinuated himself into disputes large and small and his name appears in dozens of official documents pertaining to cultural, political and economic

governance in the Marquesas. In the summer of 1902, for example, Gauguin became involved in the matter of the internment of native children in convent schools. He counseled the natives that the law of 27 August 1897 only required internment if the child lived within a four kilometer radius of the school. Thus he and the natives contrived to move Marquesan families with school age children into communities that lay just outside the prescribed perimeter. "Monsieur Gauguin, despite the difficulty he experiences walking," wrote Special Corporal Charpillet in a secret communiqué to the colonial administrator in Papeete, "has not hesitated to go by himself to the beach in order to try to convince the natives to remove their children [from the convent boarding-schools] and argue that the law cannot oblige parents to send them." For native Marquesans, the beach was the agora, the meeting place where ideas were discussed and news was spread; they went there to hear what they call "the coconut wireless." Gauguin painted such communication and dissemination in *Riders on the Beach* (1902). Charpillet continued:

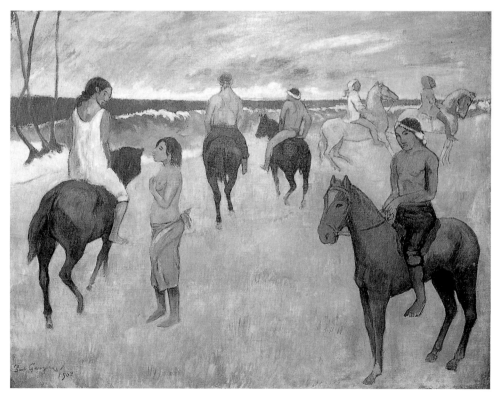

Riders on the Beach 1902

On Wednesday, August 20, some indigenes came to find me—to be precise the ones named Tenefitu and Makahooni from the valley of Vaitahu—and said: "Why did the gendarme of Vaitahu say to us that we must bring our children to school if it is not the law? Gauguin came to us on the beach and said we could take them back home." All I could do was tell them that the Governor, during his recent visit, said that the population had to send their children away to school. Despite this, the indigenes have taken back their children . . . Thus the schools are empty.

The schools were vexatious to the native Marquesans because it was abundantly clear that their primary purpose was not education but merely segregation from native families. "It is not necessary at this time to give the children a proper education," wrote Admiral Bergen in a letter from 1880 proposing the establishment of religious boarding-schools, "but simply to save them, during their early years, from debauchery and the rampant destruction of morals [that occurs in the company of their families]." Moreover, punishment in the schools tended to be quite severe. Inspector Salles's letter of 1901 specifically warranting the internment of native children makes this clear, when he writes: "the teachers are very good, with only a few criticized for brutality."[42] The resistance of Gauguin and the natives to this program was indeed successful; between 1900 and 1904 the number of students at the Catholic Community of Saint Anne at Atuona declined from seventy-five to fifty-five and the policy of forced internment was re-examined and ultimately rescinded.

What was worse than encouraging non-attendance at convent schools, Charpillet also reported, was the artist's insinuation of himself into colonial law and finance. In an unpublished letter of November 1902 for instance, Gauguin complained to the President of the Tahitian General Council in Papeete about the wanton killing of pigs which strayed onto plantation lands. His petition was recorded in the council's official minutes:

> Permit me to submit for your good judgment some observations concerning the law about rampant pigs.
> In the Marquesas there are hardly any coconut plantations, and the damage caused [by these pigs] is almost nil.
> The indigenes, having a very highly developed fraternal sentiment, arrange matters between themselves without conflict. Moreover, the pig to an indigene is like the cow to a peasant in some of our regions.

For many European colonists however, it is different.

A pig that crosses their property for even a few minutes provides sufficient rationale to kill the animal and carry it to the brigadier who will sell it for a tenth of its value. Thus there occurs a daily killing for the singular pleasure of killing and without any gain . . . an immoral spectacle and a wicked example to the indigenes, one little worthy of a people who have left barbarism behind.

The issue addressed in Gauguin's letter may at first seem trivial, but it is not. Pigs lie at the center of the indigenous economy, ecology and ritual. From the days before French colonization, travelers to the Marquesas frequently reported that although pigs were abundant, as the American David Porter wrote, "no persuasion could induce [the natives] to sell any to us, even for articles which were held in the highest estimation by them."[43] Pigs were an important food reserve in a land with limited arable soil and which was frequently subject to long droughts and brief, cataclysmic inundations. Moreover, since they were rarely bought or sold, pigs were an important instrument by which a native economy based upon the gift could be maintained at the expense of a colonial order based upon the commodity.

Gauguin's understanding of indigenous notions of reciprocity and his willingness to challenge colonial law are also revealed by his intervention in the matter of tax collection. In a letter written in early 1903, Charpillet reported that tax revenues from the Marquesas had decreased during the previous year from 20,000 to just over 13,000 francs: "The corporal sees in this deficit once again the influence of Monsieur Gauguin, who says to all who will listen, that he will not pay his taxes . . . with the result being that the natives now say that they will only pay their taxes if Gauguin does. Indeed, three or four months ago he said to the corporal: 'I will not pay, and you can do with me what you want, and if the natives were instructed properly, they would do the same and nothing could be done to them; most of them possess nothing, and the rest own in common whatever they have, and thus can avoid seizure.'"[44] The effect of Gauguin's challenge was not just financial, but political as well. French officials had long argued that efforts to suppress native culture and politics by force were counterproductive. The voluntary acceptance of a regime of taxation, as Tautain argued in a letter to Paris in 1895, would be a sure sign of indigenous subjugation.

The Marquesans, however, would not be subjugated. They became expert, Gauguin noted, at obfuscation and *sub rosa* communication. If a native Marquesan was brought before a magistrate for criminal

interrogation, Gauguin wrote in *Avant et après*, he or she "entangles the question in obscurities. Their language—always badly interpreted—gives them every facility to do this. They are able, with remarkable intelligence and imperturbable composure, to smooth over all the contradictions."[45] And even when incriminating evidence has already been collected, Gauguin adds, "all this well vouched for gossip would turn into a fable, invented to amuse the credulous European." The natives also had a knack for communicating in code. Gauguin wrote:

> Thus, for example, when the gendarmes appear, evidently in search of information, they go on talking without any sign of embarrassment. One of them says: "I think the moon is going to be very bright, so that we are not going to catch any fish." This means: "We must be on our guard and keep things dark; we must beware the brightness of the moon." The Europeans can make nothing of it, and even if they could they would not be sure.[46]

Gauguin was up to his eyes in native political struggles and intrigues. He was a "victim of society," he believed, persecuted for helping defend the natives. He explained his position to Charles Morice in 1902:

> You see how right I was to tell you in my last letter to act quickly and energetically [on my behalf]. If we are victorious the struggle will have been fine and I shall have done a great thing for the Marquesas. Many iniquities will have been done away with and it's worthwhile to suffer in such a cause. I am down but not vanquished. Is the Indian vanquished who smiles at his torturer? Decidedly the savage is nobler than we. You were mistaken that time when you said that I was wrong to call myself a savage. For it is true. I am a savage. And civilized people feel it to be so. All that is surprising and bewildering in my work is that "savagery that comes up in spite of myself." That is what makes my work inimitable. The work of a man is the explanation of the man.

Gauguin's remarks to Morice reveal his identification with the native peoples of French Polynesia. The "Indian . . . who smiles at his torturer" may be either the native Marquesan or the artist himself; Gauguin spent his early childhood in Peru and liked to imagine himself descended from an Inca. Indigene and artist alike, he apparently believed, were rebels by nature who refused to accept the rules of a colonial game in which the dice were loaded: accept the reigning hierarchies and be treated like a lowly peon or fight back and be beaten

down like a mad dog. Each stance was unstable and self-destructive. The only recourse therefore was resistance to authority through a set of complex and often changing strategies of passivity and aggression: feigned ignorance of law, refusal to vacate seized lands, failure to pay head taxes, insolence to one's putative betters, flouting of dress and gender codes, rejection of wage labor, displays of public drunkenness, participation in orgies, and ostentatious exhibition of proscribed images, dances and songs. These were some strategies of resistance to French power common to indigenes and Gauguin.

The letter to Morice is typically selfless and egotistical, humble and vainglorious. Indeed, even when he speaks up in the interest of oppressed native people, Gauguin's shrill voice can set teeth on edge. In part of course, Gauguin's tone was fostered by the political deafness of his European correspondents. They ignored his political activities, and generally dismissed as tasteless his anti-colonial diatribes. "Stay where you are and stop complaining," his friends seemed generally to be telling him. "Shut up and die, Gauguin, if you want your art to command critical respect and good prices." In response to a letter of 1902 expressing a vague desire for repatriation, the artist's best friend Daniel de Monfreid wrote:

> It is to be feared that your return would only derange the growing and slowly conceived ideas with which public opinion has sur-rounded you. Now you are that legendary artist, who, from out of the depths of Polynesia, sends forth his disconcerting and inimitable work—the definitive work of a man who has disappeared from the world. Your enemies (and you have many, as have all who trouble the mediocre) are now silent, do not dare to combat you, do not even think of it; for you are so far away! You must not return. Now you are as the great dead. You have passed into the history of art.

Gauguin's final letters, essays and artworks indicate that he did not wish to go uncomplaining into the "history of art." He would not be denied the chance to state his case as loudly and publicly as his fading strength permitted. His message, however, was contradictory.

Gauguin was not a revolutionary; he cannot be claimed to be a pre-cursor of Pouvana'a a Oopa, the great twentieth-century leader of the Tahitian independence movement. In fact, for much of his time in Polynesia, he was a rank deceiver. Gauguin was an implacable enemy of the Catholic Church, except when he was hired to be its scurrilous journalistic mouthpiece in 1898. He sought solitude and peace in the

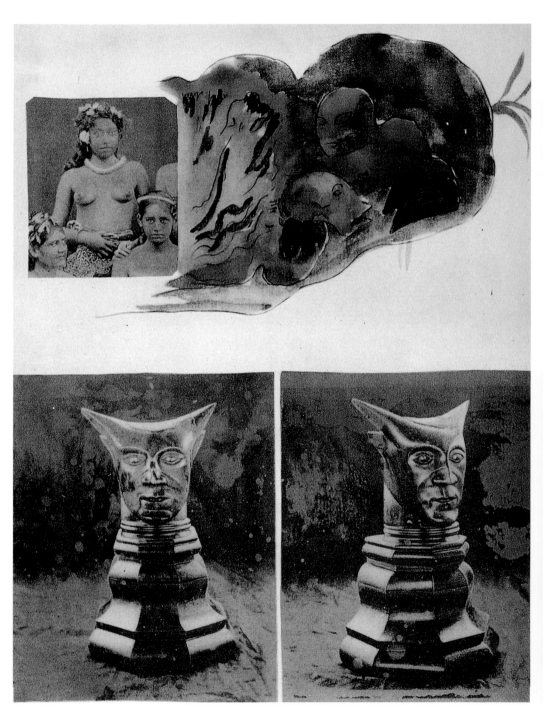

Above **Page 56 of Noa Noa 1896–1903, with photographs of lost Gauguin sculpture**
Opposite **Father Lechery c. 1901**

Marquesas, but lived the last two years of his life in Atuona on precisely the only parcel of land in a thousand miles that was within sight of a gendarmerie, a Catholic church and a Protestant mission. There he built his "House of Pleasure" on land sold to him by none other than the Catholic bishop, Joseph Martin, the very man who would soon publicly condemn the artist for depravity, and who in turn would be wickedly caricatured by Gauguin in a sculpture called *Father Lechery*. Gauguin claimed to be the protector of the indigenes, but his friends and drinking companions during his last months were instead a cross-section of French colonial misfits, refugees and apologists; they included some displaced natives and *métis* (natives of so-called mixed race), a former plantation owner, a busted gambler, an exiled Vietnamese revolutionary and a police spy. (The latter, one François Picquenot, publicly defended Gauguin against charges of slander, while privately preparing some of the confidential reports used by colonial officials against the artist.)

Gauguin took the side not only of traduced indigenes but also of aggrieved settlers in disputes with bureaucratic authority. In letters, diaries and speeches he condemned the power of colonial governors and gendarmes, and yet at other times proclaimed the virtues of France's *mission civilitrice*. At one moment he boasted membership of the class of settler élites, and at another of belonging to a tribe of savages. Priests, nuns and missionaries were generally reviled by Gauguin, yet the evangelical pastor Paul Vernier became the painter's best friend during his final weeks. Indigenous men were welcome to drink rum in the covered downstairs atrium of the "House of Pleasure," but only whites and *vahines* were permitted to visit the studio and bedroom upstairs.

Gauguin was a political agitator, yet he constantly sought official acceptance in the form of diplomatic postings and bureaucratic sinecures.

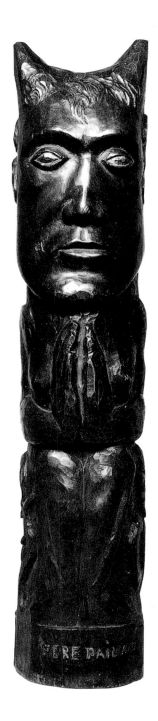

(Indeed, he had first come to Tahiti as an official emissary of the French Minister of Fine Arts, and later sought the post of Consul of the Marquesas.) The artist was unusually generous toward indigenous Marquesans and they often reciprocated with presents of food. With almost his dying breath, he courageously rallied native parents to resist the internment of their daughters in convent schools, but with a much less admirable intrepidity he also seduced (and presumably infected with his syphilis) a number of the young teenage girls whose freedom he had helped secure.

Gauguin in sum was a rebel who embraced indigenous society in part to mask his wish to be master within the colonial system: "The revolutionary wants to change the world," Sartre wrote, "he transcends it and moves toward an order of values which he himself invents. The rebel is careful to preserve the abuses from which he suffers so that he can go on rebelling against them . . . He does not want to destroy or transcend the existing order; he simply wants to rise up against it." Sartre's imputation of bad faith is partially correct in Gauguin's case: The artist invented no new "order of values," either in his life or his works; he required instead strong traditions and stable institutions—Renaissance painting and Javanese sculpture, Catholicism and Hinduism, the imperial nation state and patriarchy—against which he could rise up in ostentatious rebellion while still enacting the more or less secret melodrama of submission.

Adopting the language of ego psychology, we may speculate that Gauguin's hypocrisy was the result of a "basic fault," a psychic wound, or put more simply still, of insecurity. Unlike the American writer Henry Adams, whose small hardships on the island of Tahiti in 1891 were eased by the certainty of his own superiority to the "half-natives," "quarter-Jews," "second-rate French" and "full-blooded Negroes," that constituted local "Society," Gauguin had no such class and racial reserves upon which to draw. Indeed, his family background, his dress and manners, his strange patois, his occupation and his frequent penury must have marked him as one of those unfortunates against whom the second-raters themselves measured their worth.

But if Gauguin was to be an outcast from society, he must dictate the terms; his ostracism could not be the result of a lack, but must be the consequence of his exalted position above the common mien. Gauguin therefore could not tolerate patronizing glances and platitudinous kindnesses; he sought instead bitter disputes and scandals, lawsuits and arrest warrants. His was a nature that stood outside the constraints of historic time and colonial space; he was a savage whose

forbidden desire would bring down the entire edifice of modernization. He believed himself both a savage and a sophisticate, mistreated by enemies in the Marquesas and forgotten by friends in Europe. From such contradictions as these are political agitators and avant-garde artists made.

In fact, Gauguin had made powerful enemies in the Marquesas. By late 1902, legal and extra-legal strategies for dealing with the obstreperous artist were being devised. Deportation was one option discussed, but the process was cumbersome and expensive. Finally, on 31 March 1903, Gauguin was convicted of libeling a gendarme, fined five hundred francs and sentenced to three months in jail. Like many other debts accumulated during his last months, however, this one would remain unpaid; death would cheat Gauguin's creditors.

4 Unfinished Business

On 8 May 1903, Paul Gauguin was awakened by the familiar sounds and scents of early morning. Beneath the rhythmic clang of mission bells, the artist heard his own irregular heartbeat; amid the ambient perfume of frangipani, he smelled the rankness of his own body. Iridescent flies buzzed before alighting on the dirty bandages covering the ulcers on Gauguin's legs. They flitted like hummingbirds sampling nectar from native hibiscus and gardenia. There were no doctors in the Marquesas, and despite months of practice, the middle-aged patient in the oversized bed was not skilled at dressing his own sores.[47]

Gauguin's first act that morning was the same as his last the night before: he rolled onto his left side and inserted a syringe into his right buttock.[48] The morphine rapidly eased the pain in his legs. A dose of laudanum stimulated his heart and brain. Cigarettes, absinthe, rum, and the liberal application of rubbing alcohol were the treatments that followed; their administration commanded the artist's attention until nearly 8:00 A.M. Then, comfortably numbed and emboldened by the regime, he sat upright on the bed, parted a cloud of mosquito netting and swung his legs onto the floor. Gauguin's costume lay at his feet: a soiled and faded blue *pareu*, a green shirt, a matching green beret with a copper buckle, and a *pua*-wood walking stick, its handle carved into a large phallus.

Gauguin dressed slowly, and then stood shakily. With cautious steps, he walked through a portal leading into a disordered studio, measuring some thirty feet long by eighteen wide.[49] His vision was weakened from tertiary syphilis, but his eyes nevertheless adjusted to

the light filtering into the room from six large windows at tree-top level on walls facing west, north and east. He then directed his gaze to some pornographic photographs pinned on the walls of a small alcove nearby.[50] The harem scenes were probably purchased eight years before at Port Said in the course of Gauguin's second passage from France to Tahiti, though a lively and illegal trade in obscene books, prints and photographs was also regularly conducted on board *La Vire*, the war transport in which Gauguin had first sailed into Papeete harbor in 1891.[51] Gauguin still found these vulgarities useful, if no longer quite so stimulating: "[Native] men, women and children laughed at them," he wrote in his late journal *Avant et après*. "Only the people who called themselves respectable stopped coming to my house . . . Think this over and nail some indecency in plain sight over your door; from that time forward you will be rid of all respectable people, the most insupportable folk God has created."[52]

Turning away from the licentious photographs, Gauguin observed empty easels standing scattered throughout the room. His last shipment to Ambroise Vollard—consisting of fourteen paintings and eleven drawings—had nearly cleaned him out, and he had not touched his pencils or paints for weeks.[53] "If I can manage," he wrote in February to the critic André Fontainas, " . . . I will resume work in an attempt to finish properly the work I have commenced . . . One thing I fear is that I may become blind . . . in that case, I should be vanquished." With rest and the proper medicaments, a few more transfer drawings—what he called *dessins imprimés* (printed drawings)—could perhaps be managed. The medium, he wrote, "is of a childish simplicity." It required only ink or paint, a roller, two sheets of paper and a pencil; it did not even demand a steady hand.[54]

Gauguin approved the adage that only a genius could learn to draw like a child. The smudges, stains, figural simplifications and patterning in *Temptation*, *The Amazon* and *The Sphinx* (all 1899–1902) were satisfying records, he felt, of his descent into a world of childishness and savagery. "As you see," Gauguin wrote in 1902, "the older I get, the less civilized I become."[55] *The Sphinx* (the title is Vollard's, and probably bears no relation to the subject of the work) depicts a side-view of a young woman crawling on her elbows and knees. Her buttocks are obscenely thrust in the air and she grips a small cat in her tensed hands. Seven other women, plus an eighth figure—a mysterious archer with tensed bow—surround her at upper right and left. Above the figures at right is a roughly drawn sawtooth or arrowhead pattern, such as may be seen in many Polynesian barkcloth paintings.

The date of the sheet is uncertain and its subject is obscure. Moreover, it is unusual in its relentless diagonal hatching and in its grotesquerie; the crouching figures visible in the arch of the foreground woman's back are ape-like, and might have been inspired by the *noirs*—the lithographs and charcoals—of Gauguin's friend, the Symbolist Odilon Redon. The archer too recalls Redon's art, especially his *Centaur Aiming at the Clouds*. *The Sphinx* nevertheless, is unique in both composition and iconography and therefore prompts ethnographic speculation. It may represent Gauguin's understanding of an initiation ceremony, perhaps of an event like the *kamali kayasa* or festival of female seduction celebrated in the Trobriand Islands of Melanesia.[56] During this festival, variations of which occurred in Gauguin's Polynesia, young women were encouraged to scratch, cut and often deeply wound their young lovers with knives, arrows, sharpened shells and axes. Their ambition, Bronislaw Malinowski wrote in 1929, "was successively to slash as many men as [they] could; the ambition of [the

The Sphinx 1899–1902

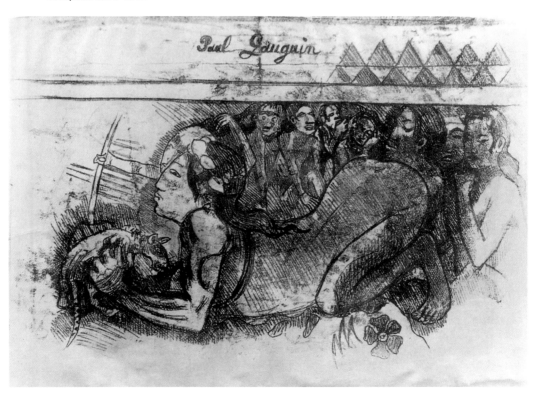

men was] to carry away as many cuts as [they] could stand, and to reap the reward in each case."[57]

Gauguin's *dessin imprimé* may alternatively allude to ceremonies performed at first menstruation, though it does not appear to depict the specifically Marquesan ritual described in 1896 by the anthropologist Tautain, in which participants adorned the thighs of the initiate with newly cut hair from family members.[58] Perhaps the only thing that can be securely stated about the subject of *The Sphinx* is that—like most of Gauguin's Polynesian artworks—it has something to do with sex. It was based on observation, memory, and imagination; it was as much ethnographic invention as representation.

Gauguin's wide-open pupils fixed on a small harmonium in a dark corner of his studio; apart from the scabrous collection of photographs, it was the only entertainment he could any longer offer visiting native women.[59] But piled on the lid of the instrument was a sobering assortment of legal documents and writs. Before anything else today, Gauguin must write again to his lawyer Léonce Brault in Papeete; the burden of a five hundred franc fine could be borne, but a term in jail would be more killing than a draught of arsenic. The critic and poet Charles Morice, and Gauguin's loyal friend and agent Daniel de Monfreid had already been told about his conviction for libel; soon all of Paris would be informed of his plight. "I am the victim," he wrote to De Monfreid in late April, "of a frightful trap." He continued:

> After scandalous happenings in the Marquesas I wrote to the Administrator, asking him to make an investigation. I had not thought that the police were all in connivance, that the Administrator would be on the side of the Governor, etc. The fact is that a lieutenant ordered me to be prosecuted, and a bandit of a judge, at the order of the prosecuting attorney, whom I had abused, has sentenced me (code of July 1881) to three months of prison and to a fine of one thousand francs, all on account of one particular letter . . . it will be said that all my life I have been fated to fall, only to pull myself up to fall again . . . each day some of my old strength forsakes me . . . All these worries are killing me.

(Gauguin had a purpose in exaggerating the fine, which was in fact only five hundred francs; De Monfreid might thereby feel inspired to squeeze more money from the artist's few European buyers.)

Gauguin also rehearsed the letter he had just sent to the lieutenant of the gendarmerie in Papeete: "It is a good thing I am the native's protector, since the impoverished settlers . . . have always been afraid to

antagonize the gendarmes and thus have kept silent . . . I am incriminated simply for defending poor defenseless people. Animals at least have a Society for the prevention of cruelty." He was certain his letter would make a strong impression and that his cause was just. At all costs, he must continue to press his case—here in the Marquesas, in Tahiti, and even in the Court of Appeal in Paris. Gauguin and his native dependents were not defenseless! Gauguin had influential friends! Deliverance from the tyranny of colonial governor, police and courts could yet be won!

A different thought nagged, however. Perhaps he was on altogether the wrong tack. Perhaps he should simply forget his struggles and hatreds, keep his own counsel and quietly trundle off to prison? Had he not once depicted himself as a criminal, "an outlaw, ill-clad and powerful like Jean Valjean"? The self-portrait entitled *Les Misérables* (1888) had long ago been exchanged for one by Vincent van Gogh, but Gauguin still believed it was among his best. It was painted in just a few days in fulfillment of a promise to Van Gogh to depict himself and Emile Bernard. The latter is represented by a green and red effigy in the upper right corner, the former by a complex and baroque bust anchoring the lower left. Between the two men, nosegays of violet and hibiscus float before a saffron-yellow field. Gauguin explained the meaning of *Les Misérables* in a letter to Van Gogh:

> [I wear] the mask of a bandit, badly dressed yet powerful, like Jean Valjean with his nobility and his sweet interior. The face is flushed, the eyes accented by the surrounding colors of a furnace-fire. This is to represent the volcanic flames that animate the soul of the artist. The drawing of the eyes and nose resembles the flowers in a Persian carpet, summarizing an abstract and symbolic art. The little background of the young girl with its childish flowers is there to attest to our artistic virginity. As for this Jean Valjean, whom society has oppressed, cast out—for all his love and vigor—is he not equally a symbol of the contemporary Impressionist painter? In endowing him with my own features I offer you—as well as an image of myself—a portrait of all wretched victims of society who avenge us by doing good.[60]

Gauguin's words were almost paraphrases of Hugo's celebrated novel; they would be repeated at the end of his life. "Between two such beings as [Vincent] and I," Gauguin wrote in early 1903, "the one a perfect volcano, the other boiling too, inwardly, a sort of struggle was preparing."[61] The "flames that animated the soul" of Gauguin were perhaps less fierce in the Marquesas, but the truth of the portrait remained.

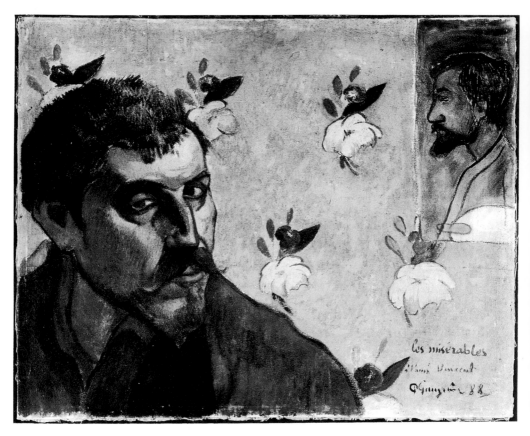

Les Misérables 1888

5 Self-Portrait

Rooted to the spot on the threshold of his cluttered studio, Gauguin considered his legal predicament and his limited options. He pictured in his mind's eye Van Gogh's *Prisoners at Exercise* (1890), after Doré, with its circle of inmates marching beneath high stone walls. He saw himself in place of the prisoner in the central foreground—the one resembling Van Gogh—who does not shrink beneath the glare of his warders, and who wears an expression of hopelessness. Surely there was as much peace as despair in that face. Had Gauguin wrongly described imprisonment, in his recent letter to the lieutenant, as "a dishonor (in our family we are not accustomed to such a thing)"? Incarceration could be a mark

of distinction and a strategy of resistance; it was in any case, hardly unknown in the Gauguin family: André Chazal, Gauguin's Peruvian grandfather, had spent twenty years in jail for shooting and wounding his wife, Flora Tristan. Besides, in prison Paul Gauguin would join the ranks of a number of excellent Symbolist writers. Some lines of verses composed by celebrated ex-convicts and *invertis* came readily to mind: "But there is no sleep when men must weep/Who never yet have wept," wrote Oscar Wilde from Reading Gaol. "What have you done, who weep,/Your endless tears? What have you done, who weep,/With youth's lost years?" wrote Paul Verlaine on the eve of his imprisonment at Les Petits-Carmes in Brussels.

VINCENT VAN GOGH Prisoners at Exercise 1890

Gauguin quickly turned to confront his own face in a mirror. While studying his own features, he remembered Verlaine's dissipated expression and ostentatious garb, and recalled the benefit held for the poet and himself on the eve of departure for the South Seas in 1891. The two Pauls had much in common, everyone agreed, including a fondness for simplicity in art and extravagance in sex. Verlaine was now long dead, however, and the painter had aged greatly in a dozen years. The face was changed even from the one he recorded in a self-portrait completed just a few months earlier and given to his Vietnamese friend Nguyen van Cam.

The Marquesan *Self-Portrait* (1902–03) was probably the last of Gauguin's self-portraits. It was retrospective and funereal, modeled in part after late Roman funerary portraits from Fayum and Thebes. The more than three-quarter view, the plain background, the Roman haircut, the severe cropping of the shoulders and the antique tunic were all derived from third century encaustic painting. The unusually distinct pattern of highlights on nose, cheeks, forehead and neck, and the extreme verticality of the portrait were also derived from the antique source.[62] Gauguin had seen funerary portraits from Roman Egypt at the Louvre, filed them in his memory and—confronted with his own imminent death—drawn from that reserve.

The face in the glass, like the face in the *Self-Portrait* was almost expressionless. Yet Gauguin's longstanding habit of assuming a disguise when gazing in a mirror—first exposed a decade and a half before in *Les Misérables* (1888), *Self-Portrait with Halo and Snake* (1889) and *Christ in the Garden of Olives* (1889)—was not so easily abandoned at his life's end. He put on his Chardinesque spectacles and imagined his hair cut short: once more he resembled the stolid sitter in the Marquesan *Self-Portrait*. Crowned with blue rays of light, the portrait head in turn recalled the ascetic bonze and artist in Van Gogh's *Self-Portrait dedicated to Paul Gauguin* (1888). In the latter, Van Gogh portrayed himself as a Buddhist monk whose wide, blank stare suggested that the search for peace extends inward as well as outward. Indeed, both Van Gogh and Gauguin were self-proclaimed visionaries pursuing unlikely exotic dreams.[63] Both men fled the alienation of metropolitan life only to find estrangement on the periphery.

At the end of his life, Gauguin was preoccupied by memories of Van Gogh. In *Avant et après*, Gauguin discussed *Les Misérables* and described the "whole series of sun-effects over sun-effects" in Van Gogh's *Portrait of Eugène Boch*. He also sought to set the official record straight as to who influenced whom: "I undertook the task of

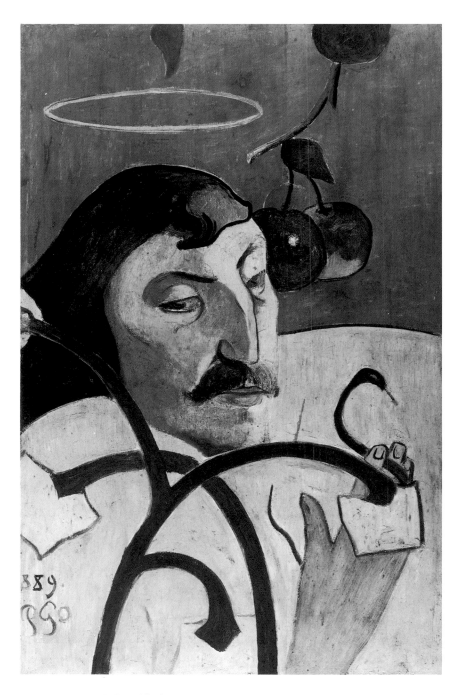

Self-Portrait with Halo and Snake 1889

Portrait of a man from the "Pollius Soter" group found at Thebes, Severan c. 193–235

Self-Portrait 1902–03

VINCENT VAN GOGH Self-Portrait dedicated to Paul Gauguin 1888

enlightening him," Gauguin wrote, "an easy matter for I found a rich and fertile soil . . . And every day he thanked me for it."[64] In addition, Gauguin sought to absolve himself of any blame for the self-mutilation and later death of Van Gogh. Gauguin writes: "The last letter I had from him was dated from Auvers."

> "Dear Master" (the only time he ever used this word), "after having known you and caused you pain, it is better to die in a good state of mind than in a degraded one." He sent a revolver shot into his stomach, and it was only a few hours later that he died, lying in his bed and smoking his pipe, having complete possession of his mind, full of the love of his art and without hatred for others.[65]

The Marquesan *Self-Portrait* was thus a homage to Van Gogh and an effort at self-justification and self-defense; it was at once a settling of accounts and a testimonial to a friend who shared with him a utopian dream of freedom.

Gauguin gave the Marquesan *Self-Portrait* to the man among his friends and acquaintances who perhaps most reminded him of Van Gogh. Nguyen van Cam, known to Gauguin by his alias "Ky-Dong," was a Vietnamese Buddhist exile who harbored a deep hatred for colonial authority. He was born in 1875 to a wealthy family in Ngoc Ding in French Indo-China, and was employed by the French civil service in the early 1890s. By the middle of the decade he was circulating seditious pamphlets under his assumed name in the region of the Mekong Delta. In 1898 he was arrested in Saigon, charged with terrorism and transported first to Guiana and later to the Marquesas. In September 1901, he was among the first to welcome Gauguin to the Marquesas, and soon thereafter helped the artist find land on which to build the "House of Pleasure." He was thus one of about a dozen men— thoroughly *encanaqué* or "primitivized"–who were the artist's close friends and drinking companions during his final months.

Van Cam was also the author of a satirical play on the subject of the perils of desire.[66] Probably written in 1901–02. *Les Amours d'un vieux peintre aux Iles Marquises* (*Loves of an Old Painter in the Marquesas*) is obviously based on the character of Gauguin. The text is vulgar and somewhat cruel, and its plot hinges upon a case of mistaken identity. Three young prostitutes steal the eyeglasses of an old "*rentier*, journalist and Symbolist painter" named Paul in order to take his money and trick him into falling in love with a hunchbacked woman called simply "Bossue." In the end, however, after much mockery and fighting, the artist and the hunchback develop a real affection for each

other, and announce their intention to remain together. Van Cam claimed in a conversation with Guillaume Le Bronnec in 1910 that his "little comedy in mock-heroic verses," was inspired by an actual incident that occurred just after Gauguin became settled in Atuona in late 1901:

> The painter was soon concerned with finding a native companion, and, as it happened, while walking we ran into five or six young Marquesan women of easy virtue whom we invited to take tea and cakes with him. Since the painter seemed very generous, they all agreed to live with him. Which one to choose? It was Fetuhonu (turtle's star) who carried the day. She was a large and beautiful girl of twenty, though she was club-footed. The rejected ones, out of spite, heaped taunts on the new couple in Marquesan, which Gauguin could not understand.
>
> I rendered this scene into a little comedy, in mock-heroic verses, which I showed Gauguin a few days later; he was heartily amused. From that day on, I remained very close to him . . . I went to see him every morning and took an aperitif with him in the evening.[67]

Though it remains uncertain if Van Cam's play was based on the anecdote or vice versa, the resemblance between the protagonist and the model is unmistakable. Indeed, one of Paul's final speeches in the play—delivered to the prostitute Germaine cross-dressed as a gendarme—attests to Van Cam's intimacy with his subject:

> I am astonished by your ignorance of my name; the world resounds with my fame . . . I personify the spirit of contradiction. I deny heaven, hell and purgatory. To the state, I express my opposition; good manners see in me their revolution. My pen and my paintbrush—those powerful armaments—are used by me to overcome stupid prejudice. My works will reveal to posterity the ample freedoms derived from pleasure![68]

Van Cam's lines appear to have come from Gauguin's own mouth. At the conclusion of "Modern Thought and Catholicism," Gauguin's unfinished theological and political tract, he writes:

> Whomsoever oppresses the people is condemned . . . to legal repression, a repression which an armed force may retard but not check. Any stream whose angry waters are dammed back, gathers force, and at the appointed time dashes everyone to pieces. Just as far as the state constitutes a policeman, as well as an executioner of society, so it will be sooner or later at the mercy of a popular

rising . . . Condemned also is the *Church*, which forgets reason, dealing with falsehood and force, to dogmatize and impose [itself] upon a suffering humanity, giving as a consolation the infamous illusion of a paradise after death . . . And she offers *Hell* to those who do not wish to believe in the absurdity.[69]

Van Cam's play is at once a travesty and a celebration of Gauguin's life and ideas. It describes a debauched artist and writer who is by turns mean-spirited and open-minded, misanthropic and idealistic, self-absorbed and generous. The play is both a crude allegory of the dangers of unbridled desire and a thinly disguised work of contemporary gossip. Not surprisingly, it was never performed and remains obscure; its author left the Marquesas for Tahiti in 1911 and died there in 1925.

6 The End

Gauguin's eyes drifted away from the mirror before him. His thoughts of Van Cam and memories of Verlaine and Van Gogh slowly faded. His former anxiety was now overcome by torpor and he sat heavily on the nearest of two camphor-wood trunks. His eyelids became heavy and he fell into a waking dream—the same he had dreamed a dozen times before. The flies that pestered him became *tupapakus*, emissaries from the Marquesan land of the dead. Daylight was changed into night and the comforting light of *ao* became the dread umbra of *po*. The face of Wagner as painted by Renoir rose up suddenly before his eyes, and some phrases from the composer's credo echoed in his brain: "I believe that the disciples of great art will be glorified, and that enveloped in a fabric of celestial rays, perfumes and melodious concords, they will be reunited for all eternity at the breast of the divine source of harmony."[70]

Amid the clash of faces and chords, a litany of sacred and profane names sounded in Gauguin's mind: Ta'aroa and Teha'amana, Bishop Martin and Governor Petit, Hina and Olympia, Eve and Seraphita, Christ and Rimbaud. Gauguin's imaginative universe was large and without clear internal divisions—characters from Romantic novels existed alongside Hebrew prophets, contemporary poets beside Polynesian gods. The boundary between waking and dreaming itself was uncertain. Gauguin had regained full consciousness by the time he repeated some words recently penned in his journal: "I remember having lived. I also remember not having lived. Not longer ago than last night I dreamed I was dead."[71]

Gauguin's eyes were wide open and his heartbeat was rapid as he examined the jumbled contents of the room before him: pornographic photographs, legal documents, stone and wooden *tikis*, a stack of odd-sized canvases, Japanese prints, a guitar, a rifle, some camera equipment, novels by Balzac and Flaubert and a dozen volumes of *Mercure de France*. (There was much more that would remain invisible until the tax assessors and creditors had their turn.) Concluding his abbreviated inventory, Gauguin stood up slowly, turned around and re-entered his bedroom aerie. The room was still and the atmosphere close. He had been wise to build his house with two storeys, using palm leaves for the roof above his head, and loosely woven bamboo for the upper walls. Yet today the heat of the day seemed trapped inside the house; it rose with the artist's fever and caused him to feel faint. He could not eat this morning, and would not bother to summon his cook Kahui or either of his other two houseboys. (Matahava and Kekela would simply have to eat with their own families today; but who would feed Pegau the dog and Taoa the cat?)[72]

Gauguin was too dizzy to descend the steep ladder that led to the ground. Leaning out of an elaborately carved wooden portal bearing the legend "Maison du Jouir," he summoned his neighbor and *tayo* Tioka.[73] "Ia ora na Gauguin," ("Good morning, Gauguin,") the painter feebly called down in greeting to the Marquesan with whom he had exchanged names. Gauguin had given half his property to Tioka after a devastating cyclone in January had inundated their lands. They now lived in the closest proximity and were like brothers. Tioka helped Gauguin with carpentry, and supplied him with fresh fish; Gauguin in turn served his *tayo* unlimited glasses of absinthe and rum, and shared with him the company of his expatriate *popa'a* friends. "Ia ora na Tioka," was the delayed echo from below. "I am sick," returned Gauguin, "please send for Vernier." Tioka was a deacon in the Protestant church and knew the pastor Paul Vernier very well. Vernier like Van Cam had some medical training, though in summoning one or the other the most important consideration was always which would do the least harm. At 9:30 A.M., Tioka left the vicinity of the "House of Pleasure" and quickly walked the mile to the church school where Vernier was teaching French to his small class of indigenous children.

In addition to receiving sympathy and medicaments, Gauguin wanted to share with his learned Protestant friend some opinions—recently set down in "Modern Thought and Catholicism"—on politics, aestheticism, and the corruption of the Catholic clergy in the Marquesas. Like most of the Protestant evangelicals in Tahiti and the

Marquesas, Vernier despised what he preferred to call "these gentlemen" and saw the artist as an ally in the sectarian contest for Marquesan souls. Gauguin in turn, was pleased whenever possible to gratify and inflame internecine colonial and religious hatreds. Two years before, in Protestant Tahiti, he had attacked Vernier in a published article in *Les Guêpes*, the organ of the Catholic party in Papeete. "Dante leading Virgil to Hell," was how Gauguin described the young evangelical's efforts to proselytize among the natives. Now in the Catholic Marquesas, he considered Vernier a friend and confidant; of late, Gauguin preferred to calumny the Catholic bishop, Joseph Martin. Among the most ostentatious examples of Gauguin's anti-Catholic *libelles* were the two wooden sculptures set at the base of the ladder leading up to Gauguin's bedroom. *Father Lechery*, which depicted Bishop Martin as a giant phallus, and *Thérèse*, which portrayed his housekeeper as a Shiva, were intended to expose a secret sexual liaison between the two.

This morning, the artist and the missionary talked for about an hour with as much animation as the former could muster. They discussed Gauguin's poor health and legal troubles; they talked as well, Vernier later reported, about Flaubert's *Salammbô*. (Perhaps they considered together the siege of Carthage and the defeat of Hamilcar; Gauguin may have enjoyed comparing himself to Hamilcar, confounded on all sides by mercenaries and barbarians and abandoned by the feckless Carthaginian people.) The literary colloquy, however, was brief today; Gauguin was easily tired, and Vernier had to return to his teaching duties. But at around 11:00 A.M., Kahui interrupted Vernier, calling him back to the "Maison du Jouir" with these words: "Come quick, the white man is dead." Vernier described the deathbed scene in a letter written a year after the event:

> I found Gauguin lifeless, one leg hanging out of the bed, but still warm. Tioka was there, he was beside himself; he said to me: "I came to see how he was, I called him from below, 'Koke Koke' [the polite, indigenous manner of announcing one's arrival] . . . Not hearing anything, I came up to see. Aie! Aie! Gauguin did not stir. He was dead." And, having said this, he began to chew hard on his friend's scalp, a particularly Marquesan way of bringing someone back to life. I myself tried rhythmic pulling of the tongue and artificial respiration, but nothing would work. Paul Gauguin was dead, and everything leads to the conclusion that he died of a sudden heart attack.

I am the only European to have seen Gauguin before he died . . . The word was that he had a family in Europe, a wife and five children. There was a photograph of a family group that, people said, was them. I saw that photograph. Moreover, people said a lot of things. We did not know what to believe. Naturally, I never asked Gauguin anything about that subject.[74]

Gauguin's wake and funeral were hurried and unseemly. On the night after his death, Gauguin's friend Emile Frébault recalled many years later, "the bishop, forgetting all the insults Gauguin heaped on him, sent a catechist and many natives to keep vigil with me all night. Before daybreak, we noticed that the body was in an advanced state of decomposition; I went to the gendarme and the bishop, and we decided to hold the funeral very early." By 1:30 P.M. on May 9, 1903, the artist was buried. "And Gauguin now rests in the Catholic Calvary," wrote Paul Vernier with indignation to Charles Morice, "sacred ground *par excellence*! In my opinion, Gauguin should have had a civil burial."

Three weeks later, the official announcements went out: "The only [recent] noteworthy event," wrote Bishop Martin, "has been the sudden death of a contemptible individual named Gauguin, a reputed artist but an enemy of God and everything that is decent." The bureaucrat Picquenot was more circumspect: "I have requested all creditors of the deceased to submit duplicate statements of their accounts, but am already convinced that the liabilities will considerably exceed the assets, as the few pictures by the late painter, who belonged to the decadent school, have little prospect of finding purchasers."

The public auction of Gauguin's worldly goods occurred on two dates: 20 July and 10 September 1903. The first sale—mostly of food, clothes, medicines and other sundries—occurred in Atuona. The chief bidders were the artist's friends, including Vernier, Tioka and Nguyen van Cam and several of Gauguin's enemies, including the Catholic church and Claverie, head of the despised gendarmerie. The second sale—consisting of books, furniture, art supplies and a few art-works—occurred in Papeete. It attracted a number of French colonials, including Brault, the lawyer and journalist, and Victor Segalen, the visiting French writer who later became celebrated for his theories of exoticism. Segalen bought well. He secured several canvases, some drawings, books, Gauguin's last palette, the carved door-frame and pediment of the "Maison du Jouir," and some scattered recollections, which he duly recorded:

One person would say: "Gauguin? A madman. He paints pink horses!" Another, a shopkeeper: "Things are going much better for him, he's even beginning to sell. There's one born every minute." A magistrate: "Gauguin gives us a lot of trouble." A pious person: "Every day he prostrates himself before a terracotta monster and they claim he's worshipping the sun." We were in the first months of the year 1903. It wasn't until June or July that they announced to me: "Oh! Gauguin passed away." . . . I purchased everything I could catch on the fly as it came up for auction.[75]

For Victor Segalen, Gauguin was every bit as racially exotic a being as the Marquesans with whom he lived; his works and personal effects must therefore be gathered together before they turned to dust, before that is, they joined the forgotten memories ("*les immémoriaux*") of the Polynesians themselves. Like Gauguin, however, the native peoples of the Pacific refused to become relics and pass into the tomb of history.

Tahitian men and women, such as those involved with the pan-Polynesian organization Hiti Tau, have embraced ancient traditions and fashions and modern political strategies simultaneously. Both of these perspectives are united in the anti-nuclear and pro-independence struggles of 1995.

Samedi
15 juillet
1995
N°10.956

37ème année

Les Nouvelles
de Tahiti

TE MAU PARAU API
NO TAHITI

110 F

Place Notre-Dame
Tel. 43.44.45. Fax 42.18.00

TAHITI NEWS

MORUROA
P.

Le cinquième zodiac «De l'intox...», affirme le général Boileau

«CÉLÉBRATIONS» DU 14 JUILLET

P. 2 et 10

CHACUN SON SYMBOLE

Alors que se déroulait le traditionnel défilé militaire, hier matin avenue Bruat,
avec notamment les légionnaires du 5e Régiment Etranger, Oscar Temaru
et ses compagnons de route embarqués sur le Rainbow Warrior étaient accueillis
comme des héros au quai d'honneur. Mais la division prévaut au sein du mouvement
de protestation anti-nucléaire, le rendez-vous fixé place Tarahoi n'ayant pas eu lieu.

(Photo: G. Kurkaaci /N. Bringold : Traitement : Photo Service : Photo Service : Sélection S.3.P. 46 43 80)

OFFENSIVE SERBE P.

Il est temps de «se ressaisir», lance J. Chirac à ses homologue

Le nono

J'sais pas comment vous vous sente
Mais moi, avec toute cette intoxicatie
A propos des essais nucléaires...
J'ai tendance à faire une fixation.
Un brin hallucinatoire !
Vous devinerez jamais sur quoi... ?
Les zodiacs !... Y sont partout.
On m'parle tellement de celui éga
Moru...
Parti au contact d'la radioactivité...
Que j'en vois partout !
Tenez, pas plus tard qu'hier matin
l'port...
Y formaient ballet pour « accueil
Oscar !
Pourtant, l'débarquement était légal
Et pis même au 14 juillet...
Dans l'avenue Bruat, j'vous assure...
Les militaires leur ont fait prendre l'e
Sur une remorque, va sans dire !
Là au moins, on risque pas une pann
moteur !

VIE SYNDICALE P.

A Tia I Mua et la CFDT sur un pied d'égalit

AUTOMOBILE P.

Le monospace Evasion de Citroën

LION'S CLUB P.

Quatre élèves méritants récompensés

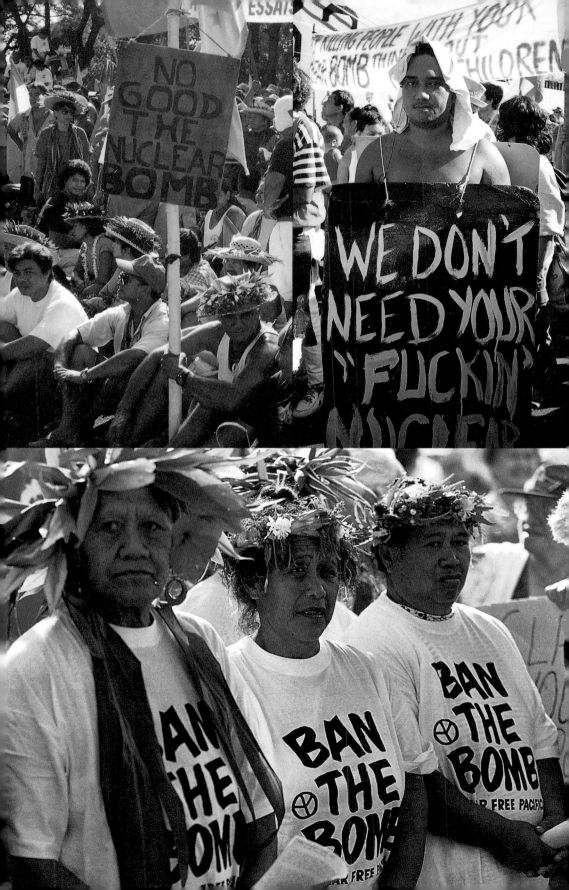

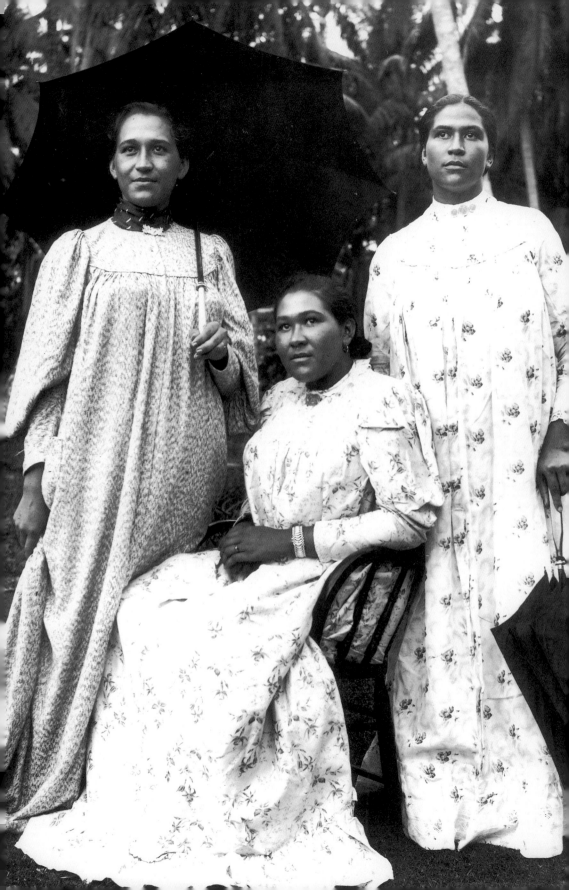

Through use of the term "primitive," Johannes Fabian wrote in *Time and the Other*, authors have lent "intellectual justification to the colonial enterprise. [They] promoted a scheme in terms of which not only past cultures, but all living societies were irrevocably placed on a temporal slope, a stream of Time—some upstream, others downstream."[1] "Primitive people," writes the American Indian activist and intellectual John Mohawk, "paid a lot of attention to dreams, to dreaming, to thinking about the universe, the interrelationship of humans and animals, to the transformation of the consciousness of human to animal. Primitives were a complex lot. Within that complexity lies the potential for a whole realm of consciousness which modern society finds unacceptable, indeed dangerous."[2] To one writer, the term primitive is the very coin of imperialism; to the other it is the currency of difference and revolution. To one, primitivism is a subset of racism and exoticism; to the other it may be a weapon with which to attack Western arrogance, capitalist greed and the very same entrenched racism.

More than a hundred years ago, the French painter Paul Gauguin held in his mind and represented in his art precisely the two contrary senses of the term primitive outlined above. His idea that contemporary Polynesian people belonged more to the past than the present, and that they were probably doomed to extirpation, was racist in the very sense described by Fabian. In answer to the journalist's question, "Why did you go to Tahiti?" Gauguin answered in 1895: "I was captivated by that virgin land and its primitive and simple race; I went back there, and I'm going to go there again. In order to produce something new, you have to return to the original source, to the childhood of mankind." However, his other idea—that modern-day Tahitians and Marquesans were people with subtle and creative minds whose conceptions of sex, nature, property and family posed a critical challenge to the received wisdom of European modernity—was incisive in just the way discussed by Mohawk. This particular critical primitivism was incipient, I have argued, in such works by Gauguin as *Merahi metua no Tehamana, Te nave nave fenua, Where Do We Come From?* and *Tahitian Woman and Boy*. The full development of this critical perspective could not be achieved by Gauguin; it would await the appearance of modern and contemporary

Three fashionable Tahitian women who have brilliantly appropriated colonial regalia, photographed by
HENRY LEMASSON c. 1895

anti-colonial and indigenous rights movements in Polynesia, Australia, North America and elsewhere.

Advocates of the Maoritanga (Maoriness) or Mana Maori (Maori power) movement in New Zealand for example, embrace an identity that derives both from ancient Maori and modern *pakeha* (white) traditions. Their primitivist emphasis upon ancestor worship, magic and a spiritual relationship to nature has permitted them to articulate a critical perspective on economic modernization, and to construct a persuasive model of what anthropologist Anne Salmond calls "the experience of bicultural living" in New Zealand.[3] Indeed, recent Maori leaders such as the anthropologist and tribal chief Sir Hugh Kawharu have effectively combined modern law and primitive semantics for the purpose of more effectively implementing the nineteenth-century Treaty of Waitangi granting land rights to native peoples.[4] Primitivist reinterpretation of Western legal and political terms like "sovereignty" have permitted Maoris to regain at least a small portion of their stolen lands and to press claims for still more territory. In the Western Pacific and elsewhere, primitivism has been shown to possess legal validity and strategic value.

French Polynesia too has recently emerged as an important locus for critical primitivism. Maohi men and women, such as the those involved with the pan-Polynesian organization Hiti Tau, have simultaneously embraced what they believe to be ancient traditions and fashions and modern radical political strategies. The Tahitian cultural and political activist Pito Clement for example, rejects all European-style clothes in favor of *pareus*, tattoos and a hairstyle that recalls William Hodges's drawing of the Tahitian man Tu. During a large 1995 Bastille Day rally in opposition to French atomic testing, Pito delivered a stirring oration in Tahitian to a large crowd gathered around a mock grave in central Papeete honoring the nuclear victims of Moruroa. At prescribed moments, a group of indigenous men and woman dressed in *pareus*, carrying bundles of palm leaves and crowned with flower tiaras, sounded a dirge by blowing into conch shells. This precisely stagecrafted demonstration, combined with others that day and after, was enormously effective; French Bastille Day exhibitions of military and cultural might were eclipsed by the massive display of primitive Maohi authority.

In Tahiti, the very same primitivism that functions to attract tourists is also used to foster Maohi solidarity and to stimulate resistance to French colonial domination. *Pareus*, outrigger canoe races, native dance competitions, tattoos and pagan ceremonies at rebuilt *maraes*

(stone temple platforms) are all primitivisms designed to appeal to *popa'a* sensibilities; they are at the same time, however, expressions of Maohi pride and anti-colonial commitment. The 1995 *heiva* (dance festival and contest) was held in July as usual, at the waterfront stadium at the Place Vaiete in Papeete harbor. French naval warships were docked in full view of the spectators and performers in the arena, casting a nuclear pall over the festivities. In this emotionally and politically charged context, the choreography of Manouche Lehartel, director of the Museum of Tahiti and its Islands, was particularly controversial. Her entry on the theme of *ao* (day) and *po* (night), was at once erotic and nightmarish and seemed a pointed affront to French national sensibilities. A few days later, a parade of several dozen *raeraes* in the Avenue Pomare raised cries of immorality and scandal. *Mahus* or *raeraes*, we have seen, are often visible in public in the company of French sailors, bureaucrats and businessmen; this display of sexual and Maohi identity, however, was clearly intended as an affront to colonial decorum.

The future course of indigenous political struggles was obviously unknown in Paul Gauguin's day; the anti-colonial effort was then in its infancy, and the artist cannot be claimed as a founding figure of the Tahitian autonomy movement. Yet the colonial significance of Gauguin can be briefly summarized: on the edge of colonial complicity, the artist shrank from the barbarous implications of his thoughts and deeds. He could not accept the racist and nationalist arrogance of past and present apologists for colonialism such as French ministers Jules Ferry in the 1880s and Theophile Delcassé in the 1890s.[5] He condemned them and their ideas in letters and journal entries written during the last decade of his life, and created a succession of works that questioned the prevailing racist and nationalist assumptions of his day.

On the threshold of insight, however, Gauguin often retreated from the radical implications of his perspective. He was never consistently anti-racist and anti-imperialist, as were the socialist politician Jean Jaurès in France and William Morris in England.[6] In an article published in *Les Guêpes* in 1900, Gauguin decried the presence of "twelve million Chinese in the Pacific." He objected to their growing role in local commerce, their clannishness and (contradictorily) their intermarriage with whites and Tahitians. "What is the famous invasion of Attila the Hun," Gauguin asks, "whose terror history hands down to us, next to this onslaught?" He continued, monstrously: "This yellow stain soiling our national flag brings a flush of shame to my face."[7] Gauguin was equally racist in his representations of the Jew Jacob Meyer de Haan, whose portrait he painted in 1889 and again in 1902 in *Primitive Tales*. In each

case he stereotypically depicts his friend with skullcap, slanted eyes, red hair and cloven hands and feet.

Gauguin's art, like his thought, thus enacted a colonial two-step as faltering and uncertain as his first footfalls down the gangplank of *La Vire* on 12 June 1891. Every aesthetic and political breakthrough was followed by a setback. He represented the intellectual breadth and cultural sophistication of indigenous women, but in some works depicted them as immature children. He devised hybrid pictorial forms inspired by Old Master paintings, Polynesian crafts and Buddhist sculpture, but in some works reverted to the trite conventions of European Salon painting.

Gauguin remains today an ambiguous figure in the Pacific, insecurely wedged between the past and the present, and between colonial and indigenous society. "Here we are in the Maison Gauguin," Joinville Pomare jokingly said to me as we reached a *fare* with lattice walls and a tin roof. The house and surrounding farm were neatly tucked into a valley, beside a swift flowing stream just a few miles north-east of Papeete. The land had been illegally seized from the colonial government by activists from the Pomare Party, and given to Roti Make, her husband Tahaeura Teihoarii and their children. The family raised chickens and tended volcanic hillsides planted with taro, vanilla and a number of vegetables. The house, along with outhouse, plant nursery and grounds, was extremely clean and orderly, and the Sunday afternoon meal they served me was copious and delicious. They had caught the fish and grown the bananas themselves.

My new friends and I had met just two days earlier during an anti-nuclear rally, and I had not yet told them I was writing a book about Gauguin. I was thus startled to hear Pomare compare this handsome *fare* to the houses in Tahiti and the Marquesas that belonged to the French painter. With some hesitation, I proceeded to mention my research in the local archives and then asked—somewhat vaguely—why he had called this *fare* "the Maison Gauguin," and what Gauguin meant to him. Pomare answered that Gauguin's houses, like this one, were open to the elements and set back in the forest. He then laughed, looked at the others and told me that Gauguin was a rogue who liked to screw eight-year-old girls. "Do you think of him as a French colonist or as a Tahitian?" I asked. Pomare joked vulgarly in French and Tahitian at my expense, and then answered seriously that he believed Gauguin was an intelligent artist who asked questions that remained salient today. Pomare then cited Gauguin's manifesto painting: "Who are you? Where do you come from? Where is your family? Where is your land? What is

your future? These are the questions we ask each other all the time here in Tahiti."

The interrogatives above express an indigenous concern with identity and tradition that is clearly pan-Pacific.[8] They are the questions that Western Pacific Maori ask each other, and that Hawaiians in the east similarly pose. Oceanic peoples have always been vitally concerned with lineage and genealogy, yet Pomare's questions would probably not have been asked by Tahitians of Gauguin's day. "Where do you come from? Who are you? Where are you going?" are specifically European primitivist questions. In Tahiti today they indicate the migration of an old European ideology to a new geographical and cultural context in which self-definition has become the necessary precondition for political solidarity and the attainment of economic autonomy. Gauguin's achievement was thus to have taken primitivism—born in the brains of Rousseau, Diderot and the rest—and transported it physically to the colonies where it might eventually do some good.

Introduction
Notes to pages 15–21.

1. David Sweetman, *Paul Gauguin: A Complete Life*, London, 1995.
2. Charles Morice, *Gauguin*, Paris, 1919; 2nd ed., Paris, 1920.
3. Robert Rey, *Gauguin*, London, 1924, p. 7. A strikingly similar formulation may be found in Henri Dorra, "The First Eves in Gauguin's Eden," *Gazette des beaux-arts*, 6th ser., vol. 40, March 1953, p. 197.
4. Wayne V. Andersen, *Gauguin's Paradise Lost*, New York, 1971.
5. Françoise Cachin, *Gauguin*, Bambi Ballard, tr., Paris, 1990, p. 275.
6. Bengt Danielsson, "Gauguin's Tahitian Titles," *Burlington Magazine*, vol. 109, April 1967, pp. 228–233.
7. Carol Duncan, "Virility and Domination in Early Twentieth-Century Vanguard Painting," *Feminism and Art History*, Norma Broude and Mary D. Garrard, eds, New York, 1982, p. 294.
8. Aijaz Ahmad, *In Theory: Classes, Nations, Literatures*, London, 1992. See also Linda Nochlin, "The Imaginary Orient,"*Art in America*, LXXI, May 1983, pp. 118–131; 187–191, and Zeynep Celik and Leila Kinney, "Ethnography and Exhibitionism at the Expositions Universelles," *Readings in Nineteenth-Century Art*, Upper Saddle River, N.J., 1996, pp. 181–211.
9. Abigail Solomon-Godeau, "Going Native," *Art in America*, LXXVII, July 1989, pp. 119-128; 161.
10. Griselda Pollock, *Avant-Garde Gambits 1888–1893: Gender and the Colour of Art History*, London, 1993.
11. Homi K. Bhabha, "Signs Taken for Wonders: Questions of Ambivalence and Authority under a Tree outside Delhi, May 1817," *Critical Inquiry*, 12:1, 1985, p. 156; cited in Robert J. C. Young, *Colonial Desire: Hybridity in Theory, Culture and Race*, London and New York, 1985, p. 23.
12. Ranajit Guha, ed., *Subaltern Studies I: Writings on South Asian History and Society*, Delhi, 1982. See also Gayatri Chakravorty Spivak, "Can the Subaltern Speak? Speculations on Widow Sacrifice," in Cary Nelson and Lawrence Grossberg, eds, *Marxism and the Interpretation of Culture*, London,1988, pp. 271–313.

On "Hottentot" and the naming of the indigenous people of
Southern Africa, see Edwin N. Wilmsen, *Land Filled with Flies:
The Political Economy of the Kalahari*, Chicago, Ill., 1989,
pp. 24–32; also see Robert J. Gordon, *The Bushman Myth: The
Making of a Namibian Underclass*, Boulder, Colo., 1992, pp. 4–7.

13. Richard S. Field, *Paul Gauguin: The Paintings of the First Trip to
Tahiti*, New York and London, 1977; Ziva Amishai-Maisels,
Gauguin's Religious Themes, New York and London, 1985; Jehanne
Teilhet-Fisk, *Paradise Reviewed: An Interpretation of Gauguin's
Polynesian Symbolism*, Ann Arbor, Mich., 1975. An exceptional
effort to place Gauguin in the context of European ethnographic
writing is found in Petra-Angelika Rohde, *Paul Gauguin auf Tahiti*,
Rheinfelden, 1988.

14. My use of the term "hybrid" is somewhat idiosyncratic. As indicated
earlier, post-colonial theory has tended to describe social and
cultural hybridity as a species of anti-colonial resistance. This
presumption is too often untested, however; in particular cases,
combinations of religious, artistic or political practices may serve to
support or negate colonial regimes and hegemonic ideas. Paul
Gauguin's particular representations of Tahitian hybridity never
entered fully into late nineteenth- and early twentieth-century
debates about imperialism, and thus cannot be claimed to be either
contestatory nor affirmative. The paintings are, however, richly
historical, and thus exist as valuable resources for radical politics.
I am in general agreement with Nicholas Thomas who writes of
hybridity: "the awkward botanical metaphor a) conflates a variety
of kinds of cultural mixing and b) in general, assumes that these
have subversive effect or progressive value. At a theoretical level,
I do not really accept that creolized or hybrid cultural forms *in
principle* can bear these values. In the Polynesian context I would
want to suggest that the 'hybridity' of syncretic Christianity is very
different to that of Gauguin's persona and work, and that the
former should not be seen as part of a deliberate anti-colonial
effort, even though a number of new religious movements certainly
were and are consciously and ingeniously politicized. In many
cases, the politics of Pacific Christianities aim to subvert and trans-
form indigenous orders rather than colonial dominance (which in
some instances manifests the relatively weak character of the
latter)." Correspondence with the author, 6 March 1996.

15. Nicholas Thomas, *Colonialism's Culture: Anthropology, Travel and
Government*, Princeton, N.J., 1994.

Chapter One
Notes to pages 27–85.

1. Georges Wildenstein, "Le premier séjour de Gauguin à Tahiti d'après le manuscrit Jénot (1891–1893), "*Gazette des beaux-arts*, 6th ser., vol. 47, January–April 1956, p. 117.
2. Archives d'Outre-Mer, Aix-en-Provence, Series C, 9, 40, 13 April 1891.
3. George W. Stocking, Jr, "The Turn of the Century Concept of Race," *Modernism/Modernity*, vol. 1, no.1, January 1994, p. 8.
4. Félix Fénéon, "L'Exposition Volpini," *La Cravache*, 6 July 1889; in *Au delà de l'Impressionnisme: Fénéon*, Françoise Cachin, ed., Paris 1966, p. 109.
5. Victor Merlhès, ed., *Correspondance de Paul Gauguin 1873–1888*, Paris, 1984, no. 141.
6. Henri Dorra, ed., *Symbolist Art Theories: A Critical Anthology*, Berkeley, Calif. and Los Angeles, Calif., 1995, p. 197.
7. Victor Merlhès, ed., *Correspondance de Paul Gauguin 1873–1888*, Paris, 1984, no. 159.
8. Paul Gauguin, *The Writings of a Savage*, ed. Daniel Guérin, New York, 1978, pp. 177–179.
9. Jules Huret, "Paul Gauguin devant ses tableaux," *Echo de Paris*, 23 February 1891, p. 2; cited in Richard Brettell et al., *The Art of Paul Gauguin*, Boston, Mass., 1988, p. 161.
10. *The Complete Letters of Vincent van Gogh*, vol. 3, Greenwich, Conn., 1958, p. 483.
11. Alternatively, he may have been alluding to Herman Melville's *Typee* (1846), New York, 1979; few other nineteenth-century texts presented so sympathetic a picture of indigenous Marquesans, and even fewer would have encouraged Van Gogh in his condemnation of the European infections of "alcohol . . . money and . . . syphilis."
12. *The Complete Letters of Vincent van Gogh*, vol. 3, Greenwich, Conn., 1958, p. 483.
13. Lee Johnson, *The Paintings of Eugène Delacroix*, Oxford, 1981, vol. 1, pp. 78–79.
14. See the excellent catalogue *The Orientalists: Delacroix to Matisse*, Mary Anne Stevens, ed., London, 1984.
15. William Rubin, ed., *Primitivism in Twentieth Century Art*, vol. 1, New York, 1985, p. 101.
16. See, for example, *Notices coloniales publiées à l'occasion de l'Exposition Universelle d'Anvers*, 3 vols, Paris,1885.

17. *The Complete Letters of Vincent van Gogh*, vol. 3, Greenwich, Conn., 1958, p. 430.

18. Victor Merlhès, ed., *Correspondance de Paul Gauguin 1873–1888*, Paris, 1984, p. 274; cited in Françoise Cachin, *Gauguin*, Bambi Ballard, tr., Paris, 1990, p. 75.

19. Tzvetan Todorov, *On Human Diversity: Nationalism, Racism and Exoticism in French Thought*, Catherine Porter, tr., Cambridge and London, 1994, p. 311.

20. Pierre Loti, (Julien Viaud), *Le Mariage de Loti*, Paris, 1880, p. 21. Originally published as *Rarahu: idylle polynésienne*, Paris, 1879.

21. *Ibid.*, p. 126.

22. Gustave Le Bon, *The Psychology of Peoples*, New York, 1912, p. 35; cited in Tzvetan Todorov, *On Human Diversity: Nationalism, Racism and Exoticism in French Thought*, Catherine Porter, tr., Cambridge and London, 1994, p. 55.

23. Frederick O'Brien, *White Shadows in the South Seas*, New York, 1919, p. 68.

24. Claude Blanckaert, "On the Origins of French Ethnology: William Edwards and the Doctrine of Race," in *Bones, Bodies, Behavior: Essays on Biological Anthropology*, George W. Stocking, Jr, ed., Madison, Wis., 1988, p. 19.

25. Charles Darwin, *The Descent of Man and Selection in Relation to Sex*, London, 1901, pp. 282–283.

26. Maurice Barrès, *Scènes et doctrines du nationalisme*, vol. 2, Paris, 1925, p. 189.

27. Claude Blanckaert, "On the Origins of French Ethnology: William Edwards and the Doctrine of Race," in *Bones, Bodies, Behavior: Essays on Biological Anthropology*, George W. Stocking, Jr, ed., Madison, Wis., 1988, pp. 18–55. See also Leon Poliakov, *Le mythe Aryen: Essai sur les sources du racisme et des nationalismes*, Paris, 1971.

28. Léopold de Saussure, *Psychologie de la colonisation française*, Paris, 1899, passim.

29. Maurice Barrès, *L'Œuvre de Maurice Barrès*, Paris, 1965–69, vol. 2, p. 174; cited in Tzvetan Todorov, *On Human Diversity: Nationalism, Racism and Exoticism in French Thought*, Catherine Porter, tr., Cambridge and London, 1994, p. 233.

30. Charles Harrison and Paul Wood, eds, *Art in Theory*, Oxford, 1992, pp. 223–224.

31. *Ibid.*, p. 227.

32. Michèle C. Cone, "Vampires, Viruses and Lucien Rebatet:

Anti-Semitic Art Criticism During Vichy," *The Jew in the Text*, Linda Nochlin and Tamar Garb, eds, London, 1995, pp. 174–186.

33. See for example Richard Herrenstein and Charles Murray, *The Bell Curve: Intelligence and Class Structure in American Life*, New York, 1994; see also J. Philippe Rushton, *Race, Evolution and Behavior: A Life History Perspective*, New Brunswick, N.J., 1995. For a concise and effective criticism of the latter see C. Loring Brace, "Racialism and Racist Agendas," *American Anthropologist*, vol. 98, no. 1, March 1996, pp. 176–177.

34. Gustave Le Bon, *The Psychology of Peoples*, New York, 1912, p. 51; cited in Tzvetan Todorov, *On Human Diversity: Nationalism, Racism and Exoticism in French Thought*, Catherine Porter, tr., Cambridge and London, 1994, p. 108.

35. On theories of racial hybridity see Robert C. Young, *Hybridity in Theory, Culture and Race*, London, 1995, pp. 6–19.

36. Renato Rosaldo, *Culture and Truth: The Remaking of Social Analysis*, Boston, Mass., 1989, pp. 68–87.

37. Pierre Loti, (Julien Viaud), *Le Mariage de Loti*, Paris, 1880, p. 214. Originally published as *Rarahu: idylle polynésienne*, Paris, 1879.

38. Maurice Malingue, ed., *Paul Gauguin: Letters to His Wife and Friends*, Henry J. Stenning, tr., London, 1946, and Cleveland, Ohio and New York, 1949, p. 137.

39. Douglas Cooper, ed., *Paul Gauguin: 45 Lettres à Vincent, Théo et Jo van Gogh*, The Hague and Lausanne, 1983, no. 41, p. 315.

40. *The Complete Letters of Vincent van Gogh*, vol. 3, Greenwich, Conn., 1958, p. 284.

41. Maurice Malingue, ed., *Paul Gauguin: Letters to His Wife and Friends*, Henry J. Stenning, tr., London, 1946, and Cleveland, Ohio and New York, 1949, p. 142.

42. *Ibid.*, p. 148.

43. *Ibid.*, p. 118.

44. Léon Henrique et al., *Les colonies françaises: Tahiti, Iles sous-le-vent*, Paris, 1889; cited in Bengt Danielsson, *Gauguin in the South Seas*, London, 1965 and New York, 1966, p. 25.

45. "Un Lettre inedité de Gauguin," *Les Marges*, vol. 14, May 1918, pp. 168–169.

46. Maurice Malingue, ed., *Paul Gauguin: Letters to His Wife and Friends*, Henry J. Stenning, tr., London, 1946, and Cleveland, Ohio and New York, 1949, p. 162.

47. Paul Gauguin, *Noa Noa*, Nicholas Wadley, ed., with introduction, Salem, N.H., 1985, pp. 13–14.

48. *Gauguin's Letters from the South Seas*, Ruth Fielkovo, tr., with a foreword by Frederick O'Brien, New York, 1992, p. 16.

49. Bronislaw Malinowski, *Argonauts of the Western Pacific*, Prospect Heights, Ill., 1984, p. 6.

50. Achille Delaroche, "Concerning the Painting of Paul Gauguin," *L'Ermitage*, 1894; in *Gauguin: A Retrospective*, Marla Prather and Charles F. Stuckey, eds, New York, 1987, p. 228.

51. François Thiébault-Sisson, "Les Petits Salons," *Le Temps*, 2 December 1893; in *Gauguin: A Retrospective*, Marla Prather and Charles F. Stuckey, eds, New York, 1987, p. 218.

52. Claude Lévi-Strauss, *Structural Anthropology*, Claire Jacobson and Brooke Grundfest Schoepf, trs, New York, 1963, pp. 215–216.

53. E. S. Craighill Handy, *Marquesan Legends*, Honolulu, Hawaii, 1930, pp. 115, 117, 124 and passim.

54. Claude Lévi-Strauss, *Structural Anthropology*, Claire Jacobson and Brooke Grundfest Schoepf, trs, New York, 1963, p. 216.

55. Paul Gauguin, *Noa Noa*, O. F. Theis, tr., New York, 1985, p. 30.

56. Alan Howard and Robert Borofsky, eds, *Developments in Polynesian Ethnology*, Honolulu, Hawaii, 1989, p. 77.

57. The name Tehura replaces Teha'amana in the second draft of *Noa Noa* (Louvre, MS of 1893–97); it was possibly derived from the male character named Téharo in *The Marriage of Loti*. He is described on pp. 171–172 as "a tall figure, thoughtful and silent." Alternatively, see note 43 to Chapter Two.

58. Paul Gauguin, *The Writings of a Savage*, Daniel Guérin, ed., New York, 1978, p. 137.

59. Richard Brettell et al., *The Art of Paul Gauguin*, Boston, Mass., 1988, p. 307.

60. Paul Kay, "Tahitian Words for Race and Class," in *Essays in Honor of Douglas Oliver*, Honolulu, Hawaii, 1974, passim.

61. Paul Gauguin, *The Writings of a Savage*, Daniel Guérin, ed., New York, 1978, p. 48.

62. *The Intimate Journals of Paul Gauguin*, London, 1985, p. 46.

63. Stanley Diamond, *In Search of the Primitive: A Critique of Civilization*, New Brunswick, N.J., 1987.

64. Arthur O. Lovejoy and George Boas, *Primitivism and Related Ideas in Antiquity* (1935), New York, 1965.

65. Denis Diderot, "Supplement to Bougainville's 'Voyage'," in *Rameau's Nephew and other Works*, Jacques Barzun and Ralph H. Bowen, trs, Garden City, N.Y., 1956, p. 197. In *Le Sourire*, Gauguin briefly commended Diderot, Bougainville and Rousseau for their

contemporaneity. *Le Sourire de Paul Gauguin*, no. 4, November 1899, with intro. and notes by L.-J. Bouge, Paris, 1952.

66. A. N. de Condorcet, *Sketch for a Historical Picture of the Progress of the Human Mind*, June Barraclough, tr., London, 1979.

67. Lewis Henry Morgan, "Animal Psychology," in Marc Swetlitz, "The Minds of Beavers and the Minds of Humans," *Bones, Bodies, Behavior: Essays on Biological Anthropology*, George W. Stocking Jr, ed., Madison, Wis., 1988, p. 66.

68. Friedrich Engels, *The Origins of the Family, Private Property and the State*, with introduction and notes by Eleanor Burke Leacock, New York, 1990, p. 237.

69. Karl Marx, "Contribution to the Critique of Hegel's Philosophy of Law" (1843), in Karl Marx and Friedrich Engels, *Collected Works*, vol. 3, New York, 1975, pp. 3–129.

70. Karl Marx, "The Eighteenth Brumaire of Louis Bonaparte," in *The Marx-Engels Reader*, Robert C. Tucker, ed., New York, 1972 and London, 1978, p. 597; cited in Vincent Geoghegan, *Utopianism and Marxism*, London and New York, 1987, p. 58.

71. Jean-Jacques Rousseau, *A Discourse on the Origins of Inequality*, Maurice Cranston, tr., London, 1984, p. 115.

72. Robert C. Tucker, ed., *The Marx-Engels Reader*, New York, 1972 and London, 1978, p. 160.

73. Eleanor Burke Leacock and Christine Ward Gaily, "Primitive Communism and its Transformations," in *Dialectical Anthropology: Essays in Honor of Stanley Diamond*, vol. 1, Gainesville, Fla., 1992, pp. 98–99.

74. Jean Baronnet and Jean Chalou, *Communards en Nouvelle-Calédonie: histoire de la déportation*, Paris, 1987.

75. See, for example, Vicomte d'Haussonville, *Les Etablissements pénitentaires en France et aux colonies*, Paris, 1875.

76. Karl Marx, "Address to the International Working Class," (1848) cited in Wolfgang Abendroth, *A Short History of the European Working Class*, New York and London, 1972, p. 31.

77. Paul Lafargue, *The Right to Be Lazy* (1885), Chicago, Ill., n. d., p. 29; *The Evolution of Property from Savagery to Civilization*, London, 1890, p. 8; both cited in Vincent Geoghegan, *Utopianism and Marxism*, London and New York, pp. 60–61.

78. Roseline Bacou and Ari Redon, eds, *Lettres de Gauguin, Gide, Huysmans, Jammes, Mallarmé, Verhaeren . . . à Odilon Redon*, Paris, 1960, p. 193.

79. *The Intimate Journals of Paul Gauguin*, London, 1985, pp. 131–132.

80. Paul Gauguin, *The Writings of a Savage*, Daniel Guérin, ed., New York, 1978, p. 174.

Chapter Two
Notes to pages 91–147.

1. Griselda Pollock, *Avant-Garde Gambits 1888–1893: Gender and the Colour of Art History*, London, 1993, p. 71.
2. Gustave Le Bon, *The Psychology of Peoples*, New York, 1912, p. 36; cited in Tzvetan Todorov, *On Human Diversity: Nationalism, Racism and Exoticism in French Thought*, Catherine Porter, tr., Cambridge and London, 1994, p. 114.
3. Luce Irigaray, *The Sex Which Is Not One*, Catherine Porter and Carolyn Burke, trs, Ithaca, N.Y., 1985.
4. Sherry Ortner, "Is female to male as nature is to culture?" In Michelle Rosaldo and Louise Lamphere, eds, *Woman, Culture and Society*, Stanford, Calif., 1974, pp. 67–88.
5. Marilyn Strathern, "No nature, no culture: the Hagen case," in *Nature, Culture and Gender*, Carol P. MacCormack and Marilyn Strathern, eds, Cambridge, 1980, p. 219.
6. Marilyn Strathern, *The Gender of the Gift*, Berkeley, Calif., Los Angeles, Calif., and Oxford, 1988, pp. 309–310.
7. Michel Foucault, *The History of Sexuality: Volume I*, New York, 1978, p. 154; cited in Henrietta Moore, *A Passion for Difference*, Bloomington, Ind., and Indianapolis, Ind., 1994, p. 12.
8. See the discussion in T. Laquer, *Making Sex: Body and Gender from the Greeks to Freud*, Cambridge, Mass., 1990, pp. 232–243.
9. L. Canler, *Mémoires de Canler, ancien chef du service de sûreté* (1862), Paris, 1968; cited in Claude Courouve, *Vocabulaire de l'homosexualité masculine*, Paris, 1985, p. 211.
10. Karl Heinrich Ulrichs, "Vier Briefe," *Jahrbuch fur sexuelle Zwischenstufen*, vol. 1, Leipzig, 1899, p. 54; cited in Gert Hekma, "'A Female Soul in a Male Body': Sexual Inversion as Gender Inversion in Nineteenth-Century Sexology," in *Third Sex, Third Gender: Beyond Sexual Dimorphism in Culture and History*, Gilbert Herdt, ed., New York, 1994, p. 219.
11. Claude Courouve, *Vocabulaire de l'homosexualité masculine*, Paris, 1985, p. 144.
12. "Un grand sommeil noir," written on the eve of Verlaine's imprisonment for shooting Rimbaud, was copied in a letter from 1899:

Un grand sommeil noir	(*In slumber's night*
Tombe sur ma vie:	*my life sinks deep;*
Dormez, tout espoir,	*then sleep all hope,*
Dormez, toute envie!	*all envy sleep.*
Je ne vois plus rien,	*I see no more;*
Je perds la mémoire	*memories fail*
Du mal et du bien . . .	*of good, of ill . . .*
O la triste histoire!	*O sorry tale!*
Je suis un berceau	*A cradle I,*
Qu'une main balance	*hand-rocked at will*
Au creux d'un caveau:	*within a tomb:*
Silence, silence!	*peace, peace, be still!*)

Paul Verlaine, *Œuvres poétiques complètes*, Y. G. Le Dantec and Jacques Borel, Paris, 1962, p. 279; in Paul Verlaine, *The Sky above the Roof*, London, 1957, p. 75. In fact, Gauguin cited the first four lines of the poem at the head of a letter to André Fontainas, dated March 1899. (Maurice Malingue, ed., *Paul Gauguin: Letters to His Wife and Friends*, Henry J. Stenning, tr., London, 1946, and Cleveland, Ohio and New York, 1949, p. 215.) The poet and the painter were the beneficiaries of a matinée held in their honor at the Vaudeville Theatre in Paris on 21 May 1891. (See Henry Fouquier, "L'Avenir Symboliste," *Le Figaro*, 24 May 1891, p. 1.)

13. Claude Courouve, *Vocabulaire de l'homosexualité masculine*, Paris, 1985, p. 107. Verlaine himself used the word in his self-justification published in *La Vie Parisienne* on 26 September 1891, (Courouve, p. 107).

14. Henry Fouquier, "L'Avenir Symboliste," *Le Figaro*, 24 May 1891, p. 1.

15. Jules Lemaître, *La Revue bleue*, January 1888; cited in Charles Chadwick, *Verlaine*, London, 1973, p. 116. In their art, Verlaine and Gauguin displayed economy and simplicity in inverse proportion to the complexity of their thought and the scale of their ambition. Verlaine's rejection of the standard alexandrine in favor of 5-, 7-, 9-, 11- or 13-syllable lines emphasized musicality and rhythm in place of meaning and discursiveness; in the same way, Gauguin's near elimination of three-dimensional space in favor of flat fields of color bounded by heavy lines highlighted pattern and surface at the expense of representation and narrative. The poet and the painter were seen as artists who embraced regression—understood by them and their contemporaries to mean the childlike, the primitive, and

the pornographic—as a liberation from monogamous marriage and bourgeois politics.

16. Marla Prather and Charles F. Stuckey, eds, *Gauguin: A Retrospective*, New York, 1987, pp. 248; 377–378.

17. Armand Séguin, "Paul Gauguin," *L'Occident*, March 1903; cited in *Gauguin: A Retrospective*, Marla Prather and Charles F. Stuckey, eds, New York, 1987, pp. 100–101.

18. Jules Agostini, *Tahiti*, Paris, 1905, pp. 68–69.

19. *Le Sourire*, August 1899, Bibliothèque Nationale, DC 600, boîte 3, res.

20. See, for example, Nicholas Thomas, *Oceanic Art*, London, 1995, pp. 60–67.

21. *The Intimate Journals of Paul Gauguin*, London, 1985, pp. 2 and 62. Paul Déroulède (1846–1914) was a Boulangist and anti-Semitic leader of the Ligue des Patriotes. Edouard Drumont (1844–1917) was a xenophobe and proto-fascist whose *La France juive* (1886) was the most influential anti-Semitic tract of the *fin de siècle*.

22. *The Journal of James Morrison*, London, 1935, p. 238; cited in Robert I. Levy, "The Community Function of Tahitian Male Transvestism: A Hypothesis," *Anthropological Quarterly*, vol. 44, 1971, p. 12.

23. See the useful summaries in Niko Besnier, "Polynesian Gender Liminality Through Time and Space," in *Third Sex, Third Gender: Beyond Sexual Dimorphism in Culture and History*, Gilbert Herdt, ed., New York, 1994, pp. 285–328; Raleigh Watts, "The Polynesian Mahu," *Oceanic Homosexualities*, Stephen Murray, ed., New York and London, 1992, pp. 171–184; and Niko Besnier, "Sluts and Superwomen: The Politics of Gender Liminality in Urban Tonga," unpublished manuscript.

24. Jules Garnier, *Océanie*, Paris, 1871, p. 354.

25. L. Canler, *Mémoires de Canler, ancien chef du service de sûreté* (1862), Paris, 1882, vol. 2, p. 118; cited in Gert Hekma, "'A Female Soul in a Male Body': Sexual Inversion as Gender Inversion in Nineteenth-Century Sexology," in *Third Sex, Third Gender: Beyond Sexual Dimorphism in Culture and History*, Gilbert Herdt, ed., New York, 1994, p. 230.

26. Ernest and Pearl Beaglehole, *Ethnology of Pukapuka*, Honolulu, Hawaii, 1938. Even Bronislaw Malinowski is approbative in matters of homosexuality in the Trobriands. See *The Sexual Life of Savages*, New York, 1929, pp. 471–473.

27. Robert I. Levy, *Tahitians: Mind and Experience in the Society Islands*, Chicago, Ill. and London, 1973, pp. 134–135.

28. I have no direct knowledge of *pitaes*. The category was described to me by the anthropologist Deborah Elliston during our joint discussions and research in the summer of 1995.

29. Jeanette Marie Mageo, "Male Transvestism and Cultural Change in Samoa," *American Ethnologist*, vol. 19, no. 3, August 1992, pp. 443–459.

30. Robert I. Levy, *Tahitians: Mind and Experience in the Society Islands*, Chicago, Ill. and London, 1973, p. 119.

31. A. R. Radcliffe-Browne, "On Joking Relationships," *Africa*, vol. 13, 1940, pp. 195–210. See also Mary Douglas, "The Social Control of Cognition: Some Factors in Joke Perception," *Man*, vol. 3, no. 3, September 1968, pp. 361–376; and Keith H. Basso, *Portraits of "The Whiteman,"* Cambridge, 1979.

32. Victoria S. Lockwood, *Tahitian Transformation: Gender and Capitalist Development in a Rural Society*, Boulder, Colo. and London, 1993, pp. 105–107.

33. On the symbolism of hair in Polynesia, see, for example, Jeanette Marie Mageo, "Hairdos and Don'ts: Hair Symbolism and Sexual History in Samoa," *Man*, vol. 29, no. 2, June 1994, pp. 407–432.

34. Robert C. Suggs, "Sex and Personality in the Marquesas: A Discussion of the Linton-Kardiner Report," in Donald S. Marshall and Robert C. Suggs, eds, *Human Sexual Behavior: Variations in the Ethnographic Spectrum*, New York, 1971, p. 169.

35. Paul Gauguin, *Racontars de Rapin*, Victor Merlhès, ed., Taravoa, Tahiti, 1994, n. p.

36. Jeanette Marie Mageo, "Hairdos and Don'ts: Hair Symbolism and Sexual History in Samoa," *Man*, vol. 29, no. 2, June 1994, pp. 407–408, 412–413. Bengt Danielsson claims that the model was red-haired as "the result of some mysterious racial inter-mingling in prehistoric times," (*Gauguin in the South Seas*, London, 1965 and New York, 1966, p. 244).

37. Guillaume Le Bronnec, "La Vie de Gauguin aux Iles Marquises," *Bulletin de la Société des Etudes Océaniennes*, vol. ix, no. 5, March 1954, p. 206; cited in Bengt Danielsson, *Gauguin in the South Seas*, London, 1965 and New York, 1966, p. 244.

38. Paul Gauguin, *Noa Noa*, O. F. Theis, tr., New York, 1985, p. 20.

39. Maurice Malingue, ed., *Paul Gauguin: Letters to His Wife and Friends*, Henry J. Stenning, tr., London, 1946, and Cleveland, Ohio and New York, 1949, p. 103.

40. Paul Gauguin, *Noa Noa*, O. F. Theis, tr., New York, 1985, p. 14.

41. Paul Gauguin, "Modern Thought and Catholicism," unpublished

manuscript, Frank Pleadwell, tr., Saint Louis Museum of Art Collection, pp. 88–89.

42. *Flora Tristan's London Journal* (1840), Dennis Palmer and Giselle Pincetl, trs, Charlestown, Mass., 1980, pp. 72–73. Flora Tristan was frequently in Gauguin's thoughts during the final months of his life. "She was connected with all sorts of socialist affairs," he wrote in early 1903, "among them the workers' union . . . It is probable she did not know how to cook. A socialist-anarchist bluestocking! To her, in association with Père Enfantin, was attributed the founding of a certain religion, the religion of MaPa, in which Enfantin was the god Ma and she the goddess Pa." *The Intimate Journals of Paul Gauguin*, London, 1985, pp. 74–75.

43. In later drafts of *Noa Noa*, she is called Tehura. Much ink has been spilled on the discrepancy of names, but the most likely solution is that his model and lover was named Teha'amana a Tahura (Bengt Danielsson, *Gauguin à Tahiti et aux Iles Marquises*, Papeete, 1975, p. 298). A notice in the *Messager de Tahiti* (10–25 August 1895) lists one Temana Teura as the recipient of a third division prize from the free school of the Sisters of Saint Joseph of Cluny.

44. Herbert Spencer, *Descriptive Sociology: A Cyclopedia of Social Facts: Lowest Races, Negrito Races, and Malayo-Polynesian Races*, New York, 1874, n. p.

45. Henri le Chartier, *Tahiti et les colonies françaises de la Polynésie*, Paris, 1887. See also his *Guide de France en Océanie et d'Océanie en France*, Paris, 1889.

46. Horace Walpole, *Correspondence*, xviii, London, 1983, p. 342; cited in Francis Haskell and Nicholas Penny, *Taste and the Antique*, New Haven, Conn. and London, 1981, p. 235. (My thanks to Kathy Adler for first bringing the *Hermaphrodite* to my attention.)

47. T. J. Clark, *The Painting of Modern Life: Paris in the Art of Manet and his Followers*, New York, 1985, pp. 123–129.

48. Bengt Danielsson (*Gauguin in the South Seas*, London, 1965 and New York, 1966, p. 282) received information about Teha'amana from her friends and contemporaries.

49. Charles Morice, "Exposition d'œuvres récentes de Paul Gauguin," Paris, November 1893; reprinted and translated in *Gauguin: A Retrospective*, Marla Prather and Charles F. Stuckey, eds, New York, 1987, p. 217.

50. Théophile Gautier, *Mademoiselle de Maupin* (1835), Joanna Richardson, tr., Harmondsworth, 1981, pp. 329–330; cited in

Marjorie Garber, *Vested Interests: Cross Dressing and Cultural Anxiety*, New York and London, 1992, p. 11.

51. Victor Hugo, *Les Misérables* in *Œuvres complètes*, Paris, 1908, p. 384; cited in Kathryn M. Grossman, "Narrative Space and Androgyny in *Les Misérables*," *Nineteenth-Century French Studies*, vol. 20, nos 1–2, Fall–Winter 1991–92, p. 102.

52. Passages cited from Kathryn M. Grossman, "Narrative Space and Androgyny in *Les Misérables*," *Nineteenth-Century French Studies*, vol. 20, nos 1–2, Fall–Winter 1991–92, p. 102.

53. Paul Gauguin, *Cahier pour Aline*, facsimile, Suzanne Damiron, ed., Paris, 1963.

54. Honoré de Balzac, *La Comédie humaine: Etudes philosophiques, II, Etudes Analytiques*, Marcel Bouteron, ed., Paris, 1950, p. 469. In *Le Sourire* (no. 1, August 1899) Gauguin refers again to Seraphita/Seraphitus in his animated discussion of the plot of a play performed in Tahiti: "Et le monstre, étreignant sa créature, féconde de sa semence, des flancs généreux pour engendrer Seraphitus Seraphita." The line also accompanies a drawing of *Oviri* (*Savage*) inserted into the pages of *Le Sourire* (Musée du Louvre, Cabinet des Dessins, R. F. 28. 844).

55. Paul Gauguin, *Noa Noa*, Nicholas Wadley, ed., with introduction, Salem, N.H., 1985, p. 37.

56. For more on *tupapa'u* see Anthony Hooper, "Tahitian Folk Medicine," in *Essays in Honor of Douglas Oliver*, Honolulu, Hawaii, 1974, pp. 61–80.

57. Marshall Sahlins, *How "Natives" Think: About Captain Cook for Example*, Chicago, Ill. and London, 1995, p. 171.

58. *Ibid.*

59. The Hawaiian historian Lilikala Kame'eleihiwa has recently written: "It is interesting to note that in Hawaiian, the past is referred to as *Ka wa mamua* [in Tahitian *te matamua*] or 'the time in front or before.' Whereas the future, when thought of at all, is *Ka wa mahope* [in Tahitian *te amuria'e*], or, 'the time which comes after or behind.' It is as if the Hawaiian stands firmly in the present, with his back to the future, and his eyes upon the past, seeking historical answers for present-day dilemmas. Such an orientation is to the Hawaiian an eminently practical one, for the future is always unknown, whereas the past is rich in glory and knowledge."

60. "Genesis of a Painting" is included in Paul Gauguin, *Cahier pour Aline*, facsimile, Suzanne Damiron, ed., Paris, 1963.

61. Honoré de Balzac, *Seraphita*, Katherine Prescott Wormeley, tr., with introduction by George Frederic Parsons, Boston, 1889, pp. 69–70, 77.
62. *Ibid.*, p. 121.
63. *Gauguin's Letters from the South Seas*, Ruth Pielkovo, tr., with a foreword by Frederick O'Brien, New York, 1992, p. 49.
64. *Ibid.*, p. 64.
65. *The Complete Letters of Vincent van Gogh*, vol. 3, Greenwich, Conn., p. 183.
66. Gustave Geffroy, "Gauguin," *Le Journal*, 20 November 1898; cited in *Gauguin: A Retrospective*, Marla Prather and Charles F. Stuckey, eds, New York, 1987, p. 281.
67. André Fontainas, "Art moderne: Exposition Gauguin," *Mercure de France*, 29 January 1899, p. 238; tr. in *Gauguin: A Retrospective*, Marla Prather and Charles F. Stuckey, eds, New York, 1987, p. 286.
68. Henri Dorra, ed. *Symbolist Art Theories: A Critical Anthology*, Berkeley, Calif. and Los Angeles, Calif., 1995, pp. 208–209.
69. *Sartor Resartus* was also translated into French in 1895 and published in instalments in *Mercure de France*. Gauguin subscribed to this journal.
70. Thomas Carlyle, *Sartor Resartus*, Kerry McSweeney and Peter Sabor, eds, Oxford and New York, 1987, pp. 42–43.
71. Cited in Jehanne Teilhet-Fisk, *Paradise Reviewed: An Interpretation of Gauguin's Polynesian Symbolism*, Ann Arbor, Mich., 1975, p. 53.
72. In general, too, Gauguin's picture represents stages of life, or what Arnold van Gennep in 1908 was to call *les rites de passage*. Though the painter neither depicts specific life-crisis ceremonies, nor distinguishes rituals of *séparation* (separation), *marge* (transition) and *agrégation* (incorporation) as Van Gennep later attempted, he does, however, show Tahitian life as a ritual cycle from birth, to youth, to maturity to death. The sleeping child visible at the far right may inherit the spirit (*varua*) of a deceased parent or grandparent by means of their ghost (*tupapa'u*), seen at the far left; the androgyne at the center who plucks a fruit begins a sexual journey that may lead him/her from boy to *mahu* to husband to father. Arnold van Gennep, *The Rites of Passage*, Chicago, Ill., 1975.

1. John La Farge, *Reminiscences of the South Seas*, Garden City, N.Y., 1916, p. 315.
2. J. C. Levenson et al., eds, *The Letters of Henry Adams*, vol. 3, Cambridge and London, 1982, p. 411.
3. See for example, "La Police rurale," *L'Océanie française*, 19 February 1887, p. 2.
4. Dora Hort, *Tahiti, Garden of the Pacific*, London, 1891, pp. 23–24.
5. F. W. Christian, *Eastern Pacific Lands: Tahiti and the Marquesas Islands*, London, 1910, p. 83.
6. Archives d'Outre-Mer, Aix-en-Provence, SG Océanie, Carton 64, Q 3, no. 32, p. 25.
7. Bengt Danielsson and P. O'Reilly, eds, *Gauguin: Journaliste à Tahiti et ses articles des "Guêpes,"* Paris, 1966, pp. 52–53.
8. Bernard Dorival, "Sources of the Art of Gauguin from Java, Egypt and Ancient Greece," *Burlington Magazine*, vol. 93, April 1951, pp. 121–122.
9. Bengt Danielsson (*Gauguin à Tahiti et aux Iles Marquises*, Papeete, 1975, p. 73) has argued that the picture represents prostitutes in the central market of Papeete. On the Papeete "flesh market," see Paul Claverie, *Pages détachées*, Paris, 1894, pp. 133–135. In *Latitude 18 South: A Sojourn in Tahiti*, Cedar Rapids, Iowa, 1940, pp. 35–36, Irene Dwen Andrews described the Papeete waterfront as "formerly a cesspool of vice." She then added: "Today the rarer arrival of sailors has enabled the hopelessly promiscuous native girl to use a little discretion at least, and comparatively little disease is introduced by the more respectable travelers. The weekly inspection of all girls known to associate with the waterfront life is a stronger deterrent still, as they are compelled to stand in line outside the health office to be jeered and laughed at by a roistering crowd of riff-raff."
M. Gilles Artur, director of the Gauguin Museum in Tahiti has made a similar suggestion about the subject of *Ta matete*. Oral communication, 20 July 1995.
10. Colin Newbury, *Tahiti Nui: Change and Survival in French Polynesia, 1767–1945*, Honolulu, Hawaii, 1980.
11. *Décrets et arrêtés concernant l'organisation judiciaire des E. F. O.*, Papeete, 1890, p. 135.
12. An anti-nuclear dance performance and fashion show was staged

by Teresia Teaiwa, among others, in Suva, Fiji, in July 1995.
(Sophie Foster, "300 Attend World's First Anti-Nuclear Fashion
Show," *Tok Blong Pasifik*, September–December 1995, vol. 49,
nos. 3–4, p. 8.)

13. Maurice Malingue, ed., *Paul Gauguin: Letters to His Wife and
Friends*, Henry J. Stenning, tr., London, 1946, and Cleveland, Ohio
and New York, 1949, p. 203.

14. Indeed, the leader of the rebellion, the proud and fanatical
Teraupo'o, was arrested on 18 February 1897, and deported with
a number of other rebels to Papeete, *en route* to the penal colony at
Nouméa, New Caledonia, where he joined the ranks of the other
"savages" from France.

15. Paul Gauguin, *Les Guêpes*, no. 5, 12 June 1899; in *Gauguin:
Journaliste à Tahiti et ses articles des "Guêpes,"* Bengt Danielsson
and P. O'Reilly, eds, Paris, 1966, p. 25.

16. *The Intimate Journals of Paul Gauguin*, London, 1985, pp. 115–116.

17. Archives d'Outre-Mer, Aix-en-Provence, SG Océanie, A 144, carton
131, p. 3.

18. An interesting early account of the myth and reality of Marquesan
cannibalism is contained in Herman Melville, *Typee* (1846), New
York, 1979, pp. 257–266.

19. Paul Gauguin, *Racontars de Rapin*, Monaco, 1993, p. 50.

20. Charles Clavel, *Les Marquisiens*, Paris, 1885, n. p. See also Siméon
Delmas, "Essai d'histoire de la Mission des Iles Marquises," *Annales
des Sacrés-Cœurs*, Paris, 1905–11; cited in Siméon Delmas,
La Religion ou le paganisme des Marquisiens, Paris, 1927, p. 108.

21. Cited in Bengt Danielsson, *Gauguin in the South Seas*, London,
1965 and New York, 1966, pp. 269–270.

22. E. S. Craighill Handy, *Marquesan Legends*, Honolulu, Hawaii, 1930,
p. 5. See also Karl von den Steinen, "Marquesanische Mythen,"
Zeitschrift für Ethnologie, vol. 65: pp. 1–44; 326–373; vol. 66:
pp. 191–240; and Robert C. Suggs, "Sex and Personality in the
Marquesas: A Discussion of the Linton-Kardiner Report," in Donald
S. Marshall and Robert C. Suggs, eds, *Human Sexual Behavior:
Variations in the Ethnographic Spectrum*, New York, 1971,
pp. 163–186.

23. *The Intimate Journals of Paul Gauguin*, London, 1985, p. 43.
On wrapping in the Marquesas see A. Gell, *Wrapping in Images:
Tattooing in Polynesia*, Oxford, 1993; cited in Nicholas Thomas,
Oceanic Art, London, 1995, p. 107. On Gauguin's late drawing after
a Marquesan stone sculpture (*takaii*), see Merete Bodelsen,

"Gauguin and the Marquesan God," *Gazette des beaux-arts*, vol. 57, March 1961, pp. 167–180.

24. Paul Gauguin, *Racontars de Rapin*, Monaco, 1993, n. p.

25. Jules Garnier, *Océanie*, Paris, 1871, p. 328.

26. Edward Said, *Orientalism*, New York, 1978, p. 207.

27. Fiches de Police, Archives de Papeete; cited in Pierre Yves Toullelan, *Tahiti Colonial*, Paris, 1984, p. 288. Many colonists arrived in Tahiti nearly broke. When asked why he had not brought with him adequate capital to establish a business, an immigrant of the time responded: "If I had any, I would not have come here." (Charles de Varigny, "La France dans l'Océan Pacifique," *Revue des deux mondes*, vol. 44, 1882, p. 413.) The economic weakness of the colony was summarized in many reports of the period. See for example P. Bracconi, "La Colonisation française à Tahiti," *Questions diplomatiques et coloniales*, vol. 224, 1906, pp. 807–818. The oppressiveness of French colonial law and administration is effectively summarized in Jean-François Baré, *Tahiti, Les Temps et les pouvoirs: pour une anthropologie historique du Tahiti post-européen*, Paris, 1987.

28. M. Hercouet, "Etude sur Tahiti," *Bulletin de la Société de Géographie de Rochefort*, 1880–81, p. 109; in Pierre Yves Toullelan, *Tahiti Colonial*, Paris, 1984, p. 291.

29. Cited in Pierre Yves Toullelan, *Tahiti Colonial*, Paris, 1984, p. 63.

30. Frederick O'Brien, *White Shadows in the South Seas*, New York, 1919, p. 73.

31. M. Vincendon-Dumoulin and C. Desgraz, *Iles Marquises, ou Nouka-Hiva*, Paris, 1843, p. 287.

32. M. Dumoutier, *Notice phrénologique et ethnologique sur les naturels de l'Archipel Nouka-Hiva (Iles Marquises)*, Paris, 1843, p. 6.

33. Max Radiguet, *Les Derniers Sauvages: Souvenirs de l'occupation française aux Iles Marquises*, Paris, 1860, p. 124.

34. Archives d'Outre-Mer, Aix-en-Provence, SG Océanie, carton 98, H 31, n. p.

35. Robert Louis Stevenson, *In the South Seas*, London, 1900, p. 43.

36. L. Tautain, "Etude sur le mariage chez les Polynésiens (*Mao'i*) des Iles Marquises," *L'Anthropologie*, vol. 6, 1895, p. 647.

37. Archives d'Outre-Mer, Aix-en-Provence, SG Océanie, carton 131, A 144, p. 3. On polyandry in the Marquesas, see L. Tautain, "Etude sur le mariage chez les Polynésiens (*Mao'i*) des Iles Marquises," *L'Anthropologie*, vol. 6, 1895, pp. 640–650. A modern account is Nicholas Thomas, "Polyandry and Domestic Structures in the

Marquesas," in Margaret Jolly and Martha Macintyre, eds, *Family and Gender in the Pacific: Domestic Contradictions and Colonial Impact*, Cambridge, 1988.

38. Frederick O'Brien, *White Shadows in the South Seas*, New York, 1919, p. 109.

39. Maurice Malingue, ed., *Paul Gauguin: Letters to His Wife and Friends*, Henry J. Stenning, tr., London, 1946, and Cleveland, Ohio and New York, 1949, p. 226.

40. Report of Special Agent François Piquenot, Taiohae, 30 August 1902; in Archives d'Outre-Mer, SG Océanie, carton 64, n. p. "Quant à M. Gauguin il assume une lourde responsabilité; mais si vous ne pouvez l'empêcher d'agir dans la circonstance, vous devez en ce qui concerne son refus de payer les impôts, le considérer comme le premier contribuable venu. A-t-il satisfait [illegible] prescriptions des articles 43, 44, et 45 de l'arrêté du 16 fevrier 1889, n. 749? Si non, veuillez-vous conformer aux règles prescrites par les articles 59–60 et suivantes du même arrêté. C'est votre devoir et personne ne peut vous blâmer de le rempolie."

41. Archives d'Outre-Mer, Aix-en-Provence, SG Océanie, carton 64, Q 3, n. p.

42. *Ibid.*

43. David Porter, *Journal of a Cruise Made to the Pacific Ocean . . . in the United States Frigate Essex*, New York, 1822; cited in Nicholas Thomas, *Marquesan Societies*, Oxford, 1990, p. 133.

44. Archives d'Outre-Mer, Aix-en-Provence, SG Océanie, carton 64, n. p.

45. *The Intimate Journals of Paul Gauguin*, London, 1985, p. 52.

46. On the relation between Symbolist art and criminal argot or "anti-languages," see Natasha Staller, "Babel: Hermetic Languages, Universal Languages, and Anti-Languages in *Fin de Siècle* Parisian Culture," *The Art Bulletin*, vol. lxxvi, no. 2, June 1994, esp. pp. 348–354.

47. Guillaume Le Bronnec, "La Vie de Gauguin aux Iles Marquises," *Bulletin de la Société des Etudes Océaniennes*, vol. ix, no. 5, March 1954, pp. 198–211; Henri Jacquier, "Histoire locale: le dossier de la succession Paul Gauguin," *Bulletin de la Société des Etudes Océaniennes*, vol. x, no. 7, September 1957, pp. 673–711. On the absence of doctors in the Marquesas during this period, see the letter, dated 12 April 1902, of the Governor of the Colonies, Edouard Petit, to the Minister of the Colonies in Paris, in Archives d'Outre-Mer, Aix-en-Provence, SG Océanie, carton 106, A 57, n. p.

48. According to Baufré, Gauguin "the shaggy and drink-ruined Frenchman" injected morphine into his stomach. See the account of Gauguin's life and death in Frederick O'Brien, *White Shadows in the South Seas*, New York, 1919, pp. 144–153.

49. See the reconstruction of the "House of Pleasure" in Bengt Danielsson, *Gauguin in the South Seas*, London, 1965 and New York, 1966, pp. 238–239.

50. *The Intimate Journals of Paul Gauguin*, London, 1985, p. 3.

51. The sale and display of obscene "livres, écrits, brochures, journaux, dessins, gravures, lithographies ou photographes" on board *La Vire* was declared a violation of the law of 19 July 1881, according to a court case of 2 January 1889; cited in *Décrets et arrêtés concernant l'organisation judicaire des E. F. O.*, Papeete, 1890, p. 135.

52. *The Intimate Journals of Paul Gauguin*, London, 1985, p. 3.

53. Paul Gauguin, *Racontars de Rapin*, Victor Merlhès, ed., Taravao, Tahiti, 1994, p. 117.

54. In a letter to Gustave Fayet dated March 1902, Gauguin described his technique of transfer drawing: "With a roller, you coat a sheet of ordinary paper with printer's ink; then, on another sheet placed over it, you draw whatever you want. The harder and thinner your pencil (as well as your paper), the thinner the line . . . I forgot to tell you that if the spots on the paper bother you, all you have to do is watch until the surface of the ink is dry without being totally so. All this to each one's temperament . . . " in *Gauguin: A Retrospective*, Marla Prather and Charles F. Stuckey, eds, New York, 1987, pp. 299–300.

55. Paul Gauguin, *Racontars de Rapin*, Monaco, 1993, p. 51.

56. Bronislaw Malinowski, *The Sexual Life of Savages in North-Western Melanesia*, New York, 1929, pp. 256–261.

57. *Ibid.*, pp. 257–258.

58. L. Tautain, *L'Anthropologie*, vol. vii, 1896, p. 546; cited in Robert W. Williamson, *The Social and Political Systems of Central Polynesia*, vol. 2, Cambridge, 1924, p. 203.

59. The pornographic prints were obtained at Port Said in 1895, according to the recollection of Gauguin's friend Louis Grelet, interviewed by Danielsson. See Bengt Danielsson, *Gauguin in the South Seas*, London, 1965 and New York, 1966, p. 238. Information reiterated in correspondence with the author, 4 March 1995.

60. Douglas Cooper, ed., *Paul Gauguin: 45 Lettres à Vincent, Théo et Jo van Gogh*, The Hague and Lausanne, 1983, pp. 243–245. See also Victor Merlhès, *Paul Gauguin et Vincent van Gogh, 1887–1888*, Taravao, Tahiti, 1989, pp. 99–107.

61. *The Intimate Journals of Paul Gauguin*, London, 1985, p. 9.
62. Several examples of encaustic painting from Roman Egypt were available for Gauguin to have seen in the Louvre. These include three portraits from Thebes (N2733, nos. 1, 2, 3) that entered the museum in 1826. An additional portrait from Fayum (AF6883) bears an almost uncanny resemblance to Gauguin, but its date of acquisition is unknown. (My thanks to Marie-France Aubert of the Louvre's Département des Antiquités Egyptiennes for her kind assistance in this matter.)
63. *The Complete Letters of Vincent van Gogh*, vol. 3, Greenwich, Conn., 1958, p. 544a. Twice before, Gauguin had portrayed himself as Van Gogh. In his ceramic *Jug in the Form of a Head, Self-Portrait* (1889), Gauguin recalled his discovery of the earless and bloodied Van Gogh after the Christmas Eve self-mutilation. In *Christ in the Garden of Olives* (1889), Gauguin depicts the savior with his own features but the red hair and beard of Van Gogh.
64. *The Intimate Journals of Paul Gauguin*, London, 1985, pp. 14–15.
65. Also see Gauguin's letter to André Fontainas from 1902:
"If you have an opportunity, study Van Gogh's painting before and after my stay with him at Arles. Van Gogh, influenced by his neo-Impressionist studies, always worked with strong contrasts of tone on a complementary yellow, on violet, etc. Whereas later, following my advice, and my instructions, he worked quite differently. He painted yellow suns on a yellow surface, etc., and learned the orchestration of pure tone by all the derivatives of this tone."
Maurice Malingue, ed., *Paul Gauguin: Letters to His Wife and Friends*, Henry J. Stenning, tr., London, 1946, and Cleveland, Ohio and New York, 1949, pp. 230–231.
66. Ky-Dong, (Nguyen van Cam), *Les Amours d'un vieux peintre aux Iles Marquises*, Jean-Charles Blanc, ed., Paris, 1989.
67. Guillaume Le Bronnec, "La Vie de Gauguin aux Iles Marquises," *Bulletin de la Société des Etudes Océaniennes*, vol. ix, no. 5, March 1954, pp. 203–204.
68. Ky-Dong, (Nguyen van Cam), *Les Amours d'un vieux peintre aux Iles Marquises*, Jean-Charles Blanc, ed., Paris, 1989, pp. 48–49.
69. Paul Gauguin, "Modern Thought and Catholicism," unpublished manuscript, Frank Pleadwell, tr., Saint Louis Museum of Art Collection.
70. Roseline Bacou and Ari Redon, eds, *Lettres de Gauguin, Gide, Huysmans, Jammes, Mallarmé, Verhaeren . . . à Odilon Redon*, Paris, 1960, p. 194. See also Henri Dorra, "Le Texte Wagner de

Gauguin," *Bulletin de la Société de l'Histoire de l'Art Français*, 1984. Recalling Renoir's 1882 portrait of Wagner, Gauguin wrote: "In an exhibition on the Boulevard des Italiens, I saw a strange head. I do not know why, but something happened inside of me and I heard strange melodies. The head of a doctor, very pale, with eyes that do not look at you, that do not see but listen."

71. *The Intimate Journals of Paul Gauguin*, London, 1985, p. 62.

72. Taoa was the name of the cat Gauguin kept during his time in Brittany in 1894. The name of his last cat in the Marquesas is unknown, but the artist tended to reuse particularly favored names. On the death of Taoa, see *Paul Gauguin: Letters to His Wife and Friends*, Maurice Malingue, ed., and Henry J. Stenning, tr., London, 1946, and Cleveland, Ohio and New York, 1949, p. 195. "Pegau" is a short form of the artist's own name "P. Gau . . . " Gauguin frequently signed his works "PGO." "Pego" was also Victorian slang for penis. See Anon., *The Pearl*, London, 1885 and New York, 1988, passim.

73. On name exchange, see Guillaume Le Bronnec, "La Vie de Gauguin aux Iles Marquises," *Bulletin de la Société des Etudes Océaniennes*, vol. ix, no. 5, March 1954, p. 206. On the institution of *tayo* in the Marquesas and elsewhere, see Robert W. Williamson, *The Social and Political Systems of Central Polynesia*, vol. 3, Cambridge, 1924, pp. 157–161.

74. Jean de Rotonchamp, *Paul Gauguin*, Paris, 1925; cited in *Gauguin: A Retrospective*, Marla Prather and Charles F. Stuckey, eds, New York, 1987, p. 337.

75. Victor Segalen, "Homage to Paul Gauguin," cited in *Gauguin: A Retrospective*, Marla Prather and Charles F. Stuckey, eds, New York, 1987, pp. 340–341.

Conclusion
Notes to pages 201–205.

1. Johannes Fabian, *Time and the Other: How Anthropology Makes Its Object*, New York, 1983, p. 16.

2. John Mohawk, "In Search of Noble Ancestors," *Dialectical Anthropology: Essays in Honor of Stanley Diamond*, vol. 1, *Civilization in Crisis: Anthropological Perspectives*, Gainesville, Fla., 1992, p. 33.

3. Cited in Allan Hanson, "The Making of the Maori: Culture Invention

and its Logic," *American Anthropologist*, 1989, p. 897.

4. Sir Hugh Kawharu, Plenary Lecture, unpublished, Association of Social Anthropologists of Oceania, Kona, Hawaii, 9 February 1996.

5. A useful summary of French imperialist policy is contained in R. D. Anderson, *France, 1870–1914: Politics and Society*, London, 1977, pp. 141–156.

6. See Patricia Leighton, "The White Peril and *l'art nègre*: Picasso, Primitivism and Anti-colonialism," *The Art Bulletin*, vol. 72, December 1990, pp. 609–630.

7. Bengt Danielsson and P. O'Reilly, eds, *Gauguin: Journaliste à Tahiti et ses articles des "Guêpes*," Paris, 1966, p. 48.

8. Lilikala Kame'eleihiwa, in her *Native Land and Foreign Desires*, Honolulu, Hawaii, 1992, p. 2, has written:
"Hawaiian identity is, in fact, derived from Kumulipo, the great cosmogonic genealogy. Its essential lesson is that every aspect of the Hawaiian conception of the world is related by birth, and as such all parts of the Hawaiian world are one indivisible lineage. Conceived in this way, the genealogy of the Land, the Gods, Chiefs, and people intertwine with one another, and with all the myriad aspects of the universe. For if someone were to ask a Hawaiian, 'Who are you?' he or she could only meaningfully answer by referring to his or her beginnings, to his or her genealogy and lineage, which is like a map that guides each Hawaiian's relationship with the world."
Nicholas Thomas, in a personal communication with the author dated 6 March 1996, has written:
"I do not see Gauguin's *Where Do We Come From?* as raising problems that would have made sense to Polynesians of his time. I am not really sure that he would have grasped the Polynesian notion that the past lies before you, in part because the idea that this is 'the Polynesian concept' of the past is uncertain. All cultures deploy several different notions of time, and though I certainly accept that this mythological and genealogical time had some presence and salience in Polynesian cultures, my sense is that it has only been made explicit as a principle and rhetorically foregrounded relatively recently in the interests of cultural and ethnic affirmation. That's not to say, though, that Gauguin didn't grasp the significance of the relation to ancestors (*Tehamana Has Many Parents*) and related notions. But the Pomare observation relates to the way explicit dilemmas of identity have become rhetorically central in Polynesian discourse."

List of Illustrations

Unless otherwise stated, all works are by Paul Gauguin. Measurements are given in centimeters followed by inches, height before width before depth. The following abbreviations have been used: **t** top; **b** bottom; **l** left; **r** right.

Color Plates

I (57) *Te nave nave fenua (The Delightful Land)* 1892. Oil on canvas, 91 x 72 (35$^7/_8$ x 28$^3/_8$). Ohara Museum of Art, Kurashiki, Japan
II (58) *Vahine no te tiare (Woman with Flowers)* 1891–92. Oil on canvas, 70.5 x 46.5 (27$^3/_4$ x 18$^1/_4$). Ny Carlsberg Glyptotek, Copenhagen
III (59) *Merahi metua no Tehamana (Tehamana Has Many Parents)* 1893. Oil on canvas, 76 x 52 (29$^7/_8$ x 20$^1/_2$). The Art Institute of Chicago. Gift of Mr. and Mrs. Charles Deering McCormick
IV (60) *Self-Portrait* 1902–03. Oil on canvas mounted on wood, 42 x 45 (16$^1/_2$ x 17$^3/_4$). Kunstmuseum, Basel
V (125) *Mana'o tupapa'u (The Specter Watches Over Her)* 1892. Oil on canvas, 73 x 92 (28$^3/_4$ x 35$^1/_4$). Albright–Knox Art Gallery, Buffalo. A. Conger Goodyear Collection
VI (126–127) *Where Do We Come From? What Are We? Where Are We Going?* 1897–98. Oil on canvas, 139.1 x 374.6 (54$^3/_4$ x 147$^1/_2$). Courtesy Museum of Fine Arts, Boston. Tompkins Collection
VII (128) *Mahana no atua (Day of the God)* 1894. Oil on canvas, 69.9 x 90.5 (27$^3/_8$ x 35$^5/_8$). The Art Institute of Chicago. Helen Birch Bartlett Collection

2–3 Photographer unknown, *Highland Valley, Tahiti*. From Reginald G. Gallop, "Reminiscences of Tahiti, Society Islands, During a Six Week Visit, September–November, 1887." Mitchell Library, State Library of New South Wales, Sydney
4 Charles Spitz *Anne, sixteen years old c.* 1895. Getty Research Institute, Resource Collections, Santa Monica, CA
5 Paul Emile Miot *Tahitian Woman c.* 1870. Collection Musée de l'Homme, Paris
6 Henry Lemasson *Two Tahitians* 1898. Photo Archives Nationales, Aix-en-Provence
7 Paul Emile Miot *Tahitian Dancers c.* 1870. Collection Musée de l'Homme, Paris
10 Roti Make, 1995. Photo the author
14 Henry Lemasson *The Village of Atuona, Hiva-Oa, Marquesas Islands* 1898. Photo Archives Nationales, Aix-en-Provence
22 Henry Lemasson *Outskirts of Papeete, Tahiti c.* 1895. Photo Archives Nationales, Aix-en-Provence
23t Charles Spitz *Central Square, Papeete c.* 1890. Getty Research Institute, Resource Collections, Santa Monica, CA
23b Charles Spitz(?) *La Rue de la Petite Pologne c.* 1885. Collection Musée de l'Homme, Paris
24 Henry Lemasson *Old Tahitian Man* 1896. Photo Archives Nationales, Aix-en-Provence
25 Henry Lemasson *Young Couple c.* 1895. Photo Archives Nationales, Aix-en-Provence
26 Charles Spitz *Vegetation in the South Seas*. From Reginald G. Gallop, "Reminiscences of Tahiti, Society Islands, During a Six Week Visit, September–November, 1887." Mitchell Library, State Library of New South Wales, Sydney
30 *Bathers* 1885. Oil on canvas, 38.1 x 46.2 (15 x 18$^1/_4$). National Museum of Western Art, Tokyo
31 *Still Life with Vase of Japanese Peonies and Mandolin* 1885. Oil on canvas, 64 x 53 (25$^1/_4$ x 20$^7/_8$). Musée d'Orsay, Paris
32 *Sleeping Child* 1884. Oil on canvas, 46 x 55.5 (18$^1/_8$ x 21$^5/_8$). Josefowitz Collection
34 *The Haystacks, or The Potato Field* 1890. Oil on canvas,

73 x 92 (28$^3/_4$ x 36$^1/_4$). National Gallery of Art, Washington D.C. Gift of W. Averell Harriman Foundation in memory of Marie N. Harriman
35 *The Yellow Christ* 1889. Oil on canvas, 92 x 73 (36$^1/_4$ x 28$^3/_4$). Albright–Knox Art Gallery, Buffalo, New York. General Purchase Funds, 1946
37 *The Green Christ. The Breton Calvary* 1889. Oil on canvas, 92 x 73 (36$^1/_4$ x 28$^3/_4$). Musées Royaux d'Art et d'Histoire, Brussels. Photo A.C.L.
38 Gustave Courbet *Bonjour Monsieur Courbet* 1854. Oil on canvas, 129 x 149 (50$^3/_4$ x 58$^5/_8$). Musée Fabre, Montpellier
39 *Bonjour Monsieur Gauguin* 1889. Oil on canvas, 113 x 92 (44$^1/_2$ x 36$^1/_4$). Národni Gallery, Prague
40 *Christ in the Garden of Olives* 1889. Oil on canvas, 72.4 x 91.4 (28$^1/_2$ x 36). Norton Gallery and School of Art, West Palm Beach, Florida
41t *Beach at Le Pouldu* 1889. Oil on canvas, 73 x 92 (28$^3/_4$ x 36$^1/_4$). Private collection
41b *Be Mysterious* 1890. Lime wood, polychrome, 73 x 95 (28$^3/_4$ x 37$^3/_8$). Musée d'Orsay, Paris
43 *The Harvest of Mangoes* 1887. Oil on canvas, 89 x 116 (35 x 45$^5/_8$) Stedlijk Museum, Amsterdam
44 Anne-Louis Girodet *Atala at the Tomb* 1808. Oil on canvas, 197 x 260 (77$^5/_8$ x 102$^3/_8$). Musée du Louvre, Paris
45 Eugène Delacroix *The Natchez c.*1823–36. Oil on canvas, 89 x 117 (35 x 46$^1/_8$). Private collection
46 Nicolas Chevalier *Maori Girl, Hinemoa, in a Canoe* 1879. Oil on canvas, 91.4 x 152.4 (36 x 60). National Library of Australia, Canberra
63 *Vahine no te tiare (Woman with Flowers)* 1891–92. Oil on canvas, 70.5 x 46.5 (27$^3/_4$ x 18$^1/_4$). Ny Carlsberg Glyptotek, Copenhagen
64 *Tahitian Women* 1891. Oil on canvas, 69 x 91 (27$^1/_8$ x 35$^7/_8$). Musée d'Orsay, Paris
65 Henry Lemasson *Young Tahitians Making Straw Hats* 1896. Photo Archives Nationales, Aix-en-Provence
67 *Te nave nave fenua (The Delightful Land)* 1892. Oil on canvas, 91 x 72 (35$^7/_8$ x 28$^3/_8$). Ohara Museum of Art, Kurashiki, Japan
69 *Teha'amana c.* 1893. *Pua* wood polychromed with paint, stain, and gilding, H 25 (9$^7/_8$). Musée d'Orsay, Paris
70 *Merahi metua no Tehamana (Tehamana Has Many Parents)* 1893. Oil on canvas, 76 x 52 (29$^7/_8$ x 20$^1/_2$). The Art Institute of Chicago. Gift of Mr. and Mrs. Charles Deering McCormick
72 Photographer unknown *Nude c.* 1893–95. Getty Research Institute, Resource Collections, Santa Monica, CA
73 *Aita tamari vahine Judith te parari (The Child-Woman Judith Is Not Yet Breached)* 1893. Oil on canvas, 116 x 81 (45$^5/_8$ x 31$^7/_8$). Private collection
75 *Portrait of Vaïte (Jeanne) Goupil* 1896. Oil on canvas, 75 x 65 (29$^1/_2$ x 25$^5/_8$). The Ordrupgaard Collection, Copenhagen
76 *Tahitian Woman and Boy* 1899. Oil on canvas, 95 x 61 (37 $^3/_8$ x 24). Norton Simon Art Foundation, Pasadena, CA
83 *Oviri (Savage)* 1894. Stoneware, partially glazed, 75 x 19 x 27 (29$^1/_2$ x 7$^1/_2$ x 10$^5/_8$). Musée d'Orsay, Paris
86t Charles Spitz *Tahitian Boy*. From Reginald G. Gallop, "Reminiscences of Tahiti, Society Islands, During a Six Week Visit, September–November, 1887." Mitchell Library, State Library of New South Wales, Sydney
86b Frederick O'Brien *A Pearl Diver's Sweetheart*. From his *White Shadows in the South Seas* (1919)
87t Charles Spitz *Two Tahitian Men*. From Reginald G. Gallop, "Reminiscences of Tahiti, Society Islands, During a Six Week Visit, September–November, 1887." Mitchell Library, State Library of New South Wales, Sydney
87b Charles Spitz *Tahitian Men c.* 1880. Collection Musée de l'Homme, Paris
88tl Henry Lemasson *Young Tahitians* 1897. Photo Archives Nationales, Aix-en-Provence

Index